Lessons From a Lifetime of Watercolor Painting

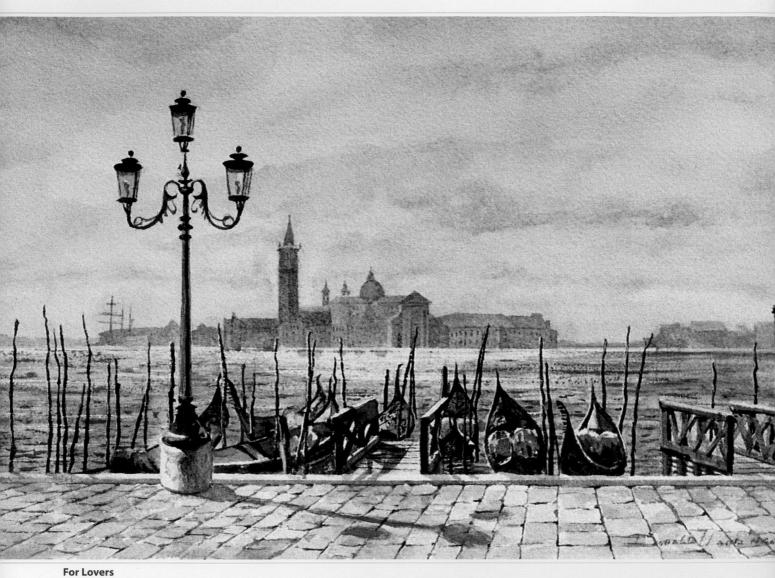

For Lovers
Watercolor on paper, 53" × 88" (135cm × 224cm)
Collection of the artist

Lessons From a *Lifetime* of Watercolor Painting

Donald Voorhees

NORTH LIGHT BOOKS

CINCINNATI, OHIO

www.artistsnetwork.com

About the Author

Donald Voorhees has been painting for more than fifty years. He graduated from the Newark Academy of Fine Arts' four-year total art immersion curriculum; he continued his education through workshops at the Art Students League of New York. He's been a teacher of watercolor and owned his own gallery for twenty-five years. Donald has written for *The Artist's Magazine*, and articles pertaining to his artistic achievements have appeared in numerous other magazines and books, including *Print*, *Graphics*, *Collector's Mart*, *Gems of New Jersey* and several *Who's Who* publications. He is a former president and life fellow of the New Jersey Watercolor Society and has had memberships in many other professional art associations and societies.

Donald's work has been exhibited in many museums and is in such collections as those of former president Ronald Reagan, the Chilean Embassy, Gannett Publishing, AIG and others too numerous to mention. His work can be seen in galleries all over the world. He lives with his wife in Atlantic Highlands, New Jersey. You can see more of Donald's work on his Web site, www.donaldvoorhees.com.

Lessons From a Lifetime of Watercolor Painting. Copyright © 2007 by Donald Voorhees. Manufactured in China. All rights reserved. No part of this book may be reproduced in any form or by any electronic or mechanical means including information storage and retrieval systems without permission in writing from the publisher, except by a reviewer who may quote brief passages in a review. Published by North Light Books, an imprint of F+W Publications, Inc., 4700 East Galbraith Road, Cincinnati, Ohio, 45236. (800) 289-0963. First Edition.

Other fine North Light Books are available from your local bookstore, art supply store or direct from the publisher.

10 09 08 07 5 4 3 2 1

DISTRIBUTED IN CANADA BY FRASER DIRECT
100 Armstrong Avenue
Georgetown, ON, Canada L7G 5S4
Tel: (905) 877-4411

DISTRIBUTED IN THE U.K. AND EUROPE BY DAVID & CHARLES
Brunel House, Newton Abbot, Devon, TQ12 4PU, England
Tel: (+44) 1626 323200, Fax: (+44) 1626 323319
Email: mail@davidandcharles.co.uk

DISTRIBUTED IN AUSTRALIA BY CAPRICORN LINK
P.O. Box 704, S. Windsor NSW, 2756 Australia
Tel: (02) 4577-3555

Library of Congress Cataloging in Publication Data
Voorhees, Donald
 Lessons from a lifetime of watercolor painting / Donald Voorhees.
 p. cm
 Includes index.
 ISBN-13: 978-1-58180-775-2 (alk. paper)
 ISBN-10 1-58180-775-9 (alk. paper)
 1. Watercolor painting—Technique. I. Title.

ND2420 .V66 2007
751.42'2—dc22 2006046449

Edited by Mona Michael and Erin Nevius
Designed by Guy Kelly
Page Layout by Kathy Gardner
Production coordinated by Jennifer L. Wagner

Metric Conversion Chart

To convert	to	multiply by
Inches	Centimeters	2.54
Centimeters	Inches	0.4
Feet	Centimeters	30.5
Centimeters	Feet	0.03
Yards	Meters	0.9
Meters	Yards	1.1
Sq. Inches	Sq. Centimeters	6.45
Sq. Centimeters	Sq. Inches	0.16
Sq. Feet	Sq. Meters	0.09
Sq. Meters	Sq. Feet	10.8
Sq. Yards	Sq. Meters	0.8
Sq. Meters	Sq. Yards	1.2
Pounds	Kilograms	0.45
Kilograms	Pounds	2.2
Ounces	Grams	28.3
Grams	Ounces	0.035

Dedication

To Terry, my wife, business partner and the person most responsible for my entrance into the business side of the art world. She was always there with praise, constructive criticism and the willingness to do anything that would assist me.

Acknowledgments

Thanks most of all to my loving family, my children, their spouses and my grandchildren. Their love has sustained me throughout the years.

There are so many people who have helped me in my long career that I hardly know where to begin, but I would like to give special thanks to the following people:

My friend and painting buddy, the eminent portrait painter and author Roberta Carter Clark, who encouraged me to write this book and agreed to write the introduction regardless of her own demanding portrait schedule.

Art Fay, friend and patron, whose articles and publicity were the catalyst in successfully promoting my work in the early years.

Sculptor Del Filardi and photographer Harriet Rubin, owners of the marvelous Blue Heron Gallery on Cape Cod. They exhibited my work and gave me shows for the twenty years they owned the gallery. Not only did they sell my work, they also bought several pieces for their own collection. They have always been kind, hospitable, good friends.

Harry and Helen Keller, who were avid collectors of my paintings and became dear friends.

Bob Gaughran, who introduced me to several influential people in the golf world, which enabled me to produce many successful golf paintings and prints. He and his wife, Lori, always thought of our gallery when they were looking for gifts. They own several of my paintings and prints. They, too, are good friends.

Joe and Linda Small and their families—Joe was vice president of a major bank and helped our gallery in ways too numerous to mention. Their families were also great supporters.

Richard and Myrna Bennett. When Richard was president of Beacon Hill Country Club, he and the board commissioned me to do a centennial painting of the club (which appears in this book). Myrna was also a very loyal supporter.

Bob and Maryann Bennett. Bob arranged for me to get approval to access the New York Stock Exchange so I could do a painting of it. That painting is also in this book.

Chuck and Jean Snoddy, who supported and helped us in so many ways. Chuck passed away a few years ago, but Jean continues to help us when needed.

Joe Hall and Ross Stout, for the large photocopies of my paintings.

And last but certainly not least, the great staff at North Light Books: Jamie Markle, executive editor, who had faith enough to allow me to bring an idea to fruition; my editors, Mona Michael and Erin Nevius, who where always there to answer my questions and make suggestions; and art director Guy Kelly for his creative cover design.

This acknowledgment would be fifty pages long if I thanked all the wonderful people who have helped me along the way. To all of you not mentioned here, believe me, I thank you. I have become friends with many of my collectors, and many of my friends have become collectors.

There are many people I would like to thank who were supportive in other ways throughout my career. It would be impossible to thank all of these people inasmuch as most of my work in the last thirty years was sold through galleries throughout the U.S., and the world, for that matter. I want to say to the many people and galleries that have sold my work, as well as collectors who prize my paintings, and all others who have helped me over the years and who patronized our gallery—THANK YOU!

Table of Contents

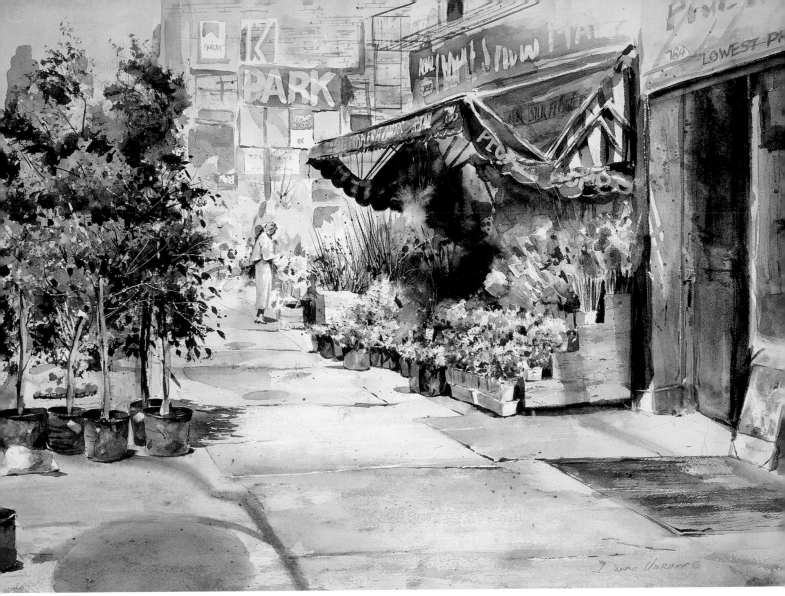

Winter's Over
Watercolor on paper, 21" × 29" (53cm × 74cm)
Collection of Ronnie and Mike Rybeck

Introduction

I love books, particularly art books. I have several hundred of them, a good many of them purchased through the excellent North Light Book Club. Several of them have pages with paint on them, torn or missing dust jackets or some other distress. It is my sincere desire that this will happen to my book: I don't want it to be a book that is scanned a couple of times and then resides on your bookshelf for years. Truthfully, I have some of those, but I also have some that have been opened so many times the binding is busted and I had to tape them up with masking tape. (You won't have to do that with this one—the publisher has thoughtfully used the exclusive Wire-O binding that enables you to lay the book flat while you're working.)

Years ago, when I was a student at the Academy of Arts in Newark, New Jersey, I often used to make the same joke while having a lively discussion about art with my fellow students. Sometimes, someone would ask me a question that I didn't have an answer for, and I would reply (in my smart-alecky way), "I'll put it in my book." Of course, never in my wildest dreams did I think I would actually write a book.

Now, I am writing a book—and I have answers, a lot of them. I sincerely hope I can answer some questions you maybe have had on your mind for some time about watercolor painting. I'm here to help you!

Section One is devoted to thoroughly covering the most common watercolor techniques, as well as some of the uncommon ones. I discuss many different subjects from the most elementary, such as paper, brushes and choosing colors, to the most bizarre, such as scrubbing off paint right down to the white of the paper using bleach. I explain how useful it is to use your camera to make a good photo reference file. I cover the use of your T-square and triangle.

When I was teaching, I found that one of the things many students seemed to lack was a thorough understanding of perspective. So I devoted some pages to the subject, using an actual commission I did to illustrate it. I also describe some masking techniques you may not be aware of. All in all, I cover fifteen different techniques in this section, some complete with demonstrations. Many of the illustrations show the hand actually making the strokes, which I hope you'll find helpful.

In Section Two, well, I don't want to spoil anything, but you'll learn how to paint everything you've always wanted—skies, water, flowers, trees and grass, dunes, light, shadow, people, porches, snow and architecture.

I've put everything I have into this book, and truly hope that my secrets help you become a better watercolorist and enable you to reach your potential sooner than you would have. The tremendous amount of work it takes to achieve success is well worth it when you reach your goal. Good luck!

Donald Voorhees
by Roberta Carter Clark, AWS
Watercolor and pencil on paper, 20" × 24" (51cm × 61cm)

Foreword

I have known Don for many years. Way back in the 1970s we used to go painting together every Tuesday morning. We had the entire Jersey coast to paint. Belford, a great old fishing village, provided us any number of subjects, and Don always knew about some ancient barn hidden away on a deserted farm.

He has always been very serious about his work and taught watercolor for many years, turning out many really good artists with his knowledge and enthusiasm. In more recent times he has branched out considerably, owning his own gallery and traveling all over the world to find exciting and challenging subjects.

I recall one time, when I had not seen him for several years, I was painting at The Barnyard shopping village in Carmel, California, and out of nowhere, I was surprised to hear that deep Voorhees voice say hello. There he was, on the West Coast for some professional marketing venture! And both of us so far from home.

I am certain this book will find many devotees, for Don has a lifetime of watercolor learning to tell us about and he enjoys sharing this with others. Just looking at this book, showing us so many of his beautiful paintings, will surely be a real treat for watercolor painters and admirers everywhere.

Thank you, Don Voorhees!

Roberta Carter Clark, AWS

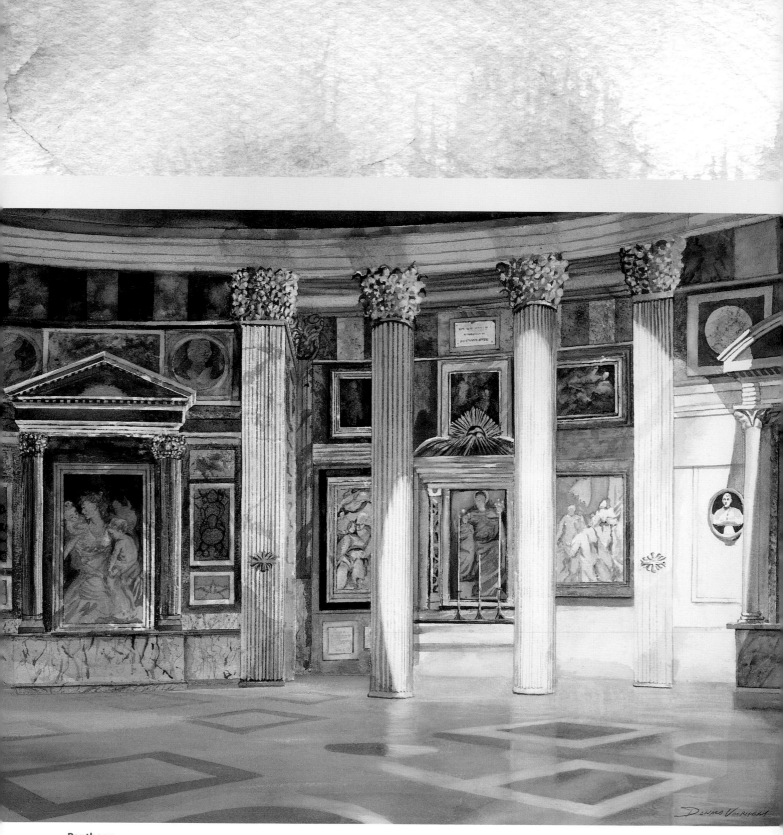

Pantheon
Watercolor on paper, 21" × 29" (53cm × 74cm) Collection of the artist

Materials, Supplies & the Basics

When I was a kid, I loved cowboys. Don't ask me why—I guess it's a little boy thing. Or maybe it's because my grandfather was always telling me stories about when he was in Buffalo Bill's Wild West Show. Anyway, when I first started to draw cowboys, my parents and grandparents used to get a big kick out of my drawing procedure. I would draw the seated cowboy first, and then put the horse under him. This made total sense to my six-year-old brain.

Shortly after that, I started copying comic strips out of the newspaper. My favorites were *Prince Valiant* by Hal Foster, *Steve Canyon* by Milton Caniff and *Tarzan* by Russ Manning because of their superb figure drawing, draftsmanship and realism. Even as a youngster I appreciated this talent and (hopefully) it's followed me through my life as an artist.

Whatever path you took to becoming a watercolor painter, be it horse-less cowboys and comic strips or some way of your own, drawing skills are essential to your success as a painter. Just as crucial are the materials you use to capture your subjects, and the amount of practice you dedicate to it.

"The artist is nothing without the gift, but the gift is nothing without work." —Emile Zola

Picking Your Paper

I think the majority of watercolorists would agree that paper is the most important ingredient in a painting. If your budget is thin and you have to skimp on something, skimp on the quality of the paints. Inferior paints always look better on good-quality paper.

I personally have never experimented with many papers. Although I have tried other brands, only Arches, made in France, has served my needs since my student days. Used by watercolorists all over the world, it is made from 100 percent rag with beautiful deckle edges, which the artist may choose to show when the painting is framed.

The cold-pressed surface is the one used by most watercolorists, although it also comes in rough and hot press. Hot-pressed paper is very smooth and rough-pressed paper is toothy and has a lot of texture; cold-press falls between these two.

Arches paper is made in three weights, 90-lb. (190gsm), 140-lb. (300gsm) and 300-lb. (640gsm). The standard sheet size is 22" × 30" (56cm × 76cm). However, there is also a 25½" × 40" (65cm × 102cm) size called a "Double Elephant." This size is classed as a 260-lb. (553gsm) weight. Paper is measured by ream weight. There are about 500 sheets to a ream, so 500 sheets of the 140-lb. (300gsm) paper weighs 140 lb. (300gsm). It also comes in 140-lb. (300gsm) pads and blocks (a block is bound on three sides to prevent buckling).

Furthermore, in addition to the normal off-white color of Arches, the standard size also comes in a bright white. For mural painters and other users of larger papers, the bright white is also available in 44½" × 10 yards (113cm × 9m) rolls, which are classified as 156-lb. (332gsm).

The 140-lb. (300gsm) cold-press Arches fits my needs perfectly. I prefer the way it accepts the paint. In my early years of painting I used the 300-lb. (640gsm), but it's so heavy it absorbs paint like a blotter. The lighter weight paper does not have this complication.

Fabriano Artistico Paper
A softer paper than the other two, the 140-lb. (300gsm) Fabriano Artistico paper tore when the masking tape was removed. The sky was not as smooth as I would have liked, but a nice coarse texture was created in the water after blade scraping and dry-brushing.

Arches Cold-Pressed Paper
This is my favorite, the 140-lb. (300gsm) Arches cold-press. The sky is very smooth, blade work gives the water sparkle and you can see some ripple-like texture from the dry-brushing.

Arches Rough-Pressed Paper
You can see grain in the sky when using 140-lb. (300gsm) rough-press Arches. The water is not very natural and the ripples are very coarse. I used to use rough-pressed paper once in awhile, but I was unhappy with it so I stopped. If you find something is working for you, don't change it.

Protecting Your Paper

You can protect any area of your painting from paint or washes in adjoining sections by masking it off. Simply cover the area you would like to remain unaffected with masking tape and trim off the excess with a craft knife or razor blade. You could also use adhesive paper or masking fluid to cover the paper.

Here's another trick: If you get some buckles in your paper as you paint and it's bothering you, place a damp cloth on the underside and iron it. If that doesn't work, you can always have the painting mounted by a professional picture framer using today's conservation mounting materials.

Setting Up Your Studio

I sometimes think the word *studio* is misused. Really, a studio is anywhere you regularly create art. My first studio was in my bedroom at my parents' home in Neptune, New Jersey. I've had six or eight studios in various residences from New York City to my present one in Atlantic Highlands, New Jersey.

At least the current studio fulfills one of my requirements—since art school, I've always had a grand vision of someday having a magnificent studio overlooking the water. Now, my studio overlooks beautiful Sandy Hook Bay and is bordered by the New York skyline. Because we live in an apartment, the studio shares space with two computer stations, a printer and several bookcases.

The point is, your studio doesn't have to be grand. It has to be is well organized, clean and comfortable. You don't really need a fancy drawing table. What you need is a nice big table to work on and another on which to place your paints, palette and water. I have north light in my studio, which is good to have but not necessary. It's supposed to be a clearer, more constant light.

Of course, there are certain amenities you do want in your painting space—it's nice to have a flat file in which to store your watercolor paper and paintings, for one thing. Here's a photo of my work area. How do you like my fancy water bucket? A mason jar or two serves the same purpose.

Materials List

These are my absolute must-haves for my painting area:

Palette, paints and brushes
Paper and a place to store it
Drawing board (which should be laminated if you plan on any wet-into-wet painting)
T-Square and triangle
Ruler or measuring tape
Tracing and transfer paper
Two tables for painting and materials
Water bucket (a mason jar works well)
Hair dryer
No. 10 craft knife
Razor blades
Utility knife
Paper towels
Bar soap
Rubber cement pickup

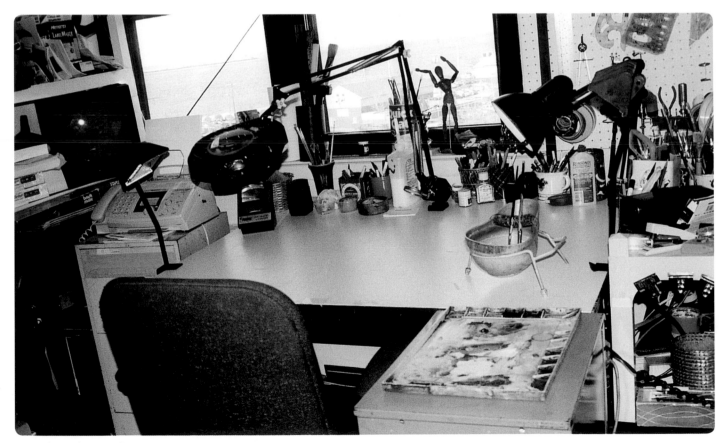

Round Up the Goods
Though a "studio" can be anywhere you like to paint, you will need to keep a few supplies on hand no matter where you might be.

Selecting Your Paints

There are two basic types of watercolor paints: those made from pigment and those made of dye. Pigmented colors lie on top of the paper and adhere to it with gum arabic. If you make a mistake, it is easier to remove than dye paint. Dye color stains and is harder to remove. So, no white clothing when you're painting with it!

It used to be that people liked to use dye paints because they are more permanent, but that's no longer as important as it used to be. Anything will fade if it's subjected to direct sunlight long enough, but with new conservational framing methods and UV protective glass, it's not a big concern.

My current palette evolved over many years of eliminating and adding colors. Where palettes are concerned, I think less is more. Most artists have favorite color schemes that work for them. You will develop your own favorites by experimenting. What works for me isn't necessarily going to work for you, but it's a start.

Try to use the highest quality paint you can afford. Keep in mind that colors vary from one manufacturer to another.

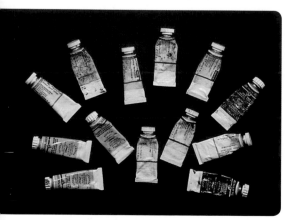

Choosing Your Paints
These are the trusty, battered colors on my palette.

My Colors

1 **Cadmium Yellow Medium** (Grumbacher). A very strong opaque I use a lot. Mixed with a blue or Payne's Gray, it makes great greens.

2 **Cadmium Red** (Winsor & Newton). I use this sparingly, as it's very bright and clear.

3 **Burnt Umber** (Grumbacher). A very dark, rich, transparent brown.

4 **Winsor Violet Dioxazine** (Winsor & Newton). This is a lovely transparent purple that I frequently use in dune and beach shadows.

5 **Ultramarine Blue** (Grumbacher). A nice blue that leans toward purple. Works well with Burnt Sienna for a nice granular texture.

6 **Payne's Gray** (Winsor & Newton). A very transparent bluish gray that makes great green grass when mixed with a yellow or Raw Sienna.

7 **Permanent Rose** (Winsor & Newton). As the name suggests, this is good for painting roses.

8 **Burnt Sienna** (Winsor & Newton). I use this for rust stains and sometimes throw a bit of it in an evergreen to break up the monotony.

9 **Raw Sienna** (Winsor & Newton). I use this when painting gold.

10 **Alizarin Crimson** (Winsor & Newton). This is the color of transparent red wine. I use it a lot.

11 **Naples Yellow** (Grumbacher). A very pale, semitransparent yellow tint. I use it very sparingly.

12 **Cerulean Blue** (Winsor & Newton). I use this in skies a lot, sometimes mixed with Payne's Gray or a touch of Raw Sienna.

13 **Cadmium Yellow Deep** (Grumbacher). Also strong, this yellow leans toward orange.

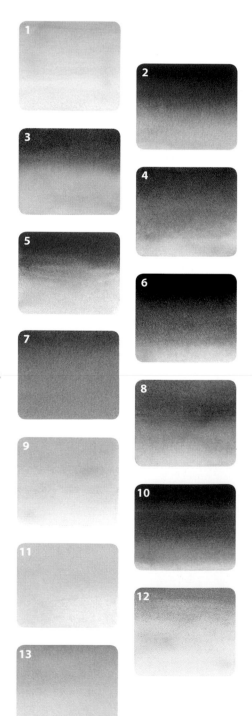

The Brushes You'll Need

Watercolor brushes are generally flat or round. The most common natural hair is sable, due to its great spring, strength and ease in coming to a point. Although many other animal hairs are used—ox, hog and squirrel, for instance—the next most commonly used hair is synthetic or a combination of synthetic and sable.

Over time, brushes get bent out of shape. They all fall victim sooner or later, not that they're totally useless when that happens. They're still good for washes, but for keeping the point that's necessary for detail work, forget it.

I recommend buying a couple of different sizes (nos. 1–8) for detail work. But buyer beware: Sizes of brushes vary. A no. 8 from one maker may not have the length or fullness as the same number from its competitor. Try going to your art supply store and looking at what's available. Ask for a little water, swish the brush around a couple of times, take it out and give it snap with your wrist. It should come to a perfect point—if it doesn't, try another one.

I've tried the large 2-inch (51mm) or 3-inch (76mm) hardware store paintbrushes that many watercolorists use for skies, but I never really felt the need for them. I can get all the coverage I need with my 1¼-inch (44mm), even for paintings as large as 25" × 40" (64cm × 102cm).

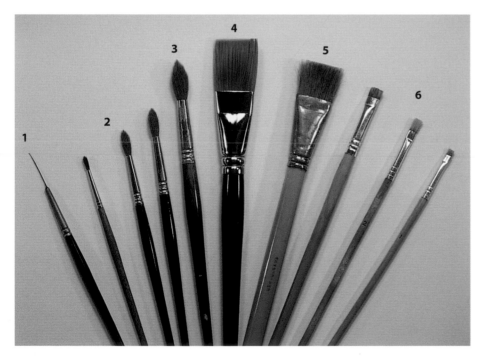

My Brushes

1 **Rigger.** A brush given to me by John Pike, one of my first teachers. He customized it by pulling most of the hair out, thereby making it much thinner. It's great for painting a single weed or a small branch or branches where needed.

2 **Nos. 2, 4 and 6 kolinsky red sable pointed rounds.** I use these for detail.

3 **No. 12 kolinsky red sable pointed round.** Perfect for small washes.

4 **1¼-inch (31mm) synthetic longhair flat.** Great for painting large washes quickly (skies, water, etc.).

5 **1-inch (25mm) shorthair flat skyscraper with pointed handle.** Used for laying down medium-size washes and lifting out excess paint. The handle may be used on damp paper for gently scraping out tree branches, riggings or any place where you need a light line on a dark background.

6 **Nos. 2, 3 and 5 oil painter's shorthair stiff bristles.** Used for scrubbing out mistakes. I took a pair of scissors and cut the hair on the no. 2 to make it even shorter so I could have more control when working a small area.

Cameras and Photography

The camera is a marvelous tool for an artist—it allows you to capture several phases of something fleeting, like a sunrise, and refer to it whenever you need. I've recorded information from places where I've spent only a few seconds, such as from the windows of trains, and created comprehensive paintings of the scenes later.

My current camera is an Olympus ISSLR 35mm. Everything on it is automatic—auto-focus, power zoom, automatic loading, winding and rewinding and auto film speed setting. I use 400-speed slide film, which is fast enough for normal landscape use with good quality and I don't have to worry about camera movement blurring the shot. I also have an Olympus C2500 2.5 megapixel SLR digital, but I rarely use it to shoot reference material. Although digital cameras do have the advantage of letting you see your shot instantly, I still prefer the 35mm.

The first camera I used to take reference photos was a Pentax 35mm SLR. It has a built-in, through-the-lens exposure meter, an easy focusing system and aperture control. This is a good, basic, user-friendly camera for a first-timer. I understand it is the favorite in photography classes.

Making Slides

Turning your photos into slides and using a slide projector lets you blow up the most minute details of a scene to several feet, as well as providing a much sharper image than you can get from prints—because there is no negative, the film you shoot actually becomes the slide.

You can pick up an inexpensive slide viewer for starters. I still use mine occasionally, for quick reference when I'm painting. However, you will really need a slide projector. Mine is a Vivitar 3000 auto-focus rotary carousel/type.

To use your slide projector in a light room, fashion a "light-reducer" out of a cardboard box. Leave the flaps on and tape them together to make it deeper. If you want to, you can cover the inside with black paper to reduce the light reflection from the screen. It's not like using it in a darkened room, but it's pretty good. I've even used mine when teaching a class on a cold winter day when we couldn't go outside.

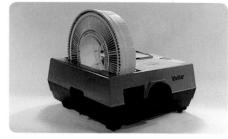

Slide Projector
You will need a slide projector to view your reference photos on a large, clear scale. I use a Vivitar 3000 auto-focus rotary carousel type. The carousel holds one hundred slides. In this instance, I have filled it with about twenty.

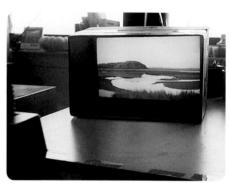

Slide Projection in the Light
It's not quite as good as viewing your slides in a dark room, but you can fashion a cardboard box into a "light-reducer" that will reduce the light reflection from the screen.

Slide Viewer
Inexpensive, small slide viewers are handy for quick reference while painting.

Easy-to-Use Cameras
The camera on the left is an Olympus ISSLR 35mm, and my current favorite. The one on the right is the first I ever bought for reference photos, a Pentax 35mm SLR, which is great for a first-timer and also relatively inexpensive.

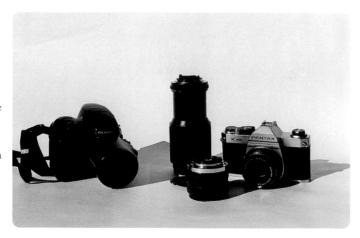

Other Equipment

Over the years, I have found these tools essential. Some are in the invaluable category and some are merely nice to have, but I like to have them all on hand as I paint.

My Equipment

T-square and triangle. Like love and marriage, you can't have one without the other. Both are absolutely essential for squaring up your paper with your drawing board, making sure that a building is truly vertical and innumerable other applications.

My T-square is metal and, unfortunately, no longer available. Today, they are only made of plastic. The triangles are also plastic and come in clear or pink. I prefer the pink—it's easier to see.

Bow compass-divider. I use this infrequently; it's nice to have, but not on a high-priority list. The divider is handy for measuring the distance between brick courses and clapboard as well as for drawing circles.

Fixative sprayer. I've had this one since art school. It's good for re-wetting a dry area and can give you a finer mist than a spray bottle.

Measuring tape. Of course!

Plastic shoehorn. This works great for burnishing (polishing or smoothing a surface by rubbing). I prefer it to a commercial burnishing tool because it has a curved edge. It's also good for fitting your foot back into your shoe after throwing it at an unsuccessful painting.

Magnifying glass. For the little things.

French curve. Used for drawing an irregular line.

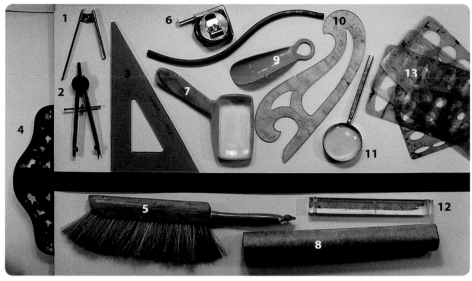

Tools of the Trade
Many of these are not indispensable, but you'll find that they come in handy time and again as you paint.

1	fixative sprayer	8	transfer paper
2	bow compass-divider	9	plastic shoehorn
3	triangle	10	French curve
4	T-square	11	reducing glass
5	horsehair brush	12	plastic bar
6	measuring tape	13	elliptical templates
7	magnifying glass		

Reducing glass This enables you to see how your painting looks from a distance without leaving your drawing table.

Elliptical templates. Used for drawing partial or complete ovals.

Plastic bar. Helps you draw straight lines.

Transfer paper. Can be used to make a tracing of your drawing.

Horsehair brush. Keeps your artwork clean of eraser residue or anything else that might fall onto your painting.

Hair dryer and electric eraser. The hair dryer is absolutely mandatory equipment for a watercolorist, period. The electric eraser is used for making sharp, crisp highlights (for instance, corners of buildings, the top of a ship's mast or highlights on a pot).

SECRET
Telephoto Zoom

If you want to buy a film camera to take reference photos, I would recommend a fully automatic zoom SLR. You can zoom in and out easily, which makes it easy to compose the future painting right in the viewfinder. You can buy them fairly inexpensively on eBay because of the current popularity of digital photography. However, make sure it comes with some kind of return policy.

Flexible Curve

I came across this tool some years ago and was immediately taken with it. Think of it as a French curve you can use with a brush. It's made of lead and steel and encased in plastic, and it can be bent into almost any shape.

Artist's Bridge

I actually made one of these myself before I found out that a manufacturer was making a clear plastic version far superior to mine. Think of it as a transparent shelf that allows you to rule straight lines with a brush.

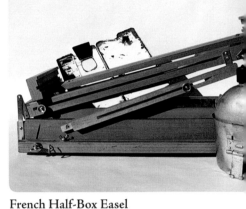

French Half-Box Easel

This type of easel is a necessity if you intend to paint while traveling or on location (*en plein air*, as they say). This is a lightweight version of an oil painter's French easel. To transport water, I use an old army canteen complete with cup which you can find at Army-Navy stores. This outfit went to Australia with me.

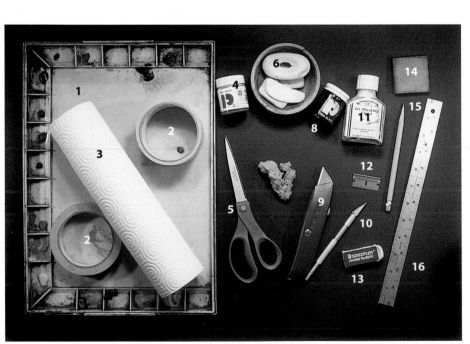

A Few More Tools

I also use these supplies regularly as I paint, and it's not a bad idea to keep them close at hand as you work.

1 John Pike palette
2 masking tape
3 paper towels
4 Pro-White
5 scissors
6 bar soap
7 natural sponge
8 Pro-Black
9 utility knife
10 craft knife
11 masking fluid
12 razor blade
13 plastic eraser
14 rubber cement pickup
15 no. 2 HB pencil
16 ruler

SECRET
Laminated Boards

If you intend to do any wet-into-wet painting, you should really have a laminated drawing board. You can go to a local kitchen counter shop where they usually have some scraps. You can cut it yourself, or they'll usually cut it for you for a few dollars. Otherwise, they are available from Daniel Smith Artists' Materials.

Subject Selection

We pick our subject matter for a number of reasons:

* a school assignment to paint a still life
* a commission to paint a person, animal, boat, building, house, golf course or whatever
* a gallery has requested a certain subject matter for which they get frequent requests
* you believe that a certain type of painting appeals to a large segment of people
* you like it and you don't care if anyone else does

If you are planning to sell your work, it is important to realize that someone else has to like it in all cases except the first and the last.

However, sometimes it's a good idea just to paint for sheer enjoyment. This is what the great portrait painter John Singer Sargent (1856–1925) did when he was on vacation. Personally, I am fortunate enough to enjoy painting things other people seem to like, such as seashore scenes and lighthouses.

Don't be afraid of repetition: You can paint the same subject many different ways. For instance, in different seasons, time of day, weather conditions, etc. Andrew Wyeth, one of my favorite artists, made a career out of painting the Olsen and Kuerner farms.

Sometimes you ride around for hours looking for just the right material, and other times you run across it when least expected. There have been places I've driven by countless times and then one day, in a certain light or season, it's transformed.

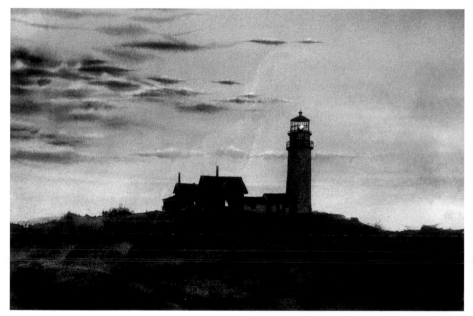

Seek Greatness

I like to put myself in a position where something great might happen, like getting up before sunrise, sitting on a dune and waiting for the sun to appear. I feel a tremendous surge of gratitude and am glad to be alive, and I always attempt to capture that feeling in my work: It gives a painting soul.

Majestic Sky
Watercolor on paper, 14" × 21" (36cm × 53cm)
Private collection

John Singer Sargent

The extraordinary portrait painter John Singer Sargent would take summers off to go to places like Venice or Morocco. He painted marvelous, loose watercolors, which his clientele did not consider "serious art." Upon his return, he tossed the paintings into a closet and forgot about them. Some were not discovered until after his death. Fortunately, they were found and are hanging in museums for all to enjoy. Today, quality watercolors are every bit as valuable and sought after as any other medium.

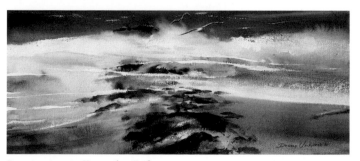

Early Risers
Watercolor on paper,
12" × 21"
(30cm × 53cm)
Collection of Valerie
Schauer

Inspiration in Everyday Life

One of my other favorites is *Early Risers*. I often go down to sit on the beach and watch the surf. One early morning after a storm, I was watching the waves pound against the jetty, which has been a favorite spot of the local fishermen for years. Two seagulls came flying by, circling the area. They were up early, anticipating the arrival of the fishermen with the hope that they might get lucky and catch a fish first.

Composition

Every time you sit down at your drawing table or stand at your easel, the first thing you do is compose. You're faced with composing the minute you touch pencil to paper. What is composition anyway? It's simply the placing of the various elements of the painting into a pleasing design.

You should start with the big overall pattern—the least number of major shapes necessary to make the design. This could be as little as two or as many as four or five. Let's start with that blank piece of paper you're staring at. Okay, we know that drawing a line across the middle of the paper and cutting it in half is generally a bad idea. However, I admit that I have located the horizon very close to the center of the paper at times. Sometimes, when something inside you tells you to, you just have to do it. Jamie Wyeth does it quite often. His father Andrew did something similar in his painting *Brown Swiss* by putting the white house so close to the left edge you'd think it would fall off.

Learning your ABCs

We all know our ABCs, but some other interesting compositional tools are certain letters of the alphabet. In this book, I've used several. For instance, "L" in *Twin Chairs* on page 107 and "Z" in *Mayo Beach* on page 49. Other letters that make great shapes are "S" and "T."

Twin Chairs on page 107 and "Z" in *Mayo Beach* on page 49.

Bad Composition
This is good subject matter—the fencing lends a feeling of depth and the cast shadows add interest. The partial view of the house is also nice. The problem is the vacant area at the top of the dune. Putting two or even three kids walking over the crest of the dune onto the beach could add the interest that area needs.

Good Composition
This sketch works so well because of the sure-fire one-point perspective that takes your eye right down the alley to the center of interest (the dock and boats). Along the way are a few flowering branches and some interesting cast shadows to hold your interest.

SECRET
Composing With Care

You can save yourself a lot of time at the drawing board by taking extra care when photographing your subject matter. Walk around, take your time, take many shots of your entire subject, then several of individual components. I've sometimes used a whole roll on one subject.

Plein Air Painting

If you want to be a realistic painter, you have to learn how to paint from nature: Location painting better enables you to correct things you might miss when using photo references. For instance, there is some perspective distortion when you're painting architecture that's more accurately seen in person, and color isn't always true in photos and varies by brand of film. You need the experience, even if you're painting abstracts. Cubist Pablo Picasso (1881–1973) and surrealist Salvador Dali (1904–1989) were accomplished realistic painters in their younger years. That enabled them to create different styles, still relying on the basics they learned from nature.

Getting Started

Start out with minimal equipment. Perhaps just paints, a few brushes, paper attached to drawing board, a bottle of water, a coffee can, or better yet, an old army canteen with a cup. A backpack, a bag with a shoulder strap or an old suitcase can be used for carrying these items.

The easiest way to start painting outside is to join an art class that teaches watercolor painting on location. Most communities have an art guild, club, alliance or association that give various art lessons. Consult your Yellow Pages. The local art supply store is another good source. Many of them either hold classes or could refer you to artists who do.

The Spontaneity of Plein Air Painting
This beach in Long Branch, New Jersey, is one of my favorite painting spots. The Victorian houses on the bluffs in the background are called "The Reservation," a name bestowed by the locals after the houses were purchased by Buffalo Bill Cody, who created a very successful cowboy and indian show that toured the world. These houses were used as quarters for the performers during the off-season and were named Cherokee, Apache, Sioux, etc.

I had just started painting when a young fisherman and his dog appeared, so I put them in—a perfect center of interest. This is another of the benefits of plein air painting; you never know what's going to happen to make the piece come together.

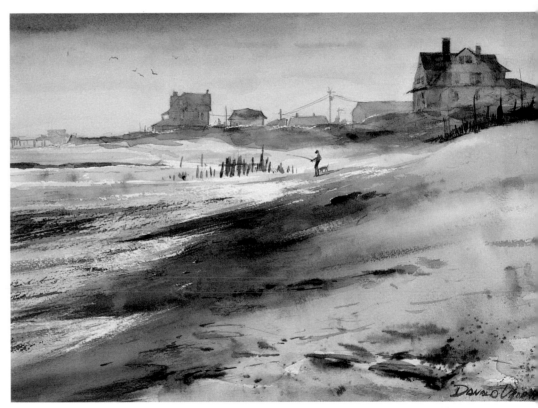

Vineyard Twilight
Watercolor on paper,
21" × 29"
(53cm × 74cm)
Collection of Valerie Schauer

The Negatives of Painting on Location

1. **Equipment:** You have to carry everything you need with you—easel, paint box, water, chair, umbrella, insect repellent, sunscreen, etc.
2. **Weather:** You constantly face the disappointment of planning a day of painting, only for it to start pouring down rain.
3. **Insects:** They can drive you nuts! Sometimes you'll think, "What the hell am I doing out here being bitten to death, when I could be back in my air-conditioned studio?!" Bring lots of bug repellent.
4. **Spectators:** They can drive you as nutty as the bugs! Particularly the kids, with their questions. After watching for several minutes, they'll invariably ask, "Are you an artist?" Of course, it's only childhood curiosity and I love kids, but their many questions can disturb your creative inspiration.

Value

Artistic values have nothing to do with family values or getting a bargain at a flea market or yard sale. You have to understand what value is to be able to paint well. Simply put, values are the relative lightness or darkness of color. In class, when criticizing a student's work, teachers will frequently say this or that part of the work needs to be a darker or lighter value.

To emphasize this point, I've made a black-and-white painting that describes the values of three basic shapes you constantly find in subject matter: a sphere, cylinder and cube. Try painting this exercise yourself. Use Payne's Gray, which is a beautiful blue-gray. Put the color down darker because Payne's Gray tends to dry much lighter. Follow the value examples given here and see how well you do. And practice, practice, practice!

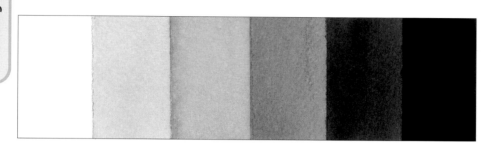

Value Scale
To further help you understand values, I've made a value scale for you. There appears to be a great deal of discrepancy among artists as to the number of values in a value chart—I've seen everything from four to twelve; in fact, a photographer's gray scale has nineteen. My particular preference is six; I believe it to be sufficient for most work.

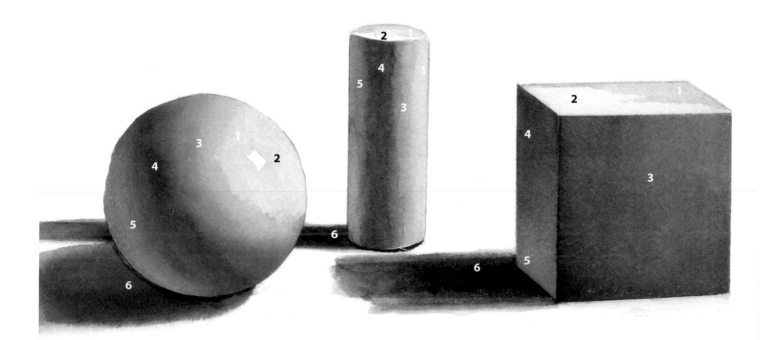

The Six Values Created by Light
1. **Light.** The side facing the primary light source. You have to make sure the light part of the object is dark enough to support a highlight.
2. **Highlight.** The lightest part of the object. You might create the highlight with the white of the paper, an opaque white or even blade scratches.
3. **Midtone.** The transition point between light and dark values.
4. **Form shadow.** The side or plane of the object being painted that isn't facing the light source. In the case of something overhead that's being lit from above, the underside is also a form shadow.
5. **Reflected light.** That part of the shadow reflecting light from a secondary source such as a table or wall. Reflected light helps make objects appear dimensional and solid. Amazingly, some artists totally disregard this important factor. It's really a must to give form to your subjects.
6. **Cast shadow.** The shadow cast by an object. When the object is on a flat surface, the cast shadow anchors it to that surface.

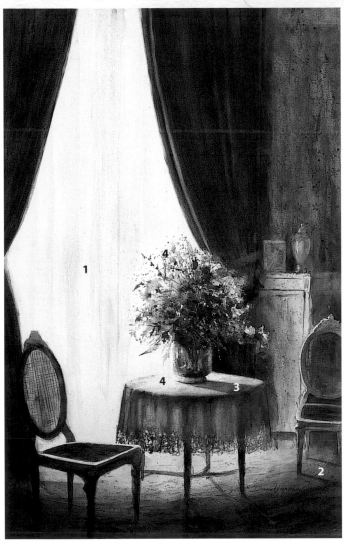

Using Value to Create Mood

The dark range of values in this painting creates an inviting yet slightly mysterious feeling. Was this a spot where elegant ladies took their tea? Was it reserved for special guests awaiting an audience with the master of the house? Either way, elegance is the theme and it's captured nicely with these dark, muted values.

Backlit
Watercolor on paper, 29" × 24" (74cm × 61cm)
Collection of the artist

1 light
2 form shadow
3 cast shadows
4 reflected light

SECRET
Squinting

If you're having problems separating the values in a still life, landscape, portrait, any painting at all really, take a tip from the masters. Many of them, including Rembrandt, had to paint in low light. Much to their surprise, they found that the values were more pronounced than they were in daylight. In today's artificial lighting or in bright sunlight, try squinting your eyes to achieve the same value clarity they had in their low light.

Making Space with Value

This painting is entirely different from *Backlit*, because the value scheme is opposite. The contrasts are made using a lot of white, which gives it a nice, airy feeling. Comfort and homeness is this painting's theme—makes you want to sit down and smell the salt air.

Porch View
Watercolor on paper, 21" × 29"
(53cm × 74cm)
Private Collection

1 light
2 form shadow
3 cast shadows
4 reflected light
5 midtone
6 highlight

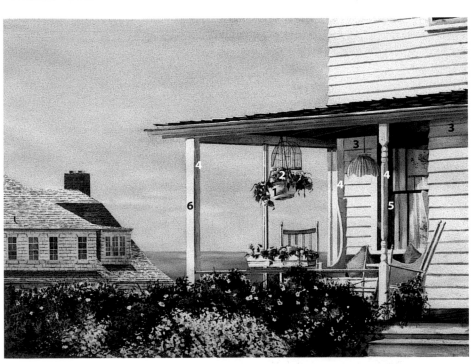

Perspective

I taught for about twenty years in the 1960s and 70s, until I opened my gallery in the late 1970s. I sometimes took my students to the countryside, where there were several nice farms with barns, silos, corncribs and such. Once we located a shady spot, I'd do a demo. Then they would paint their own version and I circulated among them and checked their progress. One of the biggest problems for many of the students was perspective, even though I went through the same drawing procedure each time.

Perspective is something you have to learn if you want to paint. It isn't that difficult once you get the hang of it and practice it for awhile. Here are the basic principles to keep in mind.

Picturing Perspective

This as an illustration I did many years ago for a construction company that was building a nursing home in my area. It was one of several they needed for a brochure. Since the building had not yet been built, all I had to work from was a set of plans.

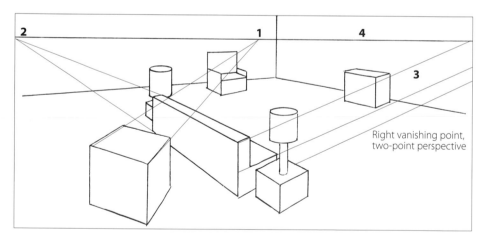

Right vanishing point, two-point perspective

Sketching First

I created a rough layout of the necessary perspective, like this one, before I painted. This is how I would see the scene from above. Each set of parallel lines goes through its own vanishing points, and a circle in perspective becomes an ellipse.

1 one-point perspective, card table
2 left vanishing point, two point perspective
3 right vanishing point, two-point perspective
4 horizon line

Determine Your Eye Level

Whether you're sitting, standing or lying down, looking out the window of a multistory building or standing on the ground floor, the horizon line in your drawing is always your eye level (the height of your eyes from the ground). The horizon line in this illustration is seen from the perspective of an approximately 6' tall (183cm) person, such as myself. This is the way I saw it.

1 eye level (horizon line)
2 ground line
3 eave line
4 right vanishing point
5 left vanishing point
6 roof line

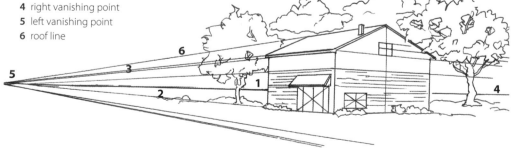

The Basic Principles of Perspective

1 Everything you draw in a picture— be it a still life, landscape, seascape, whatever—has to be related to a single common horizon line.

2 Only one eye level can be used in a drawing.

3 The eye level is always the height of your eyes to the ground.

4 The most commonly used perspective is two-point.

5 The next most frequently used perspective is one-point; think of looking down a railroad track.

6 Both perspectives are often employed on one drawing, which is fine as long as they both relate to the same horizon line.

7 The least commonly used perspective is one-point vertically, such as looking straight down from an airplane or straight up at a skyscraper while lying on the ground.

8 Three-point perspective is a combination of one- and two-point and is the most difficult to master. Use it when looking up at a skyscraper and surrounding buildings from a standing position.

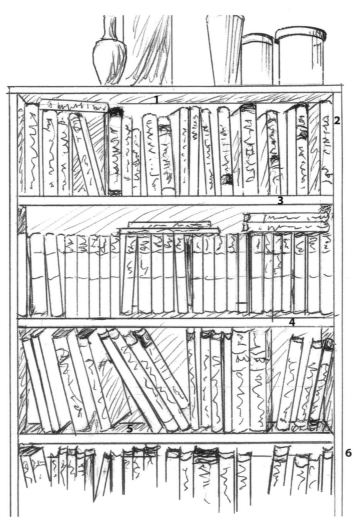

1 Top shelf: I can see underneath it.

2 If you're taller than 6'2" (188cm), your eye level could be here

3 Shelf 1: I can only see this shelf's front edge (eye level)

4 Shelf 2: I can only see a little of its top.

5 Shelf 3: I can see much of the top of this shelf.

6 These edges are perfectly vertical.

Practice Your Perspective

If you're still not confident that you understand the concept of perspective, stand in front of a bookcase in your home and look directly at the center to determine your horizon line. I'm 6' 2" (188cm), and my horizon line is the front edge of shelf no. 1. If you are shorter or taller, your line will be above or below mine. To be sure you've got the right spot, just mark it on the side of the bookcase and test your eye level again to be sure it is in the same place. Sounds like kindergarten but it works.

The horizon line is a constant for each work you produce. Painting above and below it can be as subjective as you like, as long as it is related to the vanishing points.

Put It in a Box

When you are having perspective problems with *anything*, simply draw a box in correct perspective and put the object in the box. Whether it's a figure, building, airplane, boat, whatever, if the box is drawn with right and left vanishing points it will help you establish the right perspective.

Photo Reference

I already went into the technical info about cameras, projectors and viewers earlier in this section, but this is about using your camera to gather information references. I'd first like to say a few words about digital cameras. After I've had my say, I won't mention it again. Ahem.

A few years ago I purchased a digital camera, and I use it for family photos and some travel pics as well. However, when it comes to material I may base a painting on, I much prefer my 35mm camera. Slides are more dimensional and can be blown up to a much larger size. If I want to refer to them, I can blow them up two or more feet without losing any clarity.

If you have a digital camera, by all means, use it. It does have the added advantage of seeing your shot immediately and discarding it if you care to. Just remember to take a 35mm camera as well. Never, I repeat, never travel anywhere without your camera. It's the greatest visual information-gathering piece of equipment you have. The use of a camera permits the artist to capture fleeting moments permanently, capturing images that can be used again and again as references for painting.

The use of cameras for reference by artists is nothing new. As far back as the early nineteenth century, four French painters—Eugene Delacroix (1798–1863), Edgar Degas, (1834–1917), Paul Cezanne (1839–1906) and Paul Gauguin (1848–1903)—experimented with working from photographs. This is even more interesting when you realize that the master, Leonardo da Vinci (1452–1519), discovered the camera obscura, the forerunner of the camera. This invention was nothing more than a small, darkened room on wheels with a tiny window. Images from the outside were projected on a white wall inside the structure. It was widely used by Renaissance painters.

It was more than three hundred years later when a French chemist named Joseph Niepce (1765–1833) and a fellow countryman, theatrical commercial artist Louis Jacques Daguerre (1787–1851), collaborated on how to capture these images using silver-based chemicals to make prints. You may have heard the word *daguerreotypes* in reference to early photos. Louis Jacques Daguerre is where that name originated.

However wonderful the camera is for reference, it has to be used with caution. The villain is distortion. For instance, when taking a picture, if you are too close to a seated person with her hands folded on her lap, most likely her hands and legs are going to be foreshortened so much that they will appear distorted.

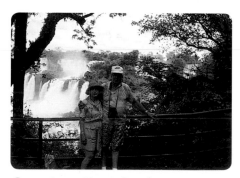

Capturing an Exotic Locale
This is a shot of my wife and me at Iguazu Falls in Argentina. This place makes Niagara and Victoria Falls look insignificant—it consists of more than three hundred separate falls. As usual, I have my faithful camera around my neck.

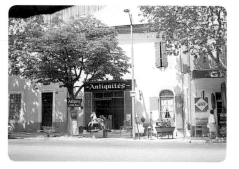

Correcting Distortion
This example is a lovely scene in rural New England. In the picture, the windows on both the left and right are tilting toward the center. When painting this, I used my T-square and triangle to make sure they were straight up. These are some of the pitfalls of using photos.

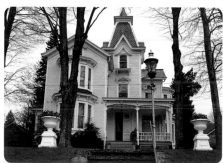

Shooting Straight
I shot this great Victorian house straight on, and as a result all the vertical lines had to be corrected. That included the columns, corner posts, balusters and window frames. Without careful attention to these items, you can end up with a house that looks like it's collapsing.

Starting a Reference File

I'm a pack rat: I have travel books and files from every place I've visited. I have photos from places as far-flung as Australia, Costa Rica and Greece. I have several thousand slides in trays and another couple thousand in various boxes. In addition to those, I have twelve or fifteen loose-leaf binders full of slides. There are filing cabinet drawers full of any picture that might be of some use to me down the road, all of them carefully catalogued in hanging folders. Get the picture! That's it. I have a picture of practically anything I could ever want to refer to.

If you want to be an artist and haven't already started a reference file, I suggest you start now. When you see something that might be useful in a future painting, clip it from the newspaper, magazine or wherever you found it and toss it into a box. Later on, you can get a small filing cabinet and a set of hanging folders and you're in business. Label them in broad categories such as "snow," "skies," "water," "boats," "lighthouses," etc. When you get a bigger collection, you can be more specific.

I started my reference collection many years ago, when I was at art school. These are two from my files that I would consider good candidates for paintings.

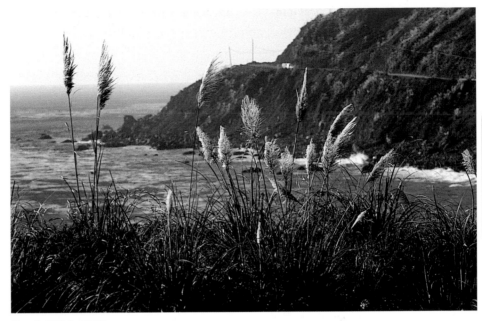

Reeds With Cliff
I love this one, maybe because I like wild plants, but it also needs a few small boats on the horizon to round it out. Keep them light if you want to try painting this yourself.

A Few Other Tips

1 Examine your capabilities—you can't be all things to all people. Sometimes you can find a niche. If you're good at painting boats, for instance, it might be better to specialize in that than trying to be something you're not. There's no shame in doing what you're good at!

2 Find your audience and cater to it. Ask yourself who you want to attract and who seems particularly drawn to your work, then make them happy.

3 Strive to improve your shortcomings and take painting workshops when they're offered. For instance, before approaching a subject, ask yourself if perspective, composition, coloring, etc. is going to be a problem. If it is, get a good book on the subject.

4 When exhibiting your work, always try to have it look as good as possible. I've seen so many shows where the framing was simply amateurish. Of course, I understand that professional framing can be expensive, but in most cases, it's worth the money. Add the framing expenses to the price of the work. It pays.

DIY Lightbox

If you don't want to spend money on a light-box to view your slides, you can improvise. Tape a sheet of tracing paper to the top of a small piece of glass, and make a bridge of it by supporting each side with a small stack of books. Now put a light underneath the bridge, and there you have it! An inexpensive photographer's loupe (a magnifier for close-up viewing) can be purchased from photography stores.

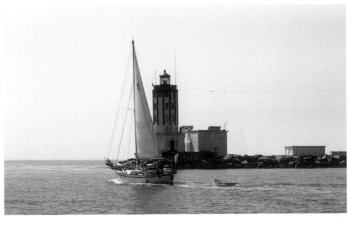

Boat With Lighthouse
This one needs something added for balance on the left horizon, a boat or perhaps a small spit of land with a building, but other than that it's a beautiful and interesting composition.

Wet-into-Wet

Painting wet-into-wet means applying paint to an already wet surface. My technique is this: Thoroughly soak a piece of 140-lb. (300gsm) Arches paper in a bathtub or sink, and once it's uniformly soaked, attach it to a piece of laminated board (I cut mine from Formica). Paint a large area of the paper with one or several colors; the paint will travel and mingle wherever the water takes it. You can manipulate the blending by tilting the board. This technique is great for big, dominate features such as skies—apply them with a wet-into-wet wash and come back to add the foreground buildings or trees when the paint has dried.

I chose *Windswept* to demonstrate this technique because it is a classic example of wet-into-wet. This method usually requires less planning than paintings done in a more realistic style. However, if you want to save the striking soft whites in this one, you must plan in advance. You can't rely on masking fluid.

The Basic Technique
Before trying it in a painting, practice a simple, one-color wet-into-wet wash.

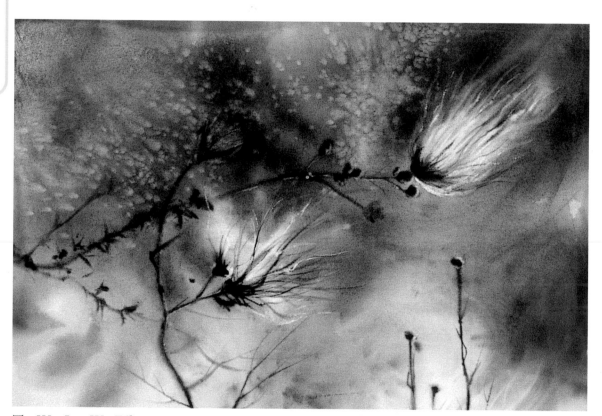

Windswept
Watercolor on paper,
21" × 29"
(53cm × 74cm)
Collection of the artist

The Wet-Into-Wet Effect
The loose, painterly style of the background here, as well as the interplay of color with no hard edges, is the result of wet-into-wet painting. In this particular piece, it was important to paint around the white of the flowers.

SECRET
Trees and Branches

A good way to suggest trees and branches in wet paint is to use the pointed handle of your brush and scratch the paper with it, creating grooves that the paint settles and dries in. When it's completely dry, you can scratch them lightly to add highlights.

Wet-on-Dry

I call this technique wet-on-dry for lack of a better term. Of course, there are soft edges here and there, but basically it's the classic sharp-edged watercolor technique perfected during the eighteenth and nineteenth centuries by such artists as Constable, Cottman and Turner. This technique was also used in the late nineteenth and early twentieth centuries by master watercolorists Winslow Homer and John Singer Sargent.

The difference between this technique and painting wet-into-wet is that you're painting on dry paper. Dilute the paint with water; the more water you mix with the paint, the lighter the color will be. Test the saturation on a piece of scrap paper before you paint to make sure the color is right, and add paint or water accordingly. The colors will still mingle, but it's much more under your control and not the control of the water. This way, you can create harder edges and sharper details.

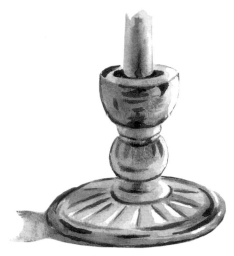

The Basic Technique
Practice your wet-on-dry technique by painting something simple that requires hard edges, like this candlestick.

The Wet-on-Dry Effect
The realistic style of this painting, with the hard edges and attention to details, is a result of painting wet-on-dry. These plants were invitingly displayed on the sidewalk to attract passersby, and the charming scene begged to be captured. I parked the van, set up my gear and went to work. This was an impromptu, loose, no-nonsense watercolor painted in one sitting. The edges are all crisp and sharp, but the color was allowed to blend on the paper.

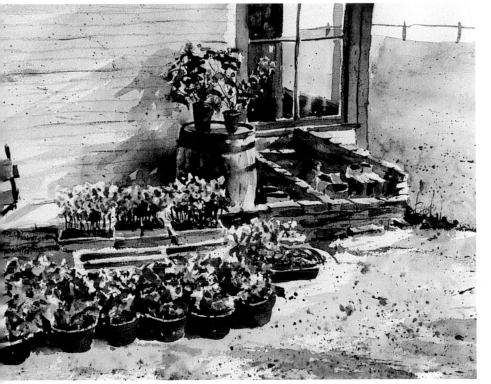

Planting Time
Watercolor on paper, 14" × 22"
(34cm × 56cm)
Collection of the artist

The Hazards of Plein Air Painting

Before I got my French easel, when I painted outside I would carry a director's chair and a small folding table for my palette, brushes, water and paint. If I were fortunate enough to find a spot with the sun to my back, I would set up by my van and use it for shade. With my drawing board on my lap, I was ready to paint.

Now, one of the interesting things about painting on location is that you'll usually attract some sort of audience. Most of the time, it's one or two youngsters. A typical conversation goes something like this:

Kid: What are you doing, Mister?
(long silence)
Me: I'm bowling.
(longer silence)
Kid: I have an aunt who paints good.
See—we get no respect!

Washing Large Areas

Clouds are the most variable element in a landscape. Trees, dunes and buildings all change their appearance under different circumstances, but clouds are constantly changing and are never the same. I love to paint them. In this demonstration, I'm going to show you how to paint a very dramatic backlit summer sky with long, streaky clouds.

First, mask the lighthouse, keeper's house and foreground using overlapping strips of 2-inch (5cm) masking tape.

Remove the excess with a no. 10 craft knife.

Now lay down a wash of plain water with your 1¼-inch (31mm) flat, keeping it wet at the top and much drier as you work down to the bottom. You don't want water seeping under the tape, but if it should happen you can correct it later on. Gently wipe the entire area with a couple of wadded-up paper towels to prevent puddles. The paper should now have a nice sheen to it.

Materials

14" × 21" (34cm × 53cm) 140-lb. (300gsm) cold-press Arches
Drop cloth
No. 2 HB pencil
Hair dryer
2-inch (5cm) masking tape
Paper towels
Plastic eraser
Electric eraser
Razor blade
No. 10 craft knife

PAINTS
Alizarin Crimson
Burnt Sienna
Burnt Umber
Cadmium Red
Payne's Gray
Raw Sienna
Ultramarine Blue

BRUSHES
1¼-inch (31mm) flat
1-inch (25mm) flat
No. 6 round
No. 12 round
No. 2 bristle

1 Lay in the Colors

With your 1¼-inch (31mm) flat, wash a pale hint of Ultramarine Blue across the top of the paper. After rinsing the brush, mix up a wash of Burnt Sienna and a little Cadmium Red. Starting at the upper left, brush the paint back and forth, moving down the paper and slightly changing the value here and there to give it variety. As it starts to dry, lift out a little color toward the bottom of the sky to create contrast for the forthcoming dark background.

When you're satisfied with the initial coat, put down your brush. The paper should be pretty wet, so pick up your board by the end and hold it vertically, so when the wash runs it won't puddle. Tilt the paper sideways and the paint will run across it, creating long strips of different values. Meanwhile, with your hair dryer in your other hand, put it on high and use a circular motion until the wash is dry. I suggest using a drop cloth as there is no way you can blame the dog for this possible mess.

2 Add Drama With Darks

This is the time to evaluate and make adjustments. Is it too light, too dark, too warm, too cool, the wrong color? When you're satisfied with what you have, re-wet the whole sky area with your 1¼-inch (31mm) flat and lightly pat it with paper towels until it gets a nice glaze. Now mix Ultramarine Blue and a little Payne's Gray and apply it to the wet clouds with the chisel edge of your 1-inch (25mm) flat, letting it explode on the paper. Make some of the clouds lighter and thinner than others so they appear to recede into the background. Let it completely dry. Then using the same mixture, only a little thicker, paint the center of each cloud with your no. 6 round. This allows the last application to bleed into the previous one, creating soft edges.

3 Suggest the Sun

When the painting is dry, use your no. 2 shorthair bristle oil brush with a little water and make horizontal strokes to scrub out the tops of some of the clouds to suggest the morning sunlight. After studying them, determine if they need a little more brightening. If so, scrape out a few highlights with a razor blade or give them a touch with your electric eraser.

4 Paint the Foreground

Thoroughly dry the painting with your hair dryer. While blowing some heat on it, remove the tape. Paint the buildings first starting on the left. Add the roofs and chimneys using a no. 6 round with dark Alizarin Crimson. Switch to Burnt Umber for the houses, being sure to leave the little specks of light for the windows. Paint the lighthouse using a no. 12 round and a mixture of Payne's Gray and Raw Sienna. Finish up by painting the foreground wet-into-wet with a mixture of Burnt Sienna and Burnt Umber with a touch of Ultramarine Blue.

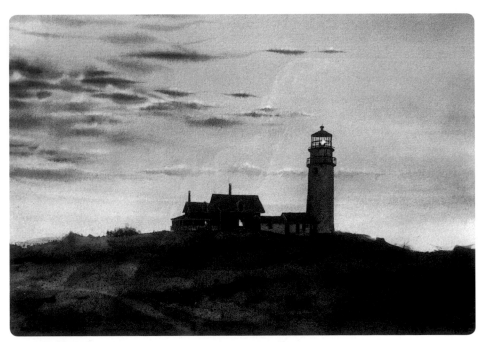

Majestic Sky
Watercolor on paper, 14" × 21" (36cm × 53cm)
Private collection

Dry-Brush

The dry-brush technique is used frequently by watercolorists. I use it a lot when painting water, particularly if it is sunlit or moonlit. Dry-brush is exactly what it sounds like: painting using stiff paint and very little water. It's used primarily to create rough, textured appearances.

This technique is easy to learn because the surface of watercolor paper is made up of hills and valleys. The rougher the paper, the more texture you can obtain. It's practically impossible to use dry-brush on hot-pressed paper since it's so smooth. Cold-pressed paper, which I recommend using for a variety of reasons, is sort of middle-of-the-road. I've used rough paper for sunlit water at times when I wanted the effect to be startling, and although the paintings were sometimes successful, I always felt I was a little short of my goal. That's why my favorite paper is cold pressed.

The theory of dry-brush painting is simply this: If you hold the brush straight up, the paint sinks into the valleys, and if you hold it practically parallel to the paper, the paint stays on the hills and you get the texture you're seeking. You can use any brush for dry-brushing, but large flat ones seem to work best (I tend to use a 1¼-inch [31mm] flat). To master the dry-brush technique, use the backs of some unsuccessful paintings and practice.

Dry-brushing
Holding your brush straight up will result in the paint sinking into the valleys of the paper. However, holding your brush almost horizontally over the paper will leave the dry paint only on the hills of the paper, creating nice texture.

The Dry-Brush Effect
The dry-brush technique is excellent for creating areas of your painting that call for a lot of texture, such as water (particularly if lit) and grass.

Vineyard Twilight
Watercolor on paper,
21" × 29"
(53cm × 74cm)
Collection of Valerie Schauer

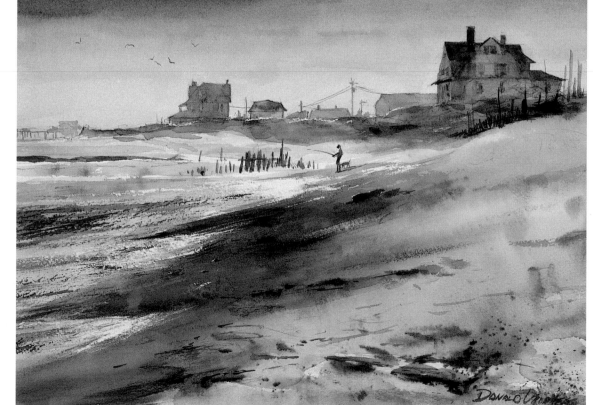

"Thirsty Brush"

I picked this painting to demonstrate the "thirsty brush" technique because it was used *eighteen* times in this painting (no joke). Use this method when you want to create a light value on a dark surface. It is particularly good for lifting out streaks in skies and water.

This technique can also be used to lift an irregular shape such as a cloud. A pointed round or a larger or smaller flat might be more appropriate than a 1-inch (25mm) flat in this case.

Holding Your Brush
The proper brush angle for the "thirsty brush" chiseled edge technique is almost vertical, with a lot of pressure applied.

Techniques

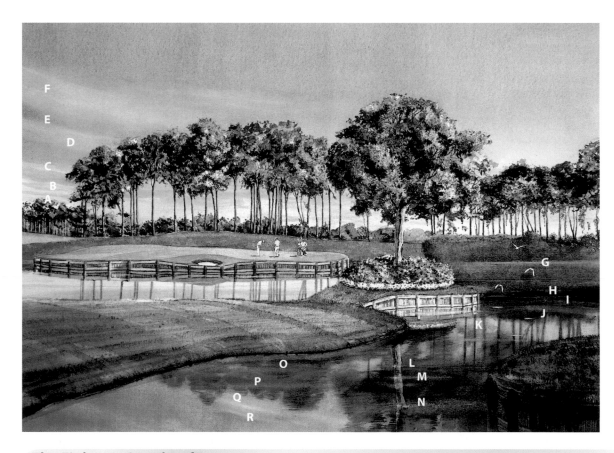

Sawgrass
Watercolor on paper,
21" × 29"
(53cm × 74cm)
Collection of the artist

The Eighteen Streaks of Sawgrass

A If the paper is dry, re-wet it and pat it with a paper towel.

B If the paper is wet, wait until it is only damp to begin lifting (you can tell it's damp when it gets a nice sheen to it).

C Dip your 1-inch (25mm) flat in clean water and pull the hair through your closed fingers until you have a nearly dry chiseled edge. Holding the handle almost straight up, horizontally stroke it across the desired area to lift the paint. If more than one stroke is needed, repeat as often as necessary.

D-H Stroke with the full width of the flat, using a semicircular stroke.

I and J Use a no. 8 round held at a 45-degree angle and a semicircular stroke to create these streaks.

K-P These streaks are made with a 1-inch (25mm) flat chiseled edge.

Q and R Use your no. 8 round, holding it at a 45-degree angle and using a semicircular stroke.

Stippling

Generally, people think of watercolors as merely traditional washes painted on either a wet or dry surface with a large brush. Of course, this isn't always the case—there are a number of other ways to paint.

Although not new, stippling is a lesser-known technique. In fact, some of the earlier English watercolorists used this method to paint almost entire paintings. David Cox (1783–1859), William Holman Hunt (1827–1910) and Miles Birket Foster (1825–1899) were such stippling experts that to the naked eye it appeared to be solid color.

Modern-day watercolorists use this technique in numerous ways. It can be applied with a pointed brush by gently touching, tapping or tap dancing on the paper. Tippety-tap-tap away! You can also stipple with a variety of other tools, such as a sponge or crumpled paper. Sometimes, you can fan a small (no. 1 or 2) brush to make grass blades by combining this technique with a short stroke. When painting a flower bush you can stipple in some small flowers with masking fluid.

Stippling With Masking Fluid
Stipple the masking fluid onto the dry paper before you paint the bush, so when it is removed you will have small white dots of various sizes that will eventually become flowers. This can also be done with the fan method to make several flowers at once.

Stippling With Sponges
Stipple in the bush using a sponge. Sometimes it's a good idea to use several different sponges to give you variety, particularly if it's a large bush. When dry, with a small brush, reshape some stipples to suggest flowers and paint the flowers in the bush. Don't forget to put the little dark spots in the centers.

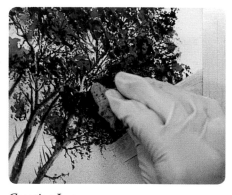

Defining Branches
This shrub has no flowers, so the branches need to be defined. After you use your sponge to make the bush, stipple some darks into it with your small brush to give it form.

Creating Leaves
You can stipple great leaves with Raw Sienna and Payne's Gray on your sponge. For a brighter green, try a mixture of Ultramarine Blue and Cadmium Yellow Deep.

Stippling Grass
When the grass is as good as you think you can make it, try this! Get out your Pro-white and pick an isolated spot on your pallet. Mix a brushful of it with a little yellow. Then fan out the bristles of an old, small brush and dip it in the mixture. With a sweeping motion away from yourself, gently tap and pull up tiny strokes to make the blades. It works! Practice it!

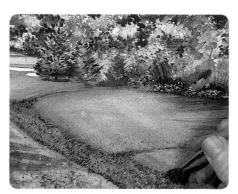

Spattering

Spattering is similar to stippling, except the shapes created have a little more definition and character. No one seems to know exactly where or when spattering started. However, it seems to be evident in some ancient Egyptian wall paintings and Australian Aborigine paintings that are centuries old. We do know that both impressionist Henri de Toulouse-Lautrec (1864–1901) and modernist Paul Klee (1879–1940) experimented with it.

Many different tools have been used to spatter, but it's primarily done with brushes of different sizes and types.

The most frequently used are pointed rounds. The size of the brush varies depending on the job at hand. Another popular tool is the toothbrush. You load it with paint and hold the bristles up and away from you. Then take a single piece of cardboard and pull it across the bristles to create spatter. Be sure to wear old clothes. I don't particularly care for this method because it's messy, not easily controlled and the spatters seem to be elongated. I much prefer using the method where you hold your pointed round filled with paint in one hand and

strike it against the handle of a second brush. This creates spatters that appear more rounded.

It is a good idea to mask the part of the painting that you don't want to get spattered (the sky, for instance). You don't have to cut a mask for this. Just tear off a piece of scrap paper or anything else that's handy and cover it. If you should get a misdirected dollop in the sky, don't panic. Keep some cotton swabs on hand, dip one in clean water and quickly dab and blot the offending spatter.

Techniques

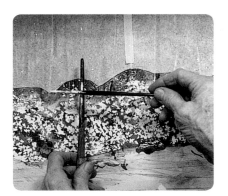

Spatter to Add Flowers

When spattering, be sure to mask off the part you wish to retain intact (as shown with the newspaper). Once dry, go back and refine some of the bigger ones by defining a few petals and adding yellow centers. On some, suggest a little shadow.

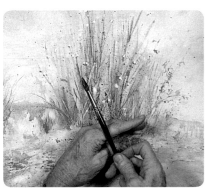

Handy Tools

You can also spatter by pointing your open hand toward the area and tapping a fully loaded brush on your fingers. Your hand can protect the areas you don't want splattered.

Spattering Snow

When spattering to suggest falling snow, take care to keep the spatter fine. Keep the paint quite dry and with a small pointed brush tap lightly against another brush. You can always make it heavier later, but not lighter.

SECRET
Elongated Spatters

Even though this isn't my favorite method, there are times when you can use elongated spatters to your advantage. For instance, say you wanted to add some foreshortened pebbles or larger stones to a beach scene. You need only turn your board sideways and use a toothbrush. Be sure to cover areas you don't want spattered before doing this.

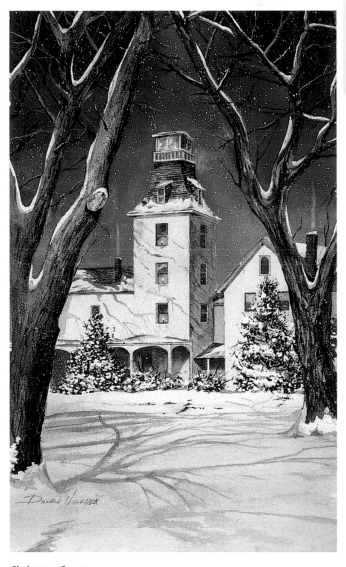

Christmas Snow
Watercolor on paper, 21" × 13" (53cm × 33cm) Collection of the artist

Lifting Out Color

The whole painting process is a matter of judgment calls. Sometimes you're right, sometimes you're wrong. If you're wrong, you fix it.

Sometimes, you can just tell that a painting is lacking something. Removing paint to create the illusion of light filtering through your subject can be just the touch you need to add interest to a somewhat dull composition.

Techniques

SECRET

Paper Towels

When you're painting, it's a good idea to paint with one hand and have a wadded-up paper towel in the other. It's particularly important when working on a large area, such as the sky. If you misjudge a value, this method enables you to blot it quickly so you can immediately make corrections.

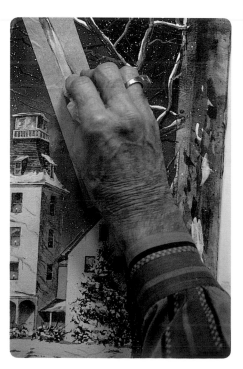

Creating Light Through the Trees
This was simple—all I had to do was wad up a little ball of damp paper towels and make a couple of diagonal strokes. There were so many trees in this painting it needed some diagonals for variety. However, this gets a little tricky. You have to make sure that the light is coming from the same direction that is depicted in the rest of the painting. Sometimes I draw a little arrow on the margin to remind me where the light is coming from.

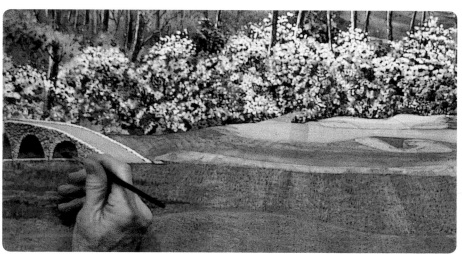

The Effect of the Light
Here's what the painting looked like after I lightened the background and created the light through the trees. It helps to add interest and bring the painting alive.

Light Trees Against a Dark Sky
After evaluating this snow scene, I decided some of the trees were too dark. I took my 2-inch (5cm) masking tape and taped over an offending tree. Then I cut a mask to expose it. This enables you to scrub out the tree and leave a nice sharp edge. I wadded damp paper towels into a ball and wiped away color until I was satisfied with the resulting value of the tree. Then I took some Burnt Umber and dry-brushed a little texture into it. Finally, I removed the tape and proceeded to the next tree.

Using Salt

Salt may have been used by watercolorists prior to 1966, but that was the first time I saw it mentioned in a book on watercolor—and I have a ton of them. This enlightening book was written by John Pike, one of my early teachers. So far as I know, not many of the old-timers used salt. However, a lot of watercolorists use it now because you can get so many nice effects with it.

If you haven't used salt and want to try it, here are a few things you should know. Sprinkling a little salt into a wash adds some interesting texture, such as a gully in a snow bank. Sprinkle a little salt on a damp wash, wait a few minutes and bingo, you have texture. The darker the wash, the more pronounced the texture. When dry, you can remove the salt residue with your hand, or better yet, a small cellulose sponge. Then just brush it away with your utility brush. You have to practice this technique a lot to determine how much salt you should use and how dark the wash should be.

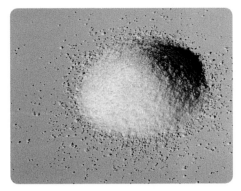

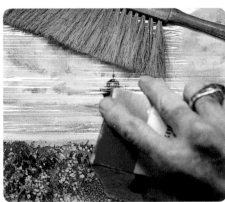

Applying the Salt
Kosher salt is sold in most supermarkets. Here you see me sprinkling it directly out of the 3-lb. (1kg) lifetime-supply box onto the work. I think I bought this box about twenty years ago. That's my horsehair utility brush sitting on top.

Go Kosher
You need to use kosher salt to make the textures you see on this page. It's far more granular than table salt and absorbs paint readily, thereby making the designs more prominent. I often use salt several times in the same painting, so I pour a little pile of it onto a small piece of paper, as you see here. Just fold the paper and pour what you don't use back into the spout. Since timing is important to this technique, it's nice to have the salt handy when you need it.

SECRET
Additional Textures

There are things other than salt that can be sprinkled on wet washes for texture. Try crayon shavings, rice, eraser crumbs and coffee. In fact, I understand there are artists from Thailand and India who paint their entire paintings with coffee and water. My philosophy on offbeat materials is to use anything that works for you.

Techniques

Creating Wind
I used salt to suggest petals caught in a slight breeze in several places across the top of this painting and toward the bottom.

Let It Snow
Salt came in handy when I wanted to break up the boredom in this snow bank.

Using Salt to Create Designs
I included this one because I wanted to show you the possibilities of this technique. This is a nice, subtle example of both the colors and designs salt can create.

Masking Your Whites

There is a lot of controversy among watercolorists about masking to save the white of their paper. Some would never think of doing it, choosing to paint around the most complicated roof-line when executing a sky. That's OK if you want to do it, but my theory is to make things as easy as possible for yourself. Watercolor painting is difficult. Executing the washes and other difficult facets of using this medium is enough to keep you busy.

Masking Products

There are many masking products on the market, ranging from tape to masking fluid. Experiment with a variety to see what works best for you.

Masking tape comes in various sizes and widths, from ½-inch (1cm) to 4-inch (10cm). Most of the time I use the 2-inch (5cm) size, but I also use the 1-inch (2.5cm) and ¾-inch (2cm) sizes. I like masking tape because it gives you a hard edge, which has advantages such as

putting a figure on a grass background. If necessary you can always soften the edges with a small bristle brush.

You can cut through the tape easily with a craft knife. It has a high tack, so the paint very seldom bleeds under the edges. Masking tape is heat sensitive, so you can use the hair dryer when removing it. A word of warning: Tape can become gummy (not grumpy—people get grumpy) when it gets old, which makes it more difficult to remove. I suggest getting rid of it and using a new roll.

Masking fluid or masking solution is a removable liquid made for protecting an area in your painting by making a mask over it. Masking fluid is made by several manufacturers. Some are clear and some come with added color so it can be seen more easily where it's applied. The fluid is easily removed with a rubber cement pickup, available at your local art supply store.

Masking fluid is a great product, but it will quickly kill a brush. I no longer

have special brushes for this; I use the same good brushes that I paint with. The trick to saving your brushes is loading the brush with soap and mixing the masking fluid with a little water. Now you can get a nice point for detail and, by rinsing it constantly as you work, you keep your brush intact. When you're finished applying the mask, immediately wash it out with soap.

There is a commercial masking fluid paper on the market. I haven't used it, but I understand that it has a low tack and has to be taped down with masking tape. There are several other products for masking on the market sold under various names such as Special Artist Tape, Watercolor Artist's Tape and the Incredible Nib. I'm happy using tape and masking fluid, but as I mentioned, it's always good to experiment with what's available.

Note: If you are allergic or sensitive to latex, please take special precaution when using masking fluids.

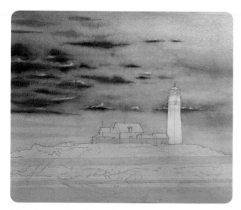

The Benefit of Masking
Preserving your white areas can make the colors you apply over them later more brilliant.

Cutting the Masking Tape
Use a craft knife to cut the mask. After the paper is squared and secured to the drawing board, start from the top of the lighthouse and lay down layers of overlapping tape over the whole drawing. The drawing should be dark enough to see through the tape and subsequent darker washes (however, some of the pencil will come off when you remove the tape). Put a new blade in the knife, then start cutting the mask from left to right across the paper. (A new blade is not always necessary, but will work better than an older, duller one—keep in mind that you want to make your work as easy as possible, and a new blade is a small investment for peace of mind.)

I usually pull the tape off while cutting—I find that it gives you more control with the

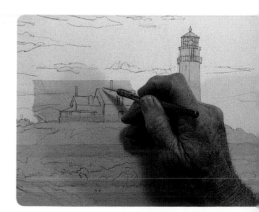

knife, and it also shows how easily it's coming off and let's you adjust the pressure on the knife accordingly. Practice this on some scrap paper to determine how much pressure you need to cut through the tape but not the paper.

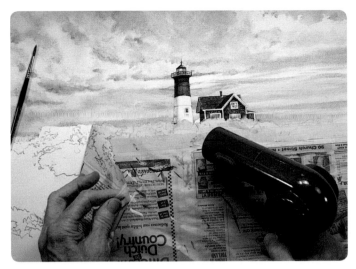

Removing the Mask

After painting the sky and lighthouse, it's time to remove the mask. If you've noticed, I used both tape and newspaper to preserve these whites. Newspaper works well on large areas and saves your 2-inch (5cm) tape. With my hair dryer in my right hand and the heat on high, I slowly pull the tape off with my left hand. Yep, it's that simple.

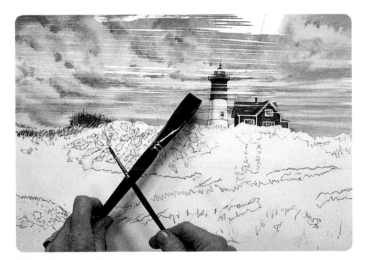

Using Plastic Wrap

Sometimes covering an area with a mask can be a disadvantage—for instance, if you're trying to see what the sky looks like and coordinate its color with the dune flowers. Here's the solution: plastic wrap. Just take a piece and wrap it around your board covering the sky and lighthouse area, then spatter away.

Tearing the Tape

After finishing this drawing, I started the masking procedure by first protecting the bottom portion of this painting with 2-inch (5cm) tape and newspaper. Then I cut the mask for the grass. Next, I stippled in some of the flowers with masking fluid then moved on to the trees.

Because there were so many masks (boring), I decided to add some variety. Instead of cutting the tape, I tore the pieces one by one to create random hard edges. I think it worked well. Lastly, I painted the initial background wash freely over all the masks and made some interesting trees. This is what masking is all about.

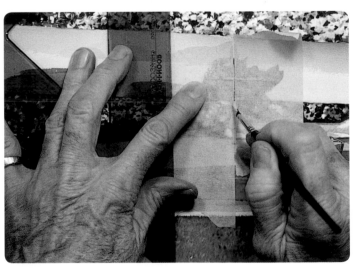

Adding Little Details

Absolute accuracy was required in the placement of this golf pin. I took two pieces of 2-inch (5cm) tape and squared them, leaving about a ¹⁄₆₄-inch (.04cm) space between, and burnished them well. Then, with a heavy mixture of Cadmium Yellow Medium and Pro-White (very dry), I carefully patted the stroke in. This method works very well for adding small, precise details into your work.

SECRET
Candle Wax

There are other ways of masking besides masking tape and fluid—some effects require lesser-known methods. I like using candle wax for giving texture to an otherwise uninteresting stone wall. Take, say, a 2-inch (5cm) piece of candle and rub it lightly down part of the wall, then paint a light-colored wash over it. Practice first!

Using a Natural Sponge

The azalea is a vibrant flowering shrub that blooms in the spring. It comes in several shades, but my favorite is red. In this demonstration, you will learn how to use a natural sponge to suggest bushes, flowers, leaves and branches. Be sure to use a natural sponge, not synthetic—natural sponges have a porous structure that leaves great textural patterns, making them an ideal tool for the landscape watercolorist. Although they are available in several varieties, the yellow natural sponge is the best for this purpose. You can purchase them at art supply stores, craft stores and hardware stores. Use scrap paper or the back of an unsuccessful painting to practice before you try this in an actual painting.

Materials List

8" × 10" (20cm × 25cm) 140-lb. (300gsm) cold-press Arches
Drawing board
No. 2 HB pencil
Natural sponge
Masking fluid
Masking tape
Eraser
Rubber cement pickup

PAINTS

Alizarin Crimson
Burnt Sienna
Burnt Umber
Cerulean Blue
Payne's Gray
Raw Sienna
Ultramarine Blue

BRUSHES

No. 2 round

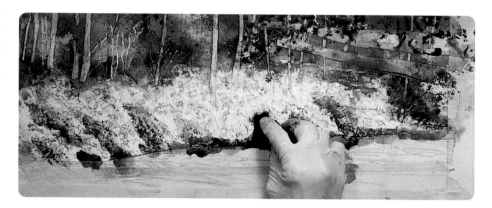

1 Sponge in the Paint and Masking Fluid
Tape a 8" × 10" (20cm × 25cm) piece of 140-lb. (300gsm) cold-press Arches to your drawing board. (What we're doing in this step-by-step is just a section of the larger painting. To create this whole work, first make a drawing of the trees and bushes that's dark enough to see through masking tape, then mask them as well as the flower bed. Paint the background behind the trees, then remove the masking tape and paint the trees. When that's complete, move onto the sponging.)

Tear your sponge into pieces smaller than a golf ball. Pick one that has an irregular shape to it, wet it and squeeze most of the water out. Mix a light wash of Cerulean Blue and Raw Sienna and apply it to the lower portion of the white dogwood flowers. Wash the sponge out well and dip it into the masking fluid, then gently press it over the entire flower area. Now throw that sponge away! With a new piece of sponge, stamp in a little Burnt Sienna and Payne's Gray to indicate the flower bed.

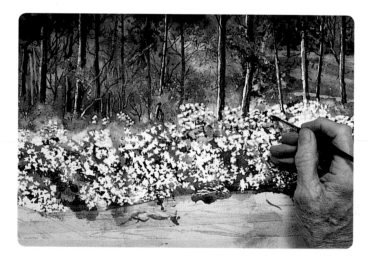

2 Develop the Primary Shapes
Make a puddle of Alizarin Crimson. Dip your sponge into it and start to develop the individual branch forms, lightly at first and gradually darker. You can now define the areas between the branches and individual bushes with some dark green mixed from Ultramarine Blue and Raw Sienna. Using the same color, stamp in a few places to suggest leaves peeking through the flowers. Use your no. 2 round with dark Alizarin Crimson to improve on some of the blossoms' shapes.

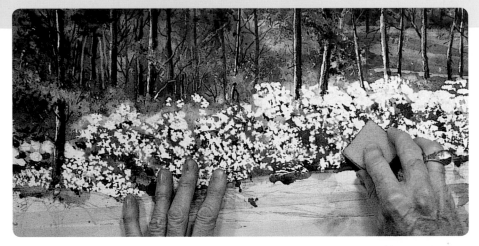

3 Remove the Masking Fluid

Using the rubber cement pickup, remove the masking fluid from the flower bed. Before the next step, apply masking fluid to a few spots that you want to preserve for highlights and suggest some branches for the dogwood trees.

4 Bring in the Sponge

Now it's time to add the secondary sponging that will make your painting sing. Randomly work your way around the page, modeling your flowers. Remember to leave some white space for highlights on the petals. Squeeze the sponge to make small, dark crevices between the branches.

Load a smaller sponge with a mixture of Alizarin Crimson and Payne's Gray and carefully sponge in the underside of the branches to give them form. Apply a light wash of Payne's Gray to the underside of the bushes and in the holes peeking through the flower branches. At this point, shadow areas shouldn't have any white in them. If they do, apply a wash of the appropriate color to that spot. Mix some dark Burnt Umber and Payne's Gray and add some small branches with your no. 2 round.

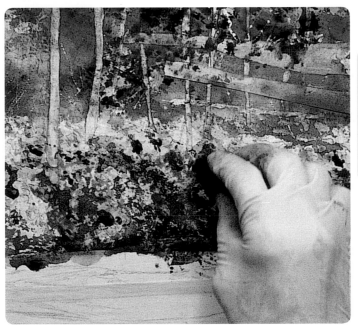

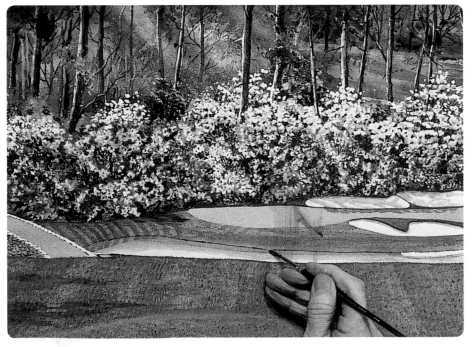

5 Finish the Painting

Notice how important the dark accents are to the finished work—they help create the form and depth that are so essential to a good painting.

Painting with Crumpled Paper

Techniques

I use this technique from time to time when I want to deviate from the usual sponging in, scraping, dry-brushing, etc. It gives some variety to the textures I'm creating, and variety is what it's all about. One of my teachers, the legendary Ed Whitney, described variety as "chewing gum for the eye." Another of his famous remarks was about composition. He'd say, "OK, you've got their attention, now let's give them something to look at."

Crumpled paper? What's the matter with the sponge? Well, there's nothing the matter with the sponge. It's a great tool, but there are things you can do with crumpled paper that you can't accomplish with the sponge. Sometimes, the two techniques are interchanged on the same subject matter in the same painting. The unique thing about crumpled paper is that you can tailor it to the particular project at hand. You can get a different texture from, say, a standard sheet of office paper than you can from expensive vellum. Each type will give you a different look and is usually easy to shape. Office paper is what I generally use, but you can experiment with others.

I used this technique in my painting of Central Park in New York City. It was painted in springtime, when the cherry blossoms were just starting to bloom.

Texture With Crumpled Paper
This is crumpled standard office paper loaded with Alizarin Crimson and Pro-White being used to create cherry blossoms.

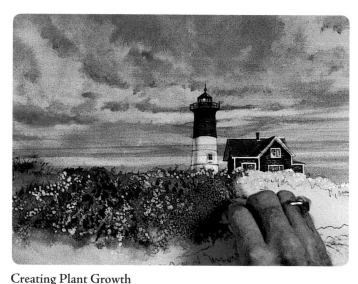

Creating Plant Growth
Using a thick mixture of Raw Sienna and Payne's Gray on crumpled office paper, I stamped in a mound of plant growth.

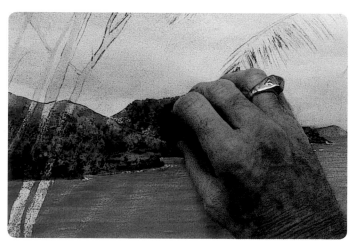

Rendering Terrain
Here I added some terrain texture on a Caribbean hillside with Burnt Umber and Payne's Gray using office paper.

Edgar Whitney (1891–1987)

I attended three summer workshops with Ed in the 1960s when he was conducting his famous wagon tours in Kennebunkport, Maine. He was a marvelous teacher and his principles and elements of design have had a great influence on my work; every aspiring art student should study them.

This is the way his classes worked: Most of the students were there for two or three weeks. We were cloistered in a motel at a location close to the painting sites.

After breakfast, Ed would hold his animated morning critique of the previous day's work, after which we would all get into cars and caravan to the painting location of the day. Then Ed, in his characteristically dramatic manner, would do a demonstration with the students looking over his shoulder. After a tailgate lunch served by his assistant, we would find a nice spot on a rock or whatever and paint for the afternoon. Some of my fellow students were Jeanne Dobie, Carl Molno and Tony van Hasselt. Those were fun times!

Using a Single-Edged Razor Blade

I find it convenient to have both a blade and a half blade on hand as I paint. The half blade is handy for working in places that are too small for the full blade. To make a half blade, simply hold one side of a full blade with a pair of pliers and snap off the other side with another pair of pliers. Wrap the remaining back edge with masking tape for protection and you have a little handle.

I love the razor blade. I use it for scraping, highlighting, picking out color and sometimes even painting. It's great for scratching out highlights on water, depicting mowed grass blades, adding texture to a branch or leaf and scratching rings on the trunk of a palm tree.

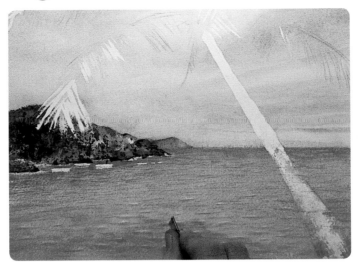

Making Waves
These little tiny waves are formed on a beautiful Caribbean day when there is the slightest breeze. Just decide where the appropriate places for highlights are, then pick away and you have them.

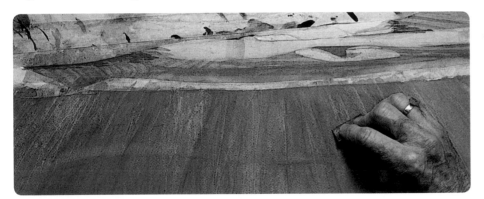

Freshly Mown Grass
The greens keeper has just mowed the grass. Using the full width of the blade and repeated quick strokes, drag it toward you to create this effect.

SECRET
Painting With Razors

A razor blade can be used for things other than highlighting, scraping and lifting out color; in fact, you can paint with it. For instance, it's very good for rock textures. After putting down your basic rock color, load the front edge of the blade with thick, dark paint and quickly drag it across the rock.

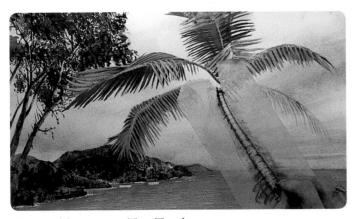

Creating Texture on a Tree Trunk
Using just the corner of your blade, with a circular motion, scratch the rings that are so typical of the palm tree trunk. (The masking tape protects the surrounding image.)

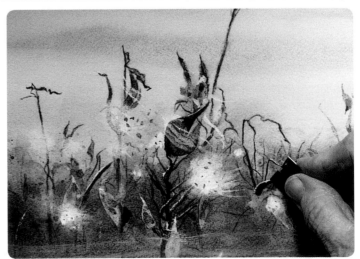

Scratching Out Highlights
Again with only the corner of your blade, very carefully scratch highlights on a few, but not all, of the leaves and branches.

Damage Control

There are times when no matter what you do, things go wrong. We're all guilty of plodding along, hoping that the painting is going to improve. Sometimes it does and sometimes it doesn't. And sometimes, it's necessary to take a drastic step. Completely immersing your failing paintings in water and scrubbing them can recover your whites no matter what pigment you're using. I've employed this method many times—as a matter of fact, there have been times I've used this technique to get out of a jam when I was giving painting demonstrations!

A word of warning: Occasionally, this technique may result in a mottled effect. That isn't a problem as long as you're working on a beach or other terrain. However, if it's a sky, you've got a problem. Cover it up with lots of little clouds.

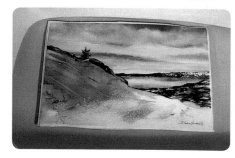

1 Submerge the Painting
First, fill your bathtub with four or five inches of water. Then take the painting and submerge it, making sure it's completely covered. Let it sit for a few minutes.

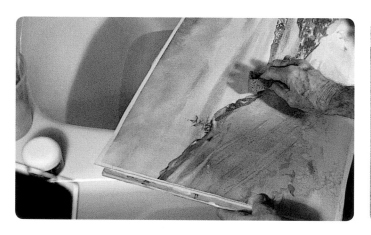

2 Scrub Off the Paint
Take the painting out of the water and put it down on your drawing board (preferably a waterproof one). Tilt your board toward the water, allowing it to drain into the tub. Then take a cellulose sponge and start scrubbing. You have to make some judgment calls here to determine what you want to achieve. How much do you want to remove? If it is scrubbed too much, you will eventually be left with only a faint image. Once you've decided you've scrubbed off enough paint, take it back to your drawing table.

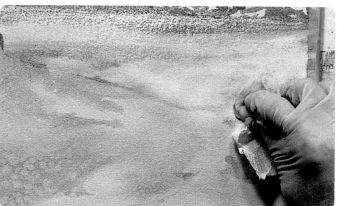

3 Bleach the Paper
Put some household bleach in a small glass and dilute it with an equal amount of water. Be sure to use a glass cup, not plastic. Have a small glass of white vinegar ready. Put on a rubber glove (the thin surgical kind are best), wad up a paper towel and dip it into the bleach mixture.

Be sure to follow the manufacturer's precautions, as bleach is poisonous. Scrub the painting slowly with your bleach mixture, using a very light stroke, and soon you will see the watercolor paper particles start to roll off.

When the area becomes entirely white, stop the procedure or eventually it will eat right through your paper. Neutralize the bleach with the vinegar immediately. Rinse with water and dry with your hair dryer. Once dry, it's a good idea to go over it with superfine sandpaper and then a plastic eraser. You're ready to redo your painting!

Other Brush Techniques

On this page I'm going to address three different issues: the many uses of the "fan," handling detail with smaller brushes and using white paint.

Fan Out Your Flats

The fan is my favorite method for painting dune grass. To do this, simply take your large 1¼-inch (31mm) longhair flat brush and, holding it by the hair, press it out with your fingers to make dozens of little tiny points. Using this method, with a sweeping upward stroke you can make many long grass blades at a time. This technique can also be used with the smaller flats and all the round brushes, and works well in combination with the dry-brush technique.

Handling Detail With Small Brushes

First and foremost, I want to emphasize the need to buy good small brushes. Red sable is a must: The hairs have to come to a perfect point to do this kind of work. Also, special care has to be taken in mixing paint when using the small (nos. 1 to 6) brushes. The mixture of paint has to be of a thicker consistency than you would make for, say, a sky wash.

Using White Paint

There. I said it. White paint is something some watercolorists would never think of using in their work. They prefer to maintain the beautiful transparency of the medium. Other prominent artists, such as Phil Jamison and Peter Hurd, used it consistently in their watercolors.

The use of white in watercolor is not new. It has been used for decades, known as gouache. It was very popular with some of the famous magazine illustrators of yesteryear, such as Al Parker,

John Gannam and Walter Biggs.

Use white paint to render grass one blade at a time, paint petals and create striking florals. It can be very effective in adding realism to your work.

Whether you use it on purpose or as a corrective measure, white paint gives you another option for obtaining your objective. However, use it with caution. As I have said before, "sometimes less is more."

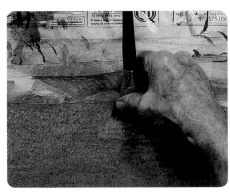

Applying the Fan
The fan can be used to render realistic grass. With your flat brush fanned out, gently paint the grass in, just barely touching the paper with the tips of the hair.

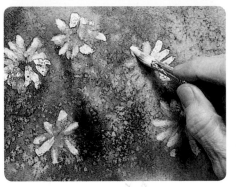

SECRET
Different Textures

On the previous pages, I've discussed various techniques for applying texture with brushes, razors, etc., but there's one I've failed to mention: body parts. Don't laugh (and you may not want to get *too* creative with this one). I'm mainly recommending palms, thumbs and forearms. A few years ago, I was painting a cattail into a floral piece and it needed a stand-out texture. I ended up just sticking my thumb into a very dark wash, and it worked great. Give it a try.

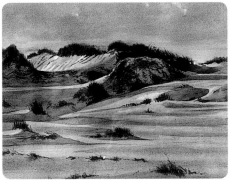

Creating Dune Grass
In this painting, I used the fan technique not only for the long blades of dune grass, but also for the many little clumps of grass in the mid- and foreground sections.

Working With Small Brushes
This no. 4 pointed round works nicely for these palm fronds. This is a good size to use because it can hold enough medium to paint several fronds and still maintain a point. Notice how crisp and sharp they are. The trick is pulling the brush toward you (away from the branch).

Painting With White
These daisy petals jump off the page with the right amount of Pro-white.

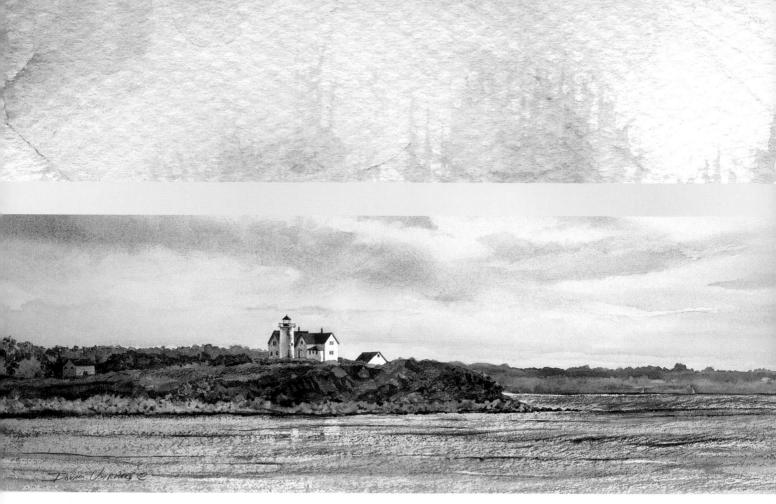

Nobska
Watercolor on paper, 14" × 29" (36cm × 74cm)
Collection of Valerie Schauer

How to Paint What You Want

This lighthouse is the last thing you see when taking the ferry from Woods Hole to Martha's Vineyard, Massachusetts, and the first thing you see upon returning to the mainland. It sits high on a bluff out at the southernmost tip of Cape Cod. Its light can be seen for seventeen miles out to sea.

This part of the book is intended to show you several of my paintings and explain how I approached and painted each one. I'll tell something about it—as I did here with the light-house—cite the location, some historical facts and how and why I chose the subject matter. In some of the paintings I will pick an element and briefly demonstrate how that part was painted (for example, a cloud in a sky painting or a wave in a water painting). You should always paint subjects you want to paint; hopefully, my demonstrations can help show you how.

Water & Beaches

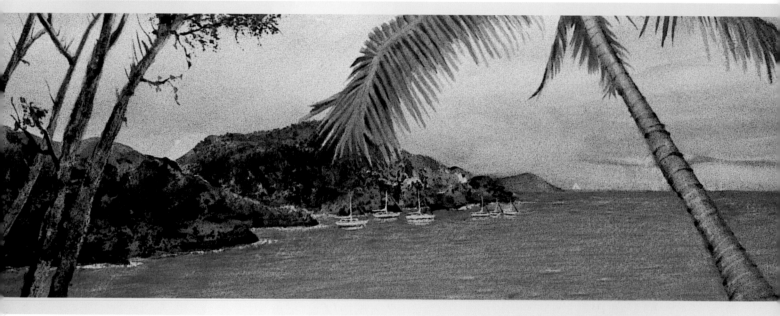

A Bay at Low Tide

Oysters from Wellfleet, Massachusetts, are widely known as some of the world's best. Clean, cold, salty waters, high tide shifts and an abundance of nutrients and plankton constitute just the right combination for the growing oysters.

I would often go to Mayo Beach in Wellfleet early in the morning. I saw many trucks out on the sand, their owners tending the oyster beds. On one of these mornings this lonely little sailboat was anchored there. It looked so all alone, so poignant, just waiting for the tide to come in. It must have been this feeling that inspired me to paint the scene. It was a nice spring morning, but nothing special, and it certainly wasn't spectacular subject matter, but I knew I should paint it. Sometimes, impulse subject material turns out the best paintings.

The variety of shapes on the cliff were very intriguing. On the left, there's a house with a turreted roof, a few nondescript houses, three or four Victorian beach houses and a row of cottages. There's some dry sand and a nice sweep of wet sand. This was good—it's a setting that naturally lent itself to the feeling of abandonment I wanted to create.

The wet sand in the foreground that converges with the distant shoreline created a nice "Z" composition. When I was satisfied with my drawing, I painted the sky with a very pale blue-gray. After that, I cut a mask out of masking tape for the boat and painted the water with my 1¼ inch (31mm) flat, charging it alternately with Raw Sienna and Burnt Sienna. I added some Ultramarine Blue around the boat and scraped some highlights into the water with a razor blade.

I painted the beach background using a 1¼-inch (31mm) flat with Burnt Umber and Burnt Sienna, which I darkened as I moved toward the foreground. Then, I removed the mask over the boat and painted it with a no. 6 round for the mast and no. 8 for the hull and a mixture of Ultramarine Blue and Burnt Sienna. Finally, I spattered some Burnt Umber on the beach to add more texture.

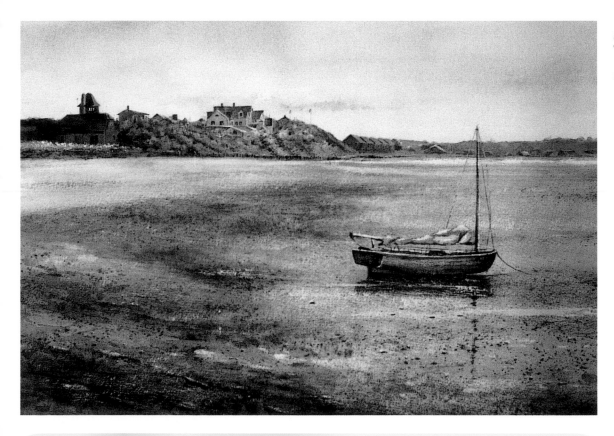

Mayo Beach
Watercolor on paper
14" × 21" (36cm × 53cm)
Private collection

Water & Beaches

Adapting to the Environment

The shift in tide height on this beach is very dramatic: 12 feet (4m). At low tide, you have to walk a couple of hundred yards to get your feet wet, but the tide comes in very fast. I had been at my easel for a few hours, completely absorbed in my work, when all of a sudden I realized I was standing in water. So, what to do? I took off my shoes and finished the painting in my bare feet. After all, what do you do at the beach? Stick your toes in the sand. Great fun!

Tumultuous Seas

These two paintings, *Boater's Playground* and *Fun Day*, were designed to be sold as a pair for the print market. Though they are similar, they feature two different renderings of a stormy sea.

Painting *Boater's Playground*

Because the paintings are a pair, I wanted to keep the same color scheme and mood in both, even though they are quite different. My palette was basically limited to Payne's Gray, Ultramarine Blue, Cerulean Blue, Raw Sienna and Burnt Sienna. After making my drawing, I masked out the yacht, the lighthouse, the small sailboat and the larger sailboat with masking tape. In this instance, I preferred tape over masking fluid because it gave me a sharper, crisper look.

I painted the sky first with a large flat brush, using all the colors on my palette in very subtle values and being careful to leave some white paper for highlights in the clouds. Then I did the water. After initially laying in a natural blue-green wash, I crisscrossed back and forth with darker values of the same colors using the chisel edge of my 1-inch (25mm) shorthair flat. Next, I went in with a small pointed brush to accent the shadows in the darker waves. After that, I started pulling out some lights from the top of some of the waves with the chisel point and the thirsty brush method. I finished up the water by scraping out some of the highlights and foam from the waves. With a small brush I put in the bridge, being careful to keep it light and in the background.

I left the boats white and added very little modeling. The small, darker sailboat was painted with a small brush and lastly, with the same brush, the lighthouse. For it, I used a mixture of Burnt Sienna and Alizarin Crimson.

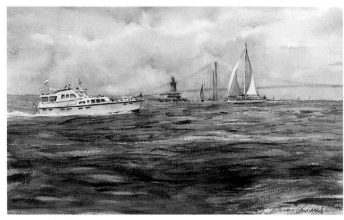

Boater's Playground
Watercolor on paper, 16" ×24" (41cm × 61cm)
Collection of the artist

Painting *Fun Day*

Having predetermined the colors, I selected a slightly higher horizon line for *Fun Day*, leaving me with a little more water area for the large wave and wake. When the drawing was finished, I applied diluted masking fluid to the fly-bridge canopy, two tower platforms, figures and the boat itself. Next I applied it to the wake and spray.

I then painted the sky much as I had the sky in *Boater's Playground*, but used bigger clouds to differentiate. I painted the background, then washed in wave-like strokes across the water. I modeled the large swell on the left using a criss-cross motion to simulate the waves. I alternated the blues with the greens to give the water variety. Finally, I added a few dry-brush strokes and a little blade work. When I was satisfied with the water, I removed all masks and painted the boat and figures with a small brush.

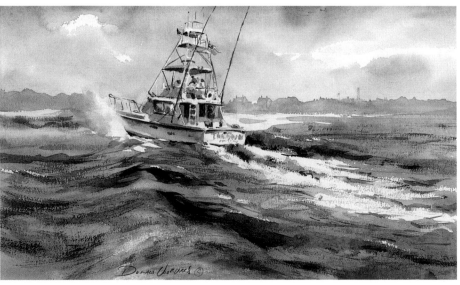

Fun Day
Watercolor on paper, 16" × 24" (41cm × 61cm)
Collection of the artist

Finding the Focal Point

This particular jetty, on Seven Presidents Oceanfront Park Beach in Long Branch, New Jersey, near where I live, is a favorite of mine. This beach is the very one that Winslow Homer (one of my heroes) selected for painting and sketching. It's so refreshing to feel the spray of water on my face and smell the sea air, and the breaking waves pounding against the rocks make it very exciting.

My take on the two seagulls in the painting is that they got up early in hopes of beating the other gulls out of whatever goodies the fishermen might leave or toss their way. They seem to believe in the old adage "the early bird gets the worm."

The dark blue water provides a nice contrast of values between the surf and the sea. The "T" formed by the surf and the rocks gives the eye a nice lead into the center of interest. The gulls give it life. My wife and I like to watch gulls. When we go to Florida, we set up our umbrella in a section of the beach where large numbers of gulls congregate. Watching their antics is fascinating and the proximity allows me to study and photograph them to my heart's content.

Painting Procedure

1 **Masking**
 Using masking fluid, preserve the white of the seagulls.

2 **Water**
 Wet the paper and lay in the dark blue water, letting it bleed into the surf.

3 **Waves**
 Using the thirsty brush technique with a 1-inch (25mm) flat, create some designs in the surf to make it appear windy.

4 **Beach**
 Paint the beach and rocks, being sure to leave plenty of white highlights.

5 **Gulls**
 When everything is dry, remove the masking fluid from the gulls and paint just the underside of their wings a light gray.

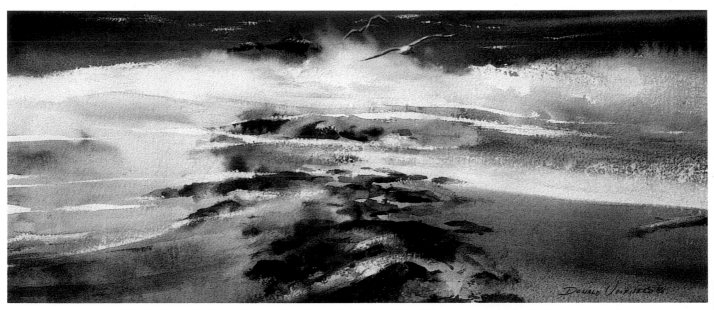

Early Risers
Watercolor on paper, 12" × 21" (30cm × 53cm)
Collection of Valerie Shauer

Winslow Homer (1836–1910)

Winslow Homer is one of America's most accomplished painters. He was born in Boston, had a studio in New York and covered the Civil War for *Harper's Weekly*. Sometime after the war he visited Long Branch, New Jersey, which was a fashionable resort at the time. It was the summer home of many presidents and New York socialites. He sketched and painted on this beach quite frequently. One of his most famous paintings, *Long Branch, New Jersey*, was painted here in 1869. It is currently in the collection of the Boston Museum.

Realistic Reflections

I'm a sucker for boats. I've never owned one, but I've painted many. There were several good reasons for choosing the boat and location that appear in this painting. For one thing, the harbor is close to home and I can drive there in five minutes. However, most importantly, there's an abundance of material. There are all kinds of boats—including a commercial fishing fleet—fishing nets hanging out to dry and lobster pots all over the place. For years, I was one of the few artists who had discovered the area. The word got out and artists from all over the state descended on it.

What first caught my eye in this scene was the outstanding play of light on the boats. The white boat surrounded by the darker ones was a great value contrast. This was a strictly impromptu, see-it-then-start-painting-it moment. It was a bright day, creating nice contrasting reflections in the water.

Painting In Sequence

This piece was painted entirely before noon, on location—it had to be done because the light changes drastically after noon. I did the drawing, which was quite involved, as quickly as possible.

In order to accurately capture reflections, you have to paint in the right order: If you don't paint the boat first, how do you know how it will look reflected in the water? First I masked the boats, buildings and water and, after painting the sky and clouds, I removed the masks and painted them. Be sure to add the boat's shadows and trim—they'll be reflected as well. Now, and only now, can you paint the reflections onto the water. Painting reflections is all about following a logical sequence.

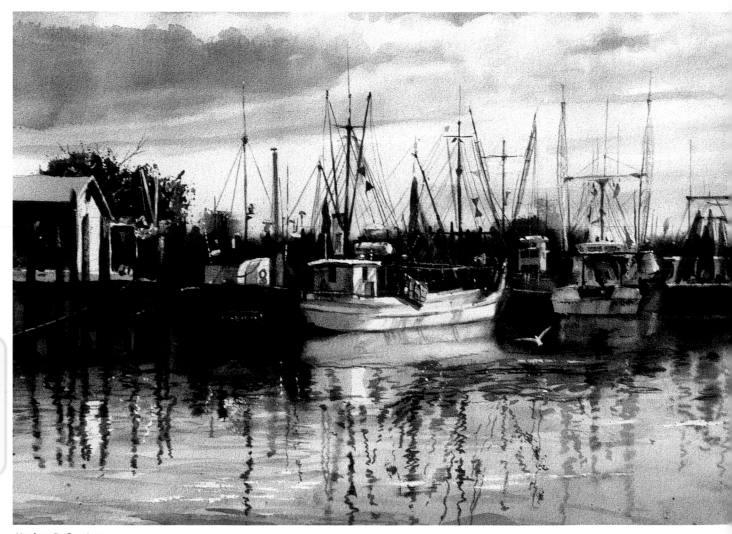

Harbor Reflections
Watercolor on paper, 14" × 21" (36cm × 53cm)
Private collection

Portrait of a Lighthouse

This little lighthouse is the first thing you see upon entering Nantucket Harbor. It is the ninth lighthouse to occupy this site. Due to the fact that they're wooden structures with big hot lights in them, fires often destroyed them. There seem to be some discrepancies about when the first lighthouse on the site was erected, but it was somewhere in the mid-eighteenth century.

Planning and Drawing

This painting has four primary elements—the medium blue sky, lighthouse buildings, beach and dark blue water. Breaking one of my own rules, I chose a horizon line at almost dead center. Naturally, I could have cropped it when it was finished, but it seemed to work so I left it alone. One of the major challenges in this painting was the waterfront cottages. I wanted to be authentic and make it a portrait of the shoreline, so I took as much care when drawing them as I did with the rest of the painting. Each of the waves were planned in advance and drawn dark enough that I could see them through the initial washes. I even drew the lighthouse reflection.

Masking and Painting

The masking in this painting is quite extensive, to say the least. First, I laid a couple of 2-inch (5cm) masking tape strips across the middle portion of the painting and cut a mask for the cottages, lighthouse and other buildings. I covered the water area with newspapers, then painted the sky Cerulean Blue with a little Winsor Violet using my 1¼-inch (31mm) flat.

When the sky was dry, I immediately protected it with newspapers and painted the trees behind the buildings. I removed all masks and carefully painted the buildings, then moved on to the beach and rocks. Then I painted the water Ultramarine Blue, with a little Winsor Violet at the entrance to the harbor and along the shoreline. I added the dark waves using the previously drawn pencil lines as a guide. I added some texture to the water with dry-brushing and scraped highlights on the waves and the reflection of the lighthouse in the water.

SECRET
Hard Work

There's only one way to paint subject matter like this: work! This requires great attention to detail. First, you must have excellent photographic references. Then, one by one, carefully draw each cottage as though it were a miniature house painting. Keep in mind that they should get larger as they approach the foreground. It's a lot of work, but worth it.

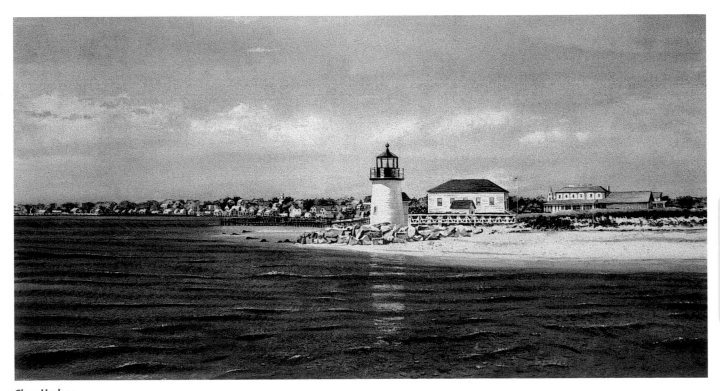

Clear Harbor
Watercolor on paper, 17" × 31" (43cm × 79cm)
Private collection

Painting Autumn Characteristics

This painting depicts one of the many salt marshes and tidal estuaries that run off the Pamet River in Massachusetts. What attracted my attention to this scene was the slight breeze that created ripples across the water. I also liked the contrast between the blue of the water and the rust color of the marshes. Because there was a chill in the air, the occupant of the house in the background had a fire going in the fireplace. This added even further interest.

When composing this painting, I chose four large, basic elements; the sky, the trees, the buildings and hills in the background, the marsh grass and the water and tide pool.

From my vantage point, standing on a knoll across the marshes, my horizon line was approximately the roof-line of the small building to the left of the house.

After completing my drawing, I covered the house and shed with masking fluid. Next, I wet the whole area and washed in a light, warm mixture of Raw Sienna and Burnt Sienna near the bottom of the sky with a 1¼-inch (31mm) flat. When dry, I re-wet the whole area and washed in a light mixture of Cerulean Blue and Ultramarine Blue for the upper portion of the sky. The water was next—I used the same blues and brush that I used in the sky. An underpainting for the ripple area was painted with a darker shade of Ultramarine Blue. Once dry, I painted the ripples by stippling one at a time with a small brush.

With the exception of the smoke coming out of the chimney, the rest of the painting was done alternating between nos. 6, 8 and 12 rounds, depending on the size of the area being worked on. The marsh grasses were painted with Burnt Sienna and a little Alizarin Crimson. I used a razor blade extensively to scrape out grass blades. The trees on the left were painted primarily with Payne's Gray, Alizarin Crimson, Raw Sienna, Cerulean Blue and Winsor Violet. The warm hills on the right were painted with Winsor Violet, Raw Sienna, Ultramarine Blue and Cerulean Blue.

I removed their masks and painted the buildings with mostly Pro-White and Payne's Gray. The smoke coming out of the fireplace was last; I painted it using a no. 1 round and Pro-White. Not only did it provide added interest, the painting sorely needed a vertical element.

SECRET
Autumn Leaves

Here's a little trick to give your autumn leaves incredible luminosity. First, protect them with masking fluid as per usual, then paint the sky, let it dry and remove the mask. Now, instead of painting the whole leaf area, stipple each individual leaf with the appropriate color on the side away from the sun, leaving the light side white. An alternate method is to pick the whites out with a razor blade.

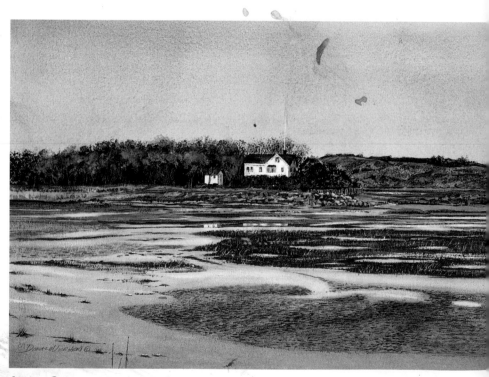

Autumn Cape
Watercolor on paper, 14" × 21" (36cm × 53cm)
Collection of the artist

Palm Trees and Island Mountains

I did this painting of the Virgin Islands a couple of years ago for my daughter Kathleen. She and my grandson have taken several cruises to the Caribbean, but she's never found any art depicting one of her favorite spots. This information was very valuable to me—I knew I could really give her a Christmas gift to remember.

I asked her if she had any videos or photos of the islands that showed a spot of particular interest and beauty to her. After viewing the material, I selected these photos for my project. One features several boats and the mountain, and the other highlighted the palm tree. Obviously, I took the background from one, the foreground from the other and proceeded to create this painting.

Reference Photos

Caribbean Palms was based on these two photos. I took the mountain from the one on the left and the palm tree from the one on the right. Before I began painting, I wanted to analyze the subject matter and come up with a plan so the finished painting would look exactly the way I wanted it.

I decided to use a little more sky and to make it lighter and less vivid, because I wanted plenty of contrast with the trees and mountain. I planned on adding a few more clouds to give it variety. I decided to make the water a little brighter and add some small waves and highlights, as well as more detail and texture to the mountain.

Materials

15" × 22" (38cm × 56cm) 140-lb (300gsm)
cold-press Arches
Drawing board
No. 2 HB pencil
Natural Sponge
Hair dryer
Magnifier (optional)
Masking fluid
2-inch (5cm) and 1-inch (2.5 cm) masking tape
Plastic eraser
Rubber cement pick-up
Razor blade
No. 10 craft knife

PAINTS
Burnt Sienna
Burnt Umber
Cadmium Yellow Deep
Cerulean Blue
Payne's Gray
Pro White
Raw Sienna
Ultramarine Blue

BRUSHES
1¼-inch (31mm) flat
No. 6 round
No. 2 round
No. 1 round

1 Draw, Mask and Paint the Sky and Water

Draw the scene, then mask out all the tree trunks and some of the palm fronds with masking fluid using a no. 6 pointed round. Switch to a no. 1 round and carefully mask out the small boats along the distant shoreline.

Wet the entire paper, then very quickly lay down a wash of light Cerulean Blue, Ultramarine Blue and Payne's Gray. Run the wash all the way down to the bottom of the sheet, saving plenty of white in the sky. Dry with your hair dryer, then put down 2-inch (5cm) masking tape across the entire sky-side of the horizon line. Use your 1¼-inch (31mm) flat to lay in the water with a wash of Cerulean Blue, Ultramarine Blue and Payne's Gray. Take your sponge and stipple in some foliage in the trees on the left, using Payne's Gray and Raw Sienna. Intensify the color of the water with more Ultramarine Blue, add some white ripples and scratch out a few highlights with your razor blade.

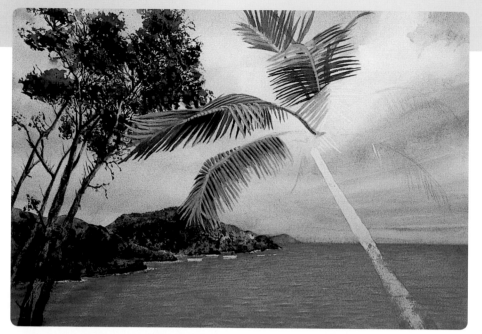

2 Paint the Mountain, Palm Fronds and Tree Trunks

Alternate between a no. 6 round and your sponge and use Payne's Gray, Raw Sienna and Cerulean Blue to paint the mountain. Remove all remaining masks with rubber cement pickup, then paint the fronds with Ultramarine Blue and Cadmium Yellow Deep using your no. 6 round. Use the same brush to paint the tree trunks on the left with Payne's Gray, Raw Sienna and a little Cerulean Blue.

3 Finish the Foliage

Go back to the trees on the left and stipple a little Burnt Sienna into the foliage using a no. 2 round.

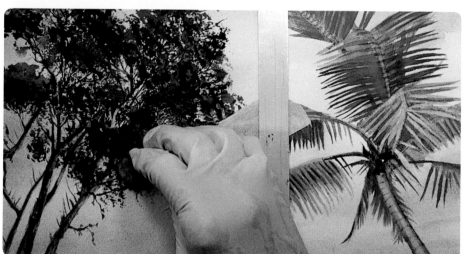

4 Paint the Tree Trunk

Cut a mask for the palm trunk, burnish well, then wash in a little Raw Sienna and Burnt Umber with your no. 6 round. While it's still wet, run a fairly dry mixture of Burnt Umber and Payne's Gray along each edge to give it dimension and make it look round. When it has dried, use your no. 1 round to paint horizontal and circular strokes with the Burnt Umber/Payne's Gray mixture. Use the same motions to scratch out some lines suggesting bark texture with your razor blade.

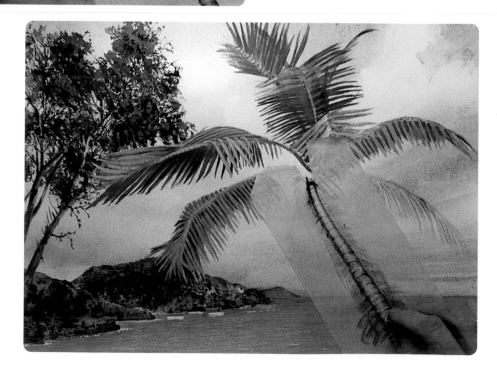

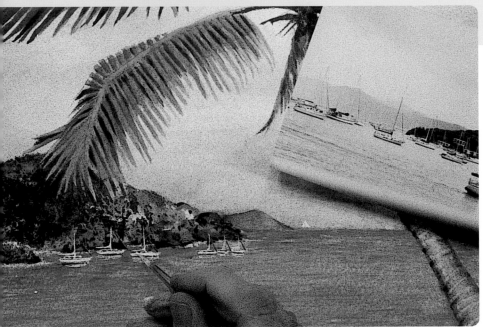

5 Add the Boats
With your no. 2 pencil, carefully redraw the boats. Then, using your no. 1 round, paint them very carefully with Pro-White. Use a magnifier if you have one, and don't forget the reflections of the boats in the water. When they're dry, stroke in a little Payne's Gray where the hull meets the water for accents with a no. 1 round.

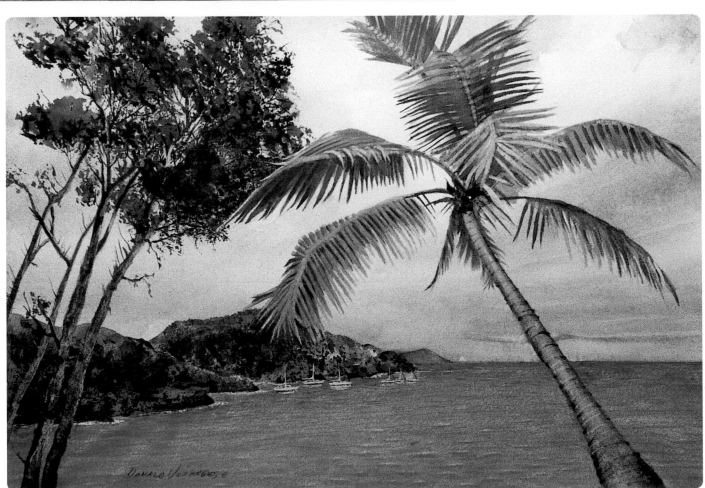

6 Finish the Painting
As you're nearing completion of a work, you need to keep the goal of the painting in mind. As my focus in this work was creating a memory of this scene from a distance, no further details were necessary. If your goal is abject realism, many details might be called for.

Caribbean Palms
Watercolor on paper, 14" × 21" (36cm × 53cm)
Collection of Kathleen Voorhees

Painting Fog

I'm fortunate enough to live within a few miles of several boat yards and marinas. I found this particular boat yard in the mid-1960s. I kept coming back to it because it was small, unpretentious and loaded with character-laden old working boats. One early morning when I got there, the fog was rolling in. Something mystical was happening. It took on a still, almost eerie look. Nature was blocking out much of the usual and focusing on the drama of a single aspect. I had to capture that feeling and began to paint.

This painting evokes wonderful memories of my friendship with the commercial fishermen who thought of me as "just one of the guys." Some even rewarded me with commissions to render their boats. I frequently took my students to this site and they were also delighted with its charm. Unfortunately, progress eventually took its toll. Condos and a ferry terminal have all but eliminated the fishing village atmosphere.

It was a great location.

Materials

10" × 12" (25cm × 30cm) 140-lb. (300gsm)
cold press Arches
Drawing board
No. 2 HB pencil
2-inch (5cm) masking tape
Masking fluid
Paper towels
Rubber cement pickup
Razor blade
No. 10 craft knife

PAINTS
Burnt Sienna
Burnt Umber
Cadmium Red
Cerulean Blue
Payne's Gray
Pro-White
Ultramarine Blue

BRUSHES
No. 2 round
No. 4 round
No. 6 round
No. 12 round

1 Draw the Scene and Start Painting

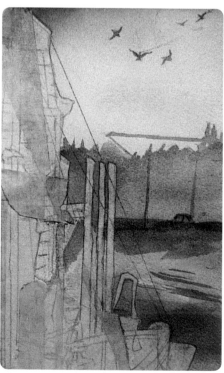

Tape your paper to your drawing board and make a careful drawing. Don't neglect the abstract shapes in the fog area. Make sure the pencil lines are dark enough to see through the masking tape, then use it to cover the boathouse, pilings, boat and rigging.

With a no. 12 round, apply Payne's Gray to the upper portion of the sky. Using the same brush and a mixture of Ultramarine Blue and Payne's Gray, paint the wooded area behind the marshes. Move to the marshes and paint them with Burnt Sienna, still using the no. 12 round. Finish up by painting the water with the same brush and a mixture of Payne's Gray and Ultramarine Blue.

2 Scrub Some Color Out

Take a wad of paper towels and scrub out almost—but not all—of what you have just painted until you get that grayish, foggy look. If it's still too dark but you're afraid you'll lose the shapes if you keep scrubbing, try putting a light wash of Pro-white over it before removing the mask. Remove the mask when you're satisfied.

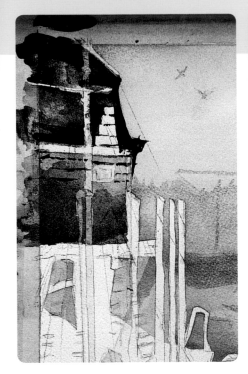

3 Paint the Building

Cover the boat's mast, building trim, pilings, windows, ladders and any other white areas on the boat with masking fluid using your no. 4 round. When the fluid is dry, paint the upper part of the building with a mixture of Burnt Umber, Ultramarine Blue and Burnt Sienna using your no. 6 round. Next, paint the lower part of the building using the same brush and a lighter value of Burnt Umber and Burnt Sienna.

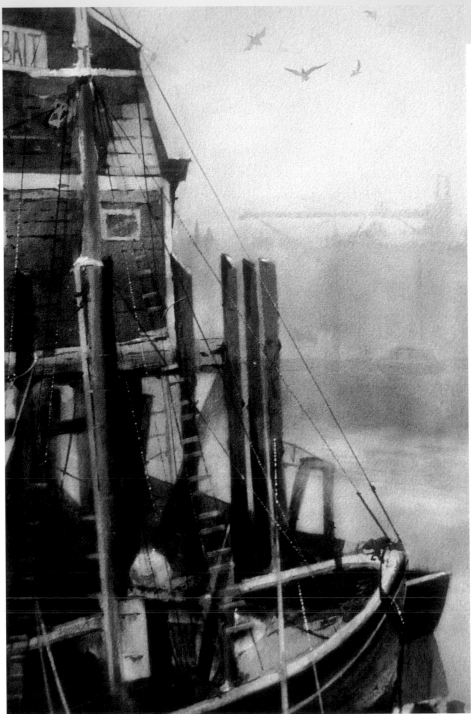

4 Finish the Painting

Using Burnt Umber and Burnt Sienna, paint the float and supports with a no. 4 round. Paint the hull of the boat using the same brush and Ultramarine Blue and Burnt Sienna. Remove all remaining masks.

Using your no. 2 round loaded with Burnt Umber, paint the long, skinny pilings one by one. The pilings were originally tree trunks and still have their original nubs: No two are exactly alike. Note that you can still see where branches and nubs were. These can be highlighted by picking them out with the corner of your razor blade.

Paint the mast using the same no. 2 round and Cadmium Red in various values, light here, dark there. Detail the inside of the boat using the same brush and Ultramarine Blue and Burnt Sienna. Switch to a no. 4 round and paint the windows and sign with Cerulean Blue and Payne's Gray. The riggings can now be done with pencil and razor blade.

Foggy Morn
Watercolor on paper,
21" × 14"
(53cm × 36cm)
Private collection

Capturing the Calm Before the Storm

I look at this scene in Atlantic Highlands, New Jersey, every day, as I am now, sitting in my studio overlooking the water. The lighthouse is on Sandy Hook Island, New Jersey, and is rich in history. It was built in 1764, making it the oldest in North America. During the American Revolutionary War it was under British control. After the war, it was used as a command post by a bunch of bandits loyal to the crown and became known as "Lighthouse Fort" or "Refugees Tower."

Painting a Thunderhead

One nice summer morning, I was setting up my painting easel on Sandy Hook when suddenly, without any warning, it started to get darker. I knew rain was imminent, and I certainly wasn't going to be painting in a thunderstorm. I hurried back to the parking lot and as I was putting my stuff in the car, I heard a deep rumbling behind me. I turned around and saw this huge thunderhead forming over the lighthouse. This was a photo opportunity too good to miss. I grabbed my camera (which is why you should always have one with you) and quickly took several shots before it started pouring. I used those photos as the reference for this painting.

Materials

10" × 12" (25cm × 30cm) 140-lb. (300gsm) cold-press Arches
Drawing board
No. 2 HB pencil
1-inch (2.5cm) and 2-inch (5cm) masking tape
No. 10 craft knife
Plastic eraser
Razor blade
Kosher Salt
Natural sponge

PAINTS
Alizarin Crimson
Burnt Sienna
Burnt Umber
Cadmium Yellow Deep
Cerulean Blue
Payne's Gray
Pro-White
Raw Sienna
Ultramarine Blue
Winsor Violet

BRUSHES
1¼" (31mm) synthetic flat
No. 2 round
No. 6 round
No. 8 round
No. 12 round

1 Draw the Scene and Paint the Sky
Tape the paper to your drawing board with 1-inch (38mm) masking tape, and use a no. 2 pencil to make a careful drawing. Lay 2-inch (5cm) masking tape over the dunes, trees and buildings and cut a mask with your craft knife, using the drawing (which should be visible through the tape) as a guide.

Begin the sky by dampening the whole area. Dry-brush Ultramarine Blue to create those delicate flare strokes, moving from left to right using a no. 12 pointed round. Leave white over the left part of the thunderhead, behind the lighthouse and the right bottom part of the sky. While still wet, sneak a little Raw Sienna into the upper right sky with the no. 12 round, and use it to create the thunderhead with Raw Sienna.

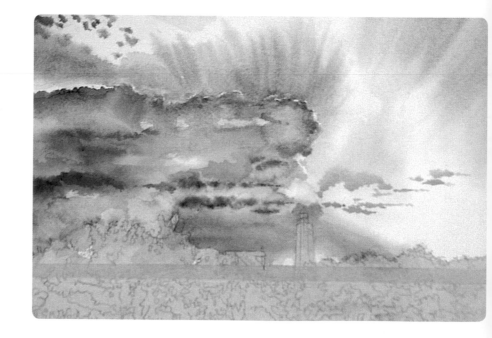

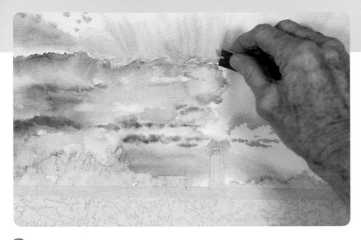

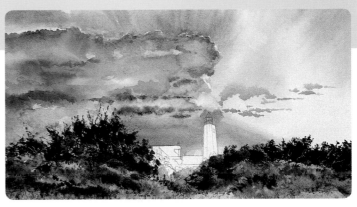

2 Highlight the Thunderhead

When the sky has thoroughly dried, highlight the top of the thunderhead clouds with your razor blade. Scrape away some of the blue to make it appear as though light is shining behind the clouds.

3 Paint the Dunes and Trees

Remove the masks and wet the uncovered area. With the chisel edge of your 1¼-inch (31mm) synthetic flat, shape the dunes using Burnt Umber, Payne's Gray, Winsor Violet and Burnt Sienna. Keep the whole area fairly dark.

Sprinkle a little salt into the damp wash, and when dry, sponge in the bushes using a dark mixture of Payne's Gray, Cadmium Yellow Deep and Raw Sienna. Save some open places in the foliage and use a no. 2 round to add some branches of varying shapes.

Storm Brewing
Watercolor on paper,
14" × 21" (36cm × 53cm)
Private collection

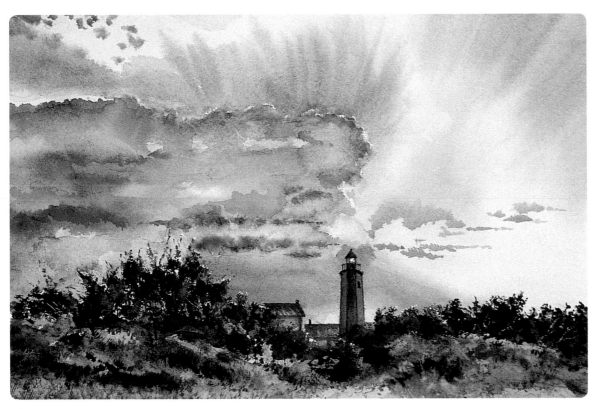

4 Add the Buildings and Lighthouse

Alternating between your no. 6 and no. 8 rounds, paint the building on the left with Payne's Gray and a little Cerulean Blue. Use Payne's Gray and Raw Sienna for the middle house, and Alizarin Crimson for its roof. For the body of the lighthouse, use Payne's Gray and Ultramarine Blue, and for the roof use Payne's Gray and Alizarin Crimson. Suggest the light at the top with a touch of Pro-White using your no. 2 round. Use a razor blade to scratch out a few highlights on the bushes and you're done!

Skies

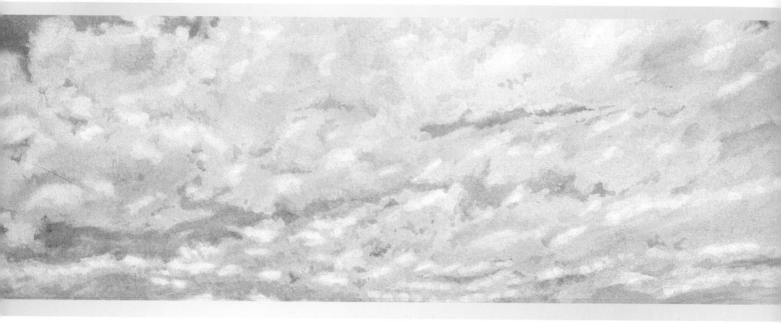

Morning Skies

The Highland House is a beautiful example of a fashionable 1907 Cape Cod summer hotel, which is now being used as a museum by the local historical society. Having painted the Highland Light many times, I decided it might be nice to use the lighthouse as a secondary center of interest. When I began this painting it was early morning, seven or eight on a lovely spring day. There wasn't much color in the sky and it wasn't all that interesting, except for a nice bank of clouds that I decided to take advantage of. Besides, the beach plums and lilacs were in bloom—that's plenty of color right there.

I parked on Highland Road, got my gear out of the car and went to work. I decided to take a low position, sitting in my folding chair with my drawing board on my lap instead of standing at my easel. This enabled me to look up at the house; I was looking at the porch ceiling, a vantage point that placed the horizon line slightly below the porch floor. By sizing up the composition and looking through my slide/mount viewer, I decided to use four distinct elements as the main body of the painting:

1 the cloud formation
2 the blue-gray-purple sky
3 the buildings and flower mass
4 the white sand

I made my drawing very carefully, which took the better part of the morning. After that, I masked off the sand and buildings with 2-inch (5cm) masking tape and the beach plums on the right with masking fluid.

Following that I mixed two large puddles of color: one a very light mixture of Cerulean Blue and Payne's Gray, and the other the same mixture with the addition of Winsor Violet. (I mixed

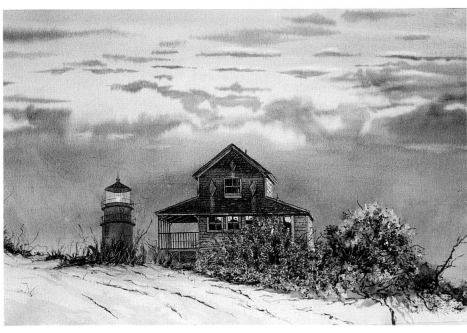

Morning Light
Watercolor on paper, 14" × 21" (36cm × 53cm)
Collection of Mr. and Mrs. Harry Keller

these colors in advance so that once I started painting, I wouldn't have to stop.) I covered the whole sky area with plain water and patted it with paper towels until it had a nice sheen, then laid the pale blue over it using a 1-inch (25mm) flat. I painted the small clouds with a no. 2 round and the blue-gray mixture. I re-wet the sky and covered the bottom portion with the purplish mixture using the 1-inch (25mm) flat.

I removed the existing masks and applied masking fluid to the lilacs in front of the house. Next I painted the lighthouse, then the house. I removed the lilac mask and painted them using a no. 2 round and diluted Winsor Violet. I painted the beach plums on the right with the same brush and the blue-gray mixture, and finally put just a touch of color down for the sand with a light mixture of Burnt Umber and Raw Sienna using a 1¼-inch (31mm) flat. I added the diagonal twig on the right to pull the

eye back into the painting.

It took me four consecutive mornings to finish this painting, each session probably lasting three or four hours. Once the sun got high in the sky, I quit! One of the downsides of painting outside is the changing light.

S E C R E T
House Commissions

If you understand perspective and are good at drawing and painting houses, there are a lot of people out there who will pay you to do a painting of their home. Put a sign in your local supermarket with a sample of your work, or try a small ad in a local mailer a month or two before the holidays—house portraits make wonderful gifts. Realtors can also be a good source for possible leads. Just keep thinking you have something people want, then tell them how to get it.

Skies

Adding Wispy Clouds to the Sky

Hyannisport, Massachusetts, is world renowned as the location of the Kennedy Compound. It's actually a neighborhood within the village of Hyannis.

The thing that first caught my artistic attention in this scene were the nice curves in the beach near the waterline. Composition-wise, they lead you right into the center of interest, the grasses and lighthouse. However, the wispy cloud formations were so predominant that I decided to take advantage of them by placing my horizon line far down past the center of the canvas, leaving the majority of space for the sky. If not for the interesting clouds, I probably wouldn't have gotten away with such a low horizon line.

Painting Procedure

1 Masking

After completing my very careful drawing of the buildings' architecture, I masked off the entire bottom portion of the painting with 2-inch (5cm) masking tape.

2 Sky

Then, I mixed up a puddle of light Cerulean Blue and washed in the sky with my 1¼-inch (31mm) flat.

3 Clouds

While still wet, I took wads of paper towels in both hands and started wiping out the clouds, a little at a time. As places started to dry, I would just re-wet them and re-wet them and re-wet them. Get the idea?

4 Trees and Buildings

I removed the mask after the sky had dried and, going from left to right, I painted the trees, the larger building behind the lighthouse, the lighthouse and finally the smaller buildings in the background.

5 Water and Beach

Next came the water and finally the beach and beach grass. I covered the entire painting—except for the beach—with newspaper and carefully spattered the whole beach. Then I darkened the areas to the left, in the middle and along the shoreline of the beach. Done!

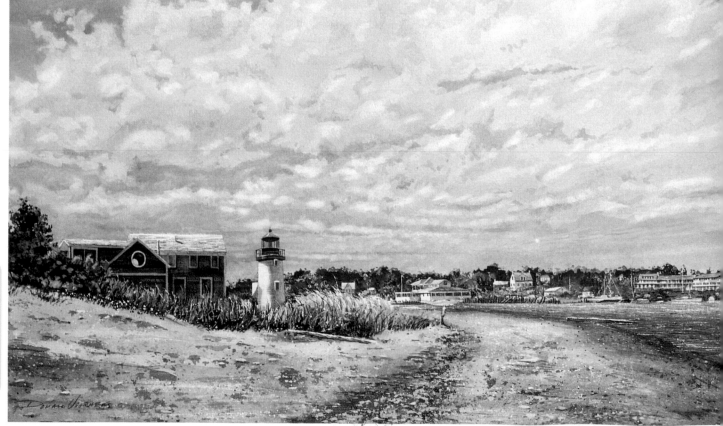

Beach Walk
Watercolor on paper, 14" × 21" (36cm × 53cm)
Collection of Donna Ziemba

Skies

Painting a Sunrise

I discovered this spot on one of my early morning jaunts around the Cape looking for subject matter. When I found it, I was so impressed! Just imagine it: Here it was predawn and I was all alone in one of the most isolated places you could find. Nothing but dunes for as far as the eye could see, with the exception of this one building. It was indeed a mysterious and awesome sight. The sky was becoming brighter and brighter by the minute. First I saw a glow and then suddenly the sun's in the sky, thus the title, *Suddenly the Sun*. If you blink your eyes, you've missed it!

No matter how often I've seen this place, I am always humbled by it. Occasionally, I've even seen breaching, spouting whales offshore. What a treat! It's a great spot.

Painting Procedure

1 Masking

I placed layers of masking tape over the building, dunes, moon and sun to preserve the white. I then cut around the objects with a craft knife and removed the excess tape.

2 Sky

I brushed in the whole sky area with clear water then painted right over the building, moving from left to right. Next, I washed an orange shade in the middle of the sky.

3 Sun

After I let the building dry, I re-wet the sky and lifted out the glow around the sun and painted it. I then added a touch of white to the bottom of the sun next to the water.

4 Dunes and Water

After the dunes had dried, I put down a strip of masking tape where the sky meets water. I painted the water leaving a little white right above the dunes. Done! Good morning!

SECRET
Transferring Your Drawing

Tape your paper to your drawing board and make sure, using a I-square and triangle, that it's square with your board and not your drawing table. Lightly sketch the major components, then put the drawing aside. Make a careful drawing of your figures on a piece of tracing paper.

Place the tracing paper on top of your initial drawing, and tape it to your drawing board in the correct place. Trace your drawing onto your paper with the transfer paper. When you are finished, don't pull the tracing paper off. Make a hinge and tape it over the back of your painting so you can retrace it later on, if necessary.

When using transfer paper to transfer a drawing to watercolor paper, it's a good idea to use a colored pencil so you can see the lines you've already traced. It's much easier then finding out you missed some lines when you think you're finished.

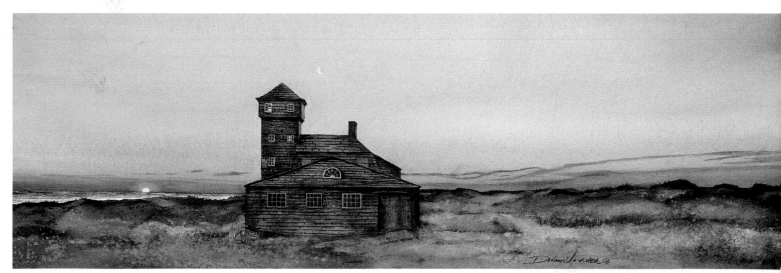

Suddenly the Sun
9½" × 29" (24cm × 74cm)
Watercolor on paper

Depicting Twilight

Martha's Vineyard is a 10 × 20 mile (16km × 32km) island off the southern tip of Cape Cod, Massachusetts, which is accessed via car ferry from Woods Hole, Massachusetts, home of the National Marine Biological Laboratories. Geologists tell us that it became an island fifty thousand years ago, right after the last ice age. The Wampanoag Indians inhabited it for thousands of years, having fled the mainland due to warring tribes there.

Prior to Painting

Obviously, you can't execute a painting like this on location. For one thing, the sunset only lasts for about ten minutes. Enter the camera!

This painting was done from many 35mm slides. That is to say, I might take the sky and water from one and the building or rocks from another. I was very concerned about the color scheme for this painting. Pinks and blues work beautifully together, so I was all right there. The problem was how much of each color was enough? The ever-present too light/too dark conundrum.

It's like balancing yourself on a tight-rope. I decided to use a very limited palette for this painting. In fact, most of the sky and water was painted with only two colors, Alizarin Crimson and Ultramarine Blue. The colors used for the land and buildings were primarily shades of blue-gray. I used Cerulean Blue, Burnt Umber, Winsor Violet and Payne's Gray, with just a little Alizarin Crimson. Alizarin Crimson is a powerful dye-based color, which means it's a staining color and has to be used with caution. This requires careful planning and working swiftly once decisions are made.

Materials

14" × 21" (36cm × 53cm) 140-lb. (300gsm) cold press Arches
Drawing board
2-inch (5cm) masking tape
Craft knife

PAINTS
Alizarin Crimson
Cerulean Blue
Ultramarine Blue

BRUSHES
1¼-inch (31mm) flat
No. 12 round

1 Paint the Sky

Place overlapping strips of 2-inch (5cm) masking tape over the lower left portion of the sky, the waterline and the buildings. Cut the mask starting from the left with your craft knife.

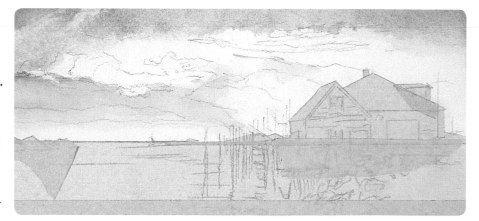

Saturate the entire sky area with water and, starting from the left, use a 1¼-inch (31mm) flat to paint a pale ribbon of Cerulean Blue across the top of the painting. Flow in a little Ultramarine Blue in both corners of the ribbon using the same brush. Again with the flat, add a touch of Alizarin Crimson to the right corner and let it bleed to a soft edge.

Re-wet the area above the waterline, reload the same brush with more Alizarin Crimson, and wash from left to right about 3" (8cm) above the waterline. Let it bleed into the wet paper until about an inch above the water, then let it dry.

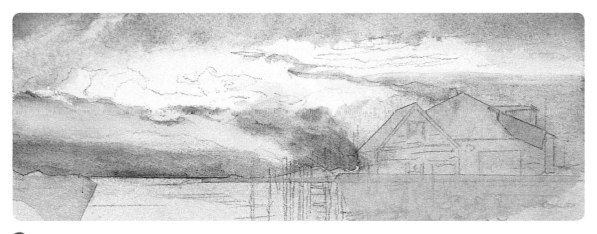

2 Add More Blue

Re-wet the paper, and while it's still wet, flow a streak of Ultramarine Blue into the white area above the waterline with the 1¼-inch (31mm) flat, below the Alizarin Crimson. Use the same brush to paint a Cerulean Blue wash across the masked buildings, and let it blend in the Ultramarine Blue.

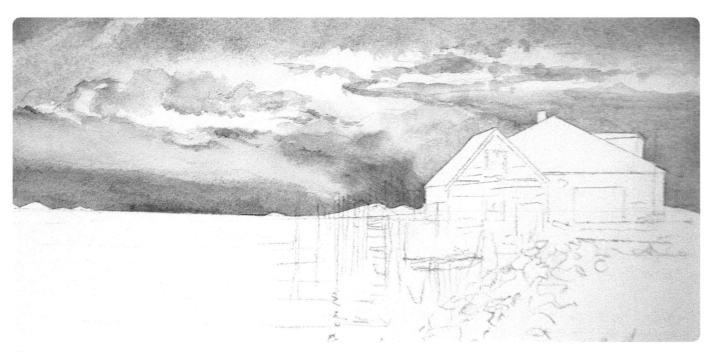

3 Paint the Clouds

The only thing left to add are the smaller clouds—for this, switch to a no. 12 round. Re-wet the paper and, starting on the left, paint a cloud over the pink area with a light wash of Ultramarine Blue. Add a little Alizarin Crimson on the left. Next, paint two small clouds over the buildings using Cerulean Blue for one and Ultramarine Blue mixed with a touch of Alizarin Crimson for the other.

Capturing Moonlit Water and Rocks

While growing up on the New Jersey shore, one of the beaches we used to frequent had a sign on it with an arrow pointing out toward the water that said "Portugal 3,300 miles." It left such an impression that I remember it to this day. Many years later I had the opportunity to go to Portugal. I drove over the bridge spanning the Rio Guadiana river from Spain and there it was, 3300 miles from home.

This section, on the southern coast of Portugal, is called the Algarve. Golden, rock-laden sands stretch for about one hundred miles westward, from Vila Real de Santo Antonio to Henry the Navigator's Cape St. Vincent. The area has become a major resort for European and Scandinavian snowbirds, not to mention many American tourists.

The beach in this painting is in a fishing village called Alvor. It was a short walk from the hotel where we stayed down to a sandy beach with rugged rocks rising out of the water. When hunger struck after swimming and sunning ourselves, we found a young man cooking freshly caught sardines on a grill right on the beach. They were delicious! My mouth still waters when I think of them.

Materials

10" × 12" (25cm × 30cm) 140-lb. (300gsm) cold-press Arches
Drawing board
No. 2 HB pencil
2-inch (5cm) masking tape
Plastic eraser
Razor blade
Craft knife
Kosher Salt
Straightedge

PAINTS

Alizarin Crimson
Burnt Sienna
Burnt Umber
Cerulean Blue
Payne's Gray
Raw Sienna
Ultramarine Blue
Winsor Violet

BRUSHES

1-inch (25mm) flat
1¼-inch (31mm) synthetic flat
No. 1 round
No. 2 round
No. 4 round
No. 8 round
No. 12 round

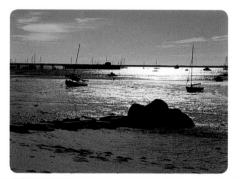

Reference Photo

1 Draw the Scene and Paint the Sky
Draw the scene, then lay masking tape across the water at the horizon. Put a little piece of masking tape over the moon, as well. Be sure that you can see the pencil marks through the tape. Now, very carefully cut a perfect circle around the moon with your craft knife. Just kidding. Do the best you can.

Dip your 1¼-inch (31mm) flat into a mixture of Cerulean Blue and a little Payne's Gray. With swift motions, moving left to right, paint the sky. While it's wet, lift out a few streaky clouds using the thirsty brush technique with your 1-inch (25mm) flat held like a chisel.

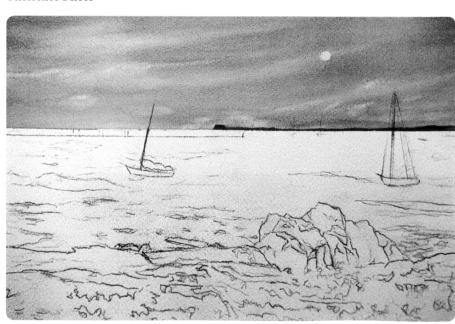

2 Paint the Water

Remove the masks from the horizon and moon, and completely cover the sky, the hulls of the two bigger boats, the rocks and beach with masking tape. Wash clear water over the whole ocean area. While it's still damp, lay down separate washes of Cerulean Blue, Ultramarine Blue and a touch of Raw Sienna with your no. 12 round and let them blend into the paper. When it has dried, use your 1¼-inch (44mm) flat and horizontally dry-brush the whole area with Cerulean Blue. Scrape the whole area with your razor blade in short, horizontal strokes until it sparkles.

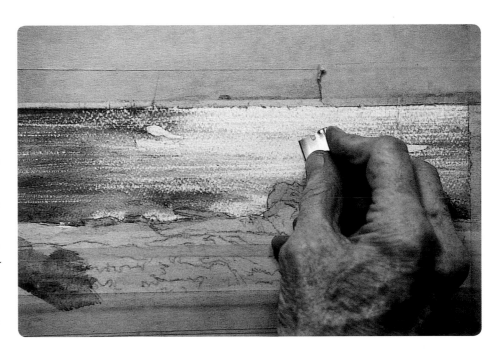

3 Paint the Boats and Rocks

Remove the boat masks. Paint the hulls and sails with Payne's Gray and Winsor Violet using a no. 2 round. Paint the boat trim and sails with Alizarin Crimson using the same brush. Add the masts using the same brush with Payne's Gray. Create the light striking the rigging on the left boat by scratching out paint with the point of a razor blade and a straightedge. Paint the dark rigging on the right with a no. 1 round and a straightedge.

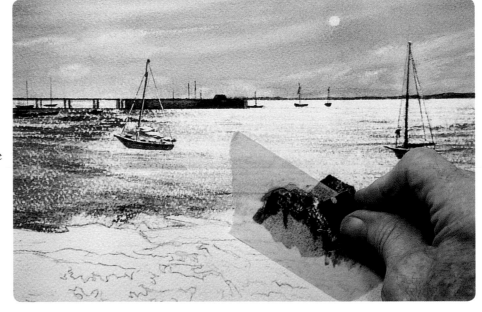

Remove all masks. Place two overlapping pieces of masking tape over the rocks and cut a new mask. Starting from the right, paint the first two rocks with a no. 4 round loaded with Burnt Umber. Paint the next rock with Burnt Umber and streak a little Cerulean Blue into the lower right using a no. 8 round. With the same brush, paint the next rock with Burnt Umber mixed with Payne's Gray and Cerulean Blue. The last rock is mostly Payne's Gray with a little Burnt Umber, Burnt Sienna, Winsor Violet and Cerulean Blue. While each rock is wet, lightly scrape it with your razor blade to give it some texture. Paint the planks and other beach debris with Winsor Violet and Payne's Gray.

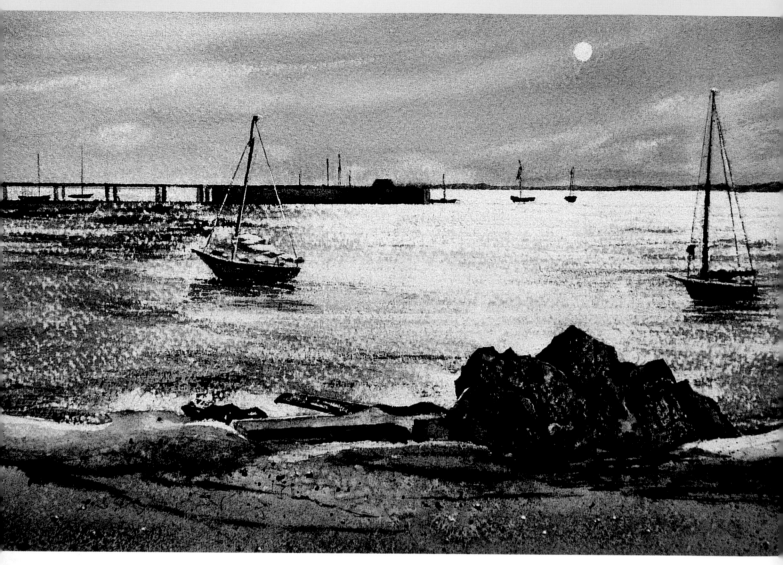

4 Paint the Beach

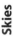

Wash Raw Sienna over the beach, making sure to leave a little white where the sand meets the water. While it's still wet, flow in a little Payne's Gray and a touch of Burnt Sienna. Lightly sprinkle some salt onto the beach to add some sand texture. When it's dry, dip your no. 2 round into Payne's Gray and stroke in a few horizontal lines on the right side near the rocks to suggest ripples. To finish the painting, cover the water and sky with a piece of paper to protect them and gently tap the handle of your no. 2 round against another brush handle and spatter Payne's Gray onto the beach, creating little pebbles.

Algarve
Watercolor on paper, 14" × 21" (36cm × 53cm)
Collection of Dr. Jennifer Drisko

Flowers

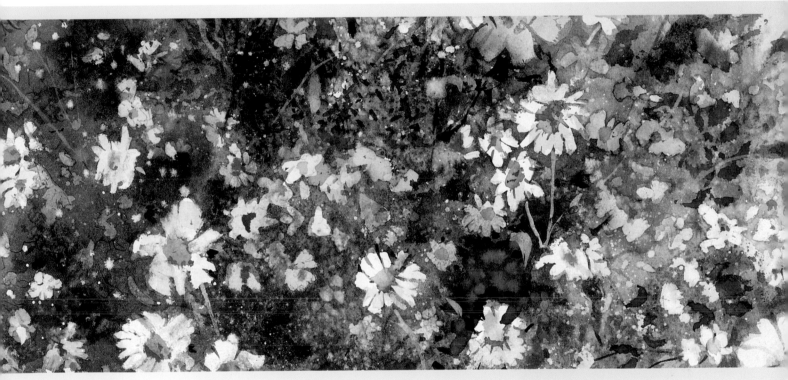

Planning Your Painting

Did you ever stand in front of a painting, trying to evaluate it, and you knew it needed something but didn't know what? In this chapter, I will show you some examples of what you can do to help that situation. Sometimes the answer is flowers. People just love flowers. I have done a lot of golf course paintings and prints. The ones with flowers far outsell those without. That "missing something" can be a mound of beach plums, as in this painting. Sometimes it can be a can with a few flowers in it, sitting on the floor in the interior of a boathouse. Maybe a rambling rose on a broken fence could relieve the severity. In these instances, flowers gave the paintings a lift.

Notice that the makeup of the dune area in *Nauset Lighthouse* consists of three different shapes and sizes. The components on the left are of different shapes and colors. The clouds are similar in color but each shape is unique. Placing the small pine tree next to the keeper's house didn't just happen—these things are planned. Planning is the key to a good painting.

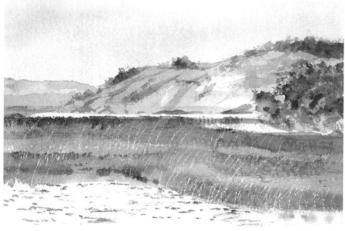

Unplanned
In this painting, the sky is too light and uninteresting, the trees lack shape, definition and color and the water is colorless and establishes no foreground focal point.

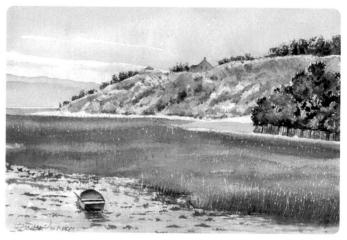

Planned
Planning the painting before starting resulted in a much better work. I added variety to the sky with subtle color and the suggestion of clouds, and added dimension to the hill with shapes, colors and a small house. Also, I improved the form and color of the trees and added the rowboat for a focal point.

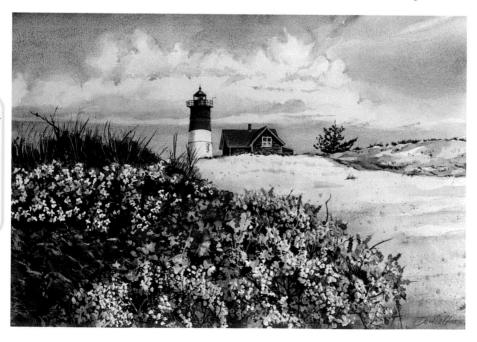

Nauset Lighthouse
Watercolor on paper,
14" × 21" (36cm × 53cm)
Collection of the artist

Flowers

Flowers in Nature

The first lighthouse on the site in this painting was erected in 1790, but this one replaced the original in 1853. This is the brightest lighthouse on the New England coast: It's credited with saving hundreds of seamen's lives. In the early 1880s, it provided shelter for famous author, poet and philosopher Henry David Thoreau on one of his many Cape Cod walks. Having been built on a 120' (37m) cliff, which erodes three or four feet every year, it became apparent that something had to be done to save it. In 1996 it was moved 450' (137m) inland. I've painted this lighthouse many times, from every angle imaginable, but I think this is one of my best.

The Sky
It's a soft, bright morning sky but it still has a lot of contrast in it due to the diagonals in the clouds. Note also the reflection of the earth color—Burnt Sienna—in the clouds.

The Pine Trees
Notice that all the trees aren't purely green, but include browns, greens, reds and blues for variety. The branches are all at different angles and have varying shapes and sizes.

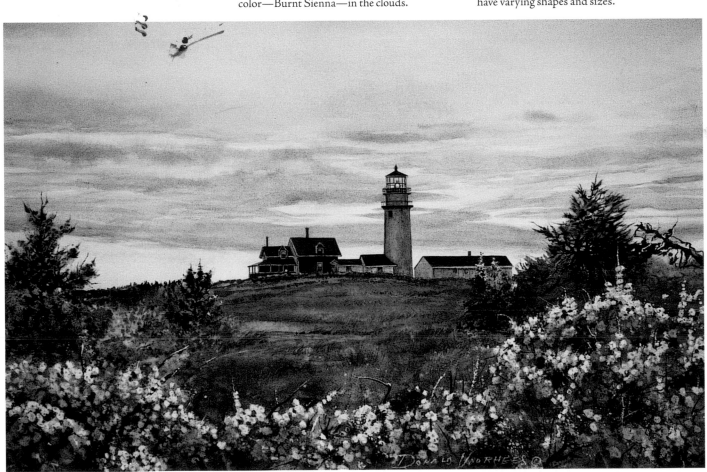

Highland Light
Watercolor on paper, 14" × 21" (36cm × 53cm)
Private collection

The Ground
This was a good choice of color. I think it throws some nice color reflections into the lighthouse and sky.

The Foreground
The beach plums are all different shapes and sizes, as are the branches. Notice the open spaces between the little clusters of blossoms that reveal more shadows and branches. If you study them, you will notice some have a three-pronged shape.

SECRET
Make it Interesting

Your number-one job as an artist is to make your work interesting. Study this painting—see how I worked a little Burnt Sienna into the lighthouse and keeper's house? It wouldn't have been nearly as interesting a painting if I had simply made it a gray shadow color. Don't be afraid of using too much color.

Flowers

Flowers With Lace Curtains

Granada, Spain, is a most memorable place. Several years ago, my wife and I spent a few delightful days in that beautiful city and stayed at the Parador San Francisco. One of the major attractions in Granada is the Moorish Palace Alhambra. The American author Washington Irving (1783–1859) lived there in the Sultan's chambers while writing his book *Tales of the Alhambra*.

We were walking down the street that ran along the Darro River, where we noticed a lovely house with a second-floor window. It was open and the lace curtains were gently blowing in the breeze. On the windowsill was a flower box filled with lovely flowers, and to the left was a wrought-iron balcony with two potted plants seeking their daily ration of sun. I thought, what an interesting scene and so typical of the city. I must make it into a painting. Because Spain is known for its wrought-iron balconies and beautiful lacework, it was appropriate to name this painting *Spanish Lace*.

Cast Shadows
After drawing the scene and because there were no large washes in this painting, I decided to paint the cast shadows first.

Lace Curtains
I very carefully applied masking fluid to the curtains. When it was dry, I painted a light wash over them and removed the mask.

The Flower Box
Next, I masked out the small flowers overhanging the front of the flower box and painted the box using a no. 8 round with diluted Payne's Gray.

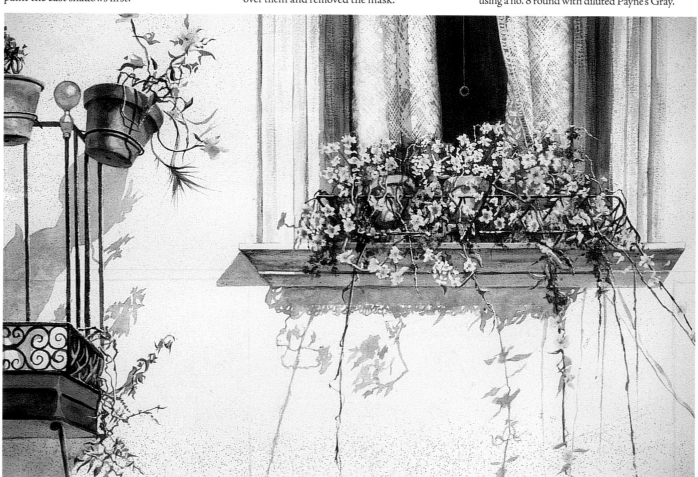

Spanish Lace
Watercolor on paper, 21" × 29" (53cm × 74cm)
Collection of Stephen and Susan Bonio

The Flowers, Pots and Branches
I removed the masking fluid from the flowers and painted the centers Cadmium Yellow Medium with a no. 2 round, then used the same brush to add in some pinks with diluted Alizarin Crimson. The branches are different values of mixed Payne's Gray and Raw Sienna; I used a no. 4 round for the greenery and a no. 2 round for the stems.

I painted the pots using a no. 6 round and Burnt Sienna, then developed the colors in the flowers with a little Cadmium Red. Finally, I finished the painting by painting the wrought iron porch with a dark Payne's Gray and a no. 2 round.

Painting Small Flowers

Patty's Flowers is the kind of no-nonsense watercolor painting that is both fun to do and an extremely popular subject. For a beginner, this type of painting is very likely to produce a sale. From a commercial standpoint, it has a nice subtle color scheme that will fit many decors.

Painting Procedure

1 Make Your Sketch

I sketched in the major components of the painting—the five flowers with petals, the sharp leaves and branches in the foreground, the soft leaves to the left, and the ball-like flowers in that same area. The reason for five flowers is because whether you are painting flowers or seagulls, an uneven number is better than an even of anything. Don't ask me why, but it is. Of course, if you're painting a portrait of a family with six kids, you can't leave one out.

2 Initial Colors

I applied masking fluid to most of the flower petals. Then, with the fluid, I spattered in a few small flowers at the top. After it was dry, I soaked it in water for a few minutes. I put it down on my drawing board and washed in the whole background.

3 Flowers

I lifted out the small round flowers and then, while the background was still wet, put in the soft dark leaves. I sprinkled a little salt in the top center and lower left corner.

4 Additional Flowers

When everything was dry, I removed all the masks and painted the pinkish peachy flowers. I painted the center white flower that's in shadow with a light muted grayish color, being careful to leave the pure white corners of the flower where the light is striking. After I added the sharp-edged leaves and branches, I spattered some gray in a few places. Done!

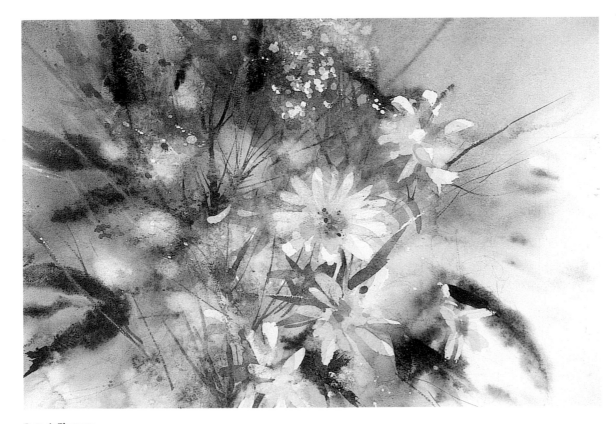

Patty's Flowers
Watercolor on paper, 10½" × 14" (27cm × 36cm)
Collection of Lou and Patty Marotta

Capturing Lots of Flowers

For a person who loves flowers as much as I do, a trip to the flower district in New York City is a treat. Many of the shops sell both wholesale and retail and the prices are good. This was painted on the first sunny day of April about twenty years ago in a somewhat looser style than I paint today.

Adding the figure of the woman selecting flowers on the busy street gives the viewer a peek at the softer side of the city. Without the figure, it would be just another street scene. She brings life and meaning to the painting.

Painting Procedure

1 Masking

After making my drawing, I applied masking fluid to the tree trunks, flowers, figure and lettering on the signs and awning. I then brushed a light gray and violet mixture into the background buildings and signs. I knew these light washes would act as an underpainting to balance the darker washes I'd add later.

2 Dark Washes

I added a dark wash to the underside of the awning, across the masked-out lettering and down the side of the stand and doorway, as well as developing the street area on the left. Then I put a lighter wash over the same mixture on the sidewalk. I detailed the area and, when that dried, put masking fluid on the tree pots.

3 More Color

I developed the sidewalk with stronger browns, blues, grays and siennas for a variety of color. Then I wet the area underneath the awning and dripped paint onto it, which blended the colors nicely. I added the stripes, concentrating on how the canopy should drape loosely over the side of the frame.

4 Trees

I dabbed the tree areas with various mixtures of Raw Sienna, blue and gray for a variety of tones. It's important to put down the whole mass of trees before painting them individually in order to suggest the overall texture. After spattering more tones and defining some of the trees' edges, I applied the accents to the sidewalk. When it dried I removed the masks.

5 Finishing

I kept the shadows of the street sign and the tree pots different in color and shape. I painted the shadow sides of the tree trunks and spattered. I then sponged in bright colors for the flowers. I scraped highlights on the dark sidewalk using my razor blade. The woman was added last.

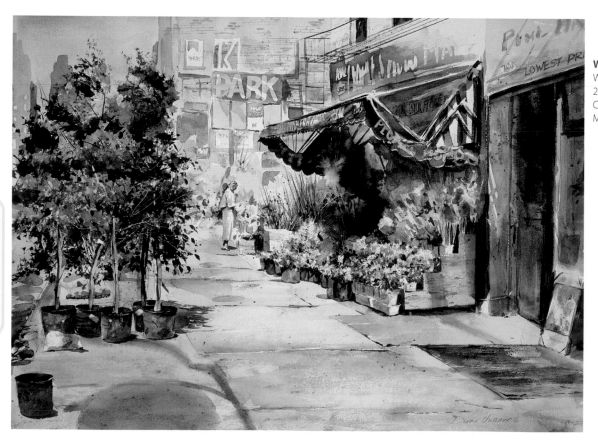

Winter's Over
Watercolor on paper,
21" × 29" (53cm × 74cm)
Collection of Ronnie and
Mike Rybeck

Flowers

Adding Flowers

In this lesson, not only will you learn the impact of flowers in a painting; I will show you how you can paint the same subject in two different ways. As I mentioned earlier I have painted this lighthouse many times, and I thought it would be a good idea to show you another version and open your eyes to the possibilities that exist in one's subject.

Before you can paint the lighthouse, however, you've got to draw it. Tape your paper to the drawing board and use your T-square and triangle to square it with the board. Lightly sketch the major components of the painting—the lighthouse, keeper's house, clouds and patches of flowers and grass. Tape a piece of tracing paper to a second board and make a careful drawing of the lighthouse and keeper's house. Place the drawing on top of your watercolor paper and tape the top edge of the drawing to your drawing board. Then, using the transfer paper, trace your drawing onto the designated spot. When you are finished, don't pull the tracing paper off—make a hinge and tape it over the back so you can retrace it later on, if necessary.

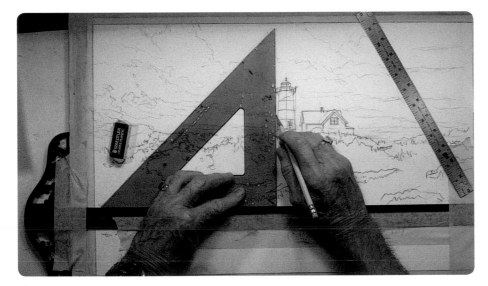

1 Refine Your Drawing

Tape your T-square directly to the drawing board to secure it, then draw a vertical line from the top center of the lighthouse down to its base with your triangle. Measure the distance from each side to the vertical line. They should be identical. Draw two more vertical lines, one from each side of the lighthouse base, to designate the perimeter of the railing Make sure to draw the keeper's house with the same care, as well as making your pencil lines dark enough to see through masking tape.

Finish the rest of your drawing by further defining the cloud formations, dunes and flowers.

Materials List

22" × 15" (56cm × 38cm) 140-lb. (300gsm) cold-press Arches
Drawing board
No. 2 HB pencil
Tracing paper
Transfer paper
Masking fluid
1-inch (38mm) and 2-inch (5cm) masking tape
Newspaper
Plastic wrap
Plastic eraser
Soap
Rubber cement pickup
No. 10 craft knife
Kosher Salt
T-square
Triangle

PAINTS
Alizarin Crimson
Burnt Sienna
Burnt Umber
Cerulean Blue
Payne's Gray
Pro-White
Raw Sienna
Winsor Violet

BRUSHES
1-inch (25mm) flat
1¼-inch (31mm) flat
No. 1 round
No. 2 round
No. 4 round
No. 6 round

SECRET
Keep Your Colors Clean

Here's a tip for mixing white with another color: Take some white from the jar with a clean brush and put it on a scrap of paper. Then, with another clean brush, take the other color off your palette and mix them on the scrap. This way, you can work from the paper and avoid contaminating any of the colors on your palette.

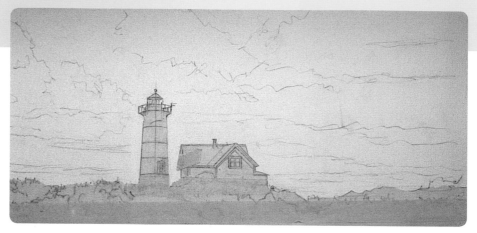

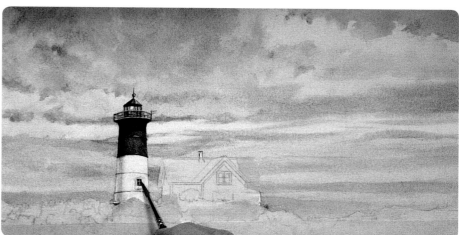

2 Mask the Lighthouse and Dunes

Tape two or three overlapping layers of masking tape to your painting, covering the lighthouse and dune area, then cover the remaining area with newspaper and tape it down. Now, take your no. 10 craft knife and install a new blade. Very carefully cut your mask, leaving the lighthouse and dune area covered. If need be, you can use a steel ruler for cutting the straight edges.

3 Paint the Sky and Lighthouse

Cover the whole sky area with clear water using your 1¼-inch (31mm) flat. Load the same brush with diluted Cerulean Blue and start painting the sky with long sweeping motions, going left to right, over the lighthouse and keeper's masks. Design the clouds as you go and leave plenty of white in them. While the sky is still damp, lift out a nice long streak behind the lighthouse with the chisel point of your 1-inch (25mm) flat.

Remove the mask from the lighthouse. Paint the shadow side of the bottom using your no. 4 round with Cerulean Blue and Payne's Gray. Lift out the shadow on the left side to suggest reflected light and add a little Raw Sienna to it. Mask the white part of the lighthouse with tape on the seam at the bottom and the railing at the top. Paint the top part of the lighthouse with Alizarin Crimson using a no. 4 round. Paint the shadows with a darker mixture of Alizarin Crimson and Winsor Violet, and paint the seams with the same mix using a no. 1 round.

Using the same brush, paint the seam and window with a little Payne's Gray. Make sure the seams are curved. Finish the top with a no. 1 round and Payne's Gray.

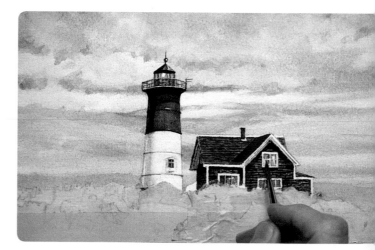

4 Paint the Keeper's House

Remove the tape from the house and mask off the windows with masking fluid. Use your no. 6 round with Burnt Umber to paint the cedar shingles. Paint the roof with the same brush, using Alizarin Crimson. Then with your no. 2 round and Burnt Sienna, paint the chimney. Now remove the mask from the windows and paint them with a light wash of Payne's Gray using your no. 2 round.

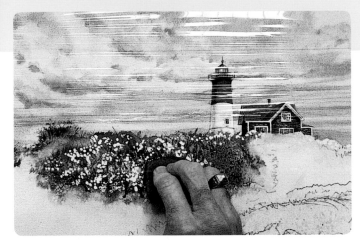

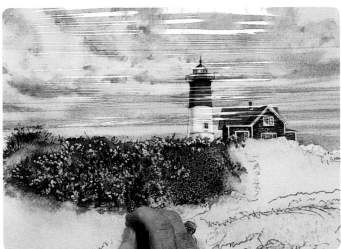

5 Paint the Dune Grass

Mask the sky with plastic wrap. Dip your no. 2 round in soap, then load it with masking fluid. Tap it against the handle of a bigger brush and gently spatter the dune. With your 1-inch (25mm) flat lay down a wash of plain water over the same area, then wash a mix of dark Payne's Gray and Raw Sienna onto the wet paper. While it's still wet, sprinkle a little kosher salt into the wash for added texture. Add some dune grass with your no. 2 round using the fan method with the same colors mixed to a darker hue.

Stipple some patches of Pro-White into the dune using your sponge. If it's too thick, add a little water to it. Let it dry, then remove the mask that's left with your rubber cement pickup.

6 Paint the Pink Flowers

Now, make most of the white spots in the foliage pink by adding a little Alizarin Crimson to them with your no. 2 round. Be sure to leave some spots white.

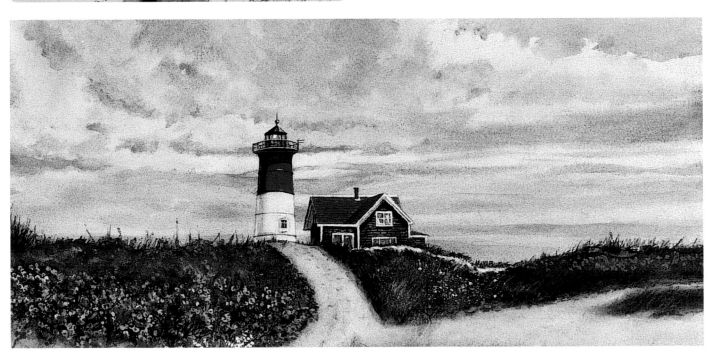

Lighthouse with Flowers
Watercolor on paper, 10" × 21" (25cm × 53cm)
Collection of the artist

7 Paint the Remaining Dunes

Finish up by painting the dunes that don't have either grass or flowers with Raw Sienna and Payne's Gray. They require very little modeling. Do some limited spattering and add a little salt for texture.

Flowers

Painting Light and Roses

Sometimes you have to search for subjects to paint, and other times it just happens. One lovely May morning, as I was driving around Truro, Massachusetts, looking for something special, I turned the corner onto a road I'd been on dozens of times before. That particular morning, however, something was different. A brilliant morning light was casting a strong shadow on this ordinary house with a broken fence and a rambling rosebush. The lighting took it from ordinary to precious. This was how *A Rose Is a Rose* came to be.

The original painting is on a 14" × 21" (36cm × 53cm) 140-lb. (300gsm) sheet of Arches cold-press, but since we're only painting a small portion of it, you could use a piece of paper as small as 8" × 10" (20cm × 25cm).

Materials

8" × 10" (20cm × 25cm) 140-lb. (300 gsm)
cold-press Arches
Drawing board
No. 2 HB pencil
Natural sponge
Tracing paper
Transfer paper
Masking fluid
2-inch (5cm) masking tape
Plastic eraser
Rubber cement pickup
Razor blade
No. 10 craft knife
T-square
Triangle

PAINTS
Burnt Sienna
Burnt Umber
Cadmium Yellow Medium
Cerulean Blue
Naples Yellow
Payne's Gray
Permanent Rose
Raw Sienna
Winsor Violet

BRUSHES
No. 1 round
No. 2 round
No. 4 round
No. 6 round
No. 8 round

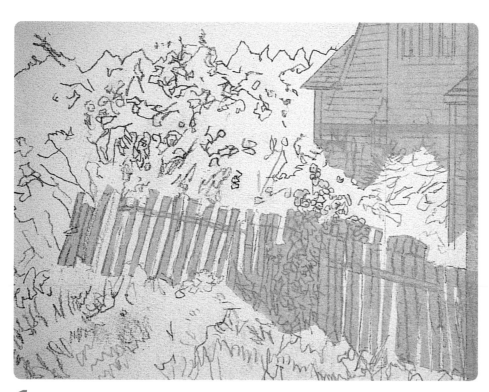

1 Make Your Drawing and Cut Masks

As usual, make your drawing on tracing paper, square it up on your board with a T-square and triangle and transfer it to your watercolor paper. Once the drawing is ready, cut masks for the house and fence. Mask out the roses with masking fluid.

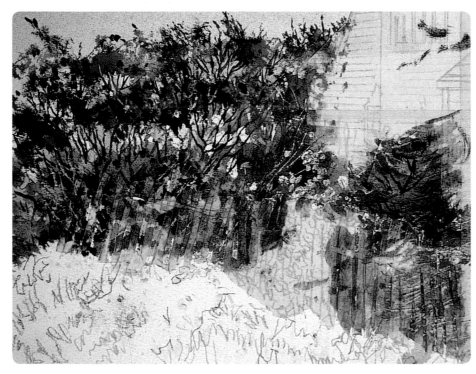

2 Lay in the Sky, Bushes and Trees
Paint the sky using your no. 8 round and Cerulean Blue. Using both the same brush and your sponge, lay in the background trees using Raw Sienna, Burnt Sienna, Cadmium Yellow Medium, Cerulean Blue, Burnt Umber and Payne's Gray.

Paint the small trees in front of the house with Winsor Violet, Burnt Sienna, Raw Sienna and Payne's Gray using your no. 6 round. Don't forget the spaces behind the fence.

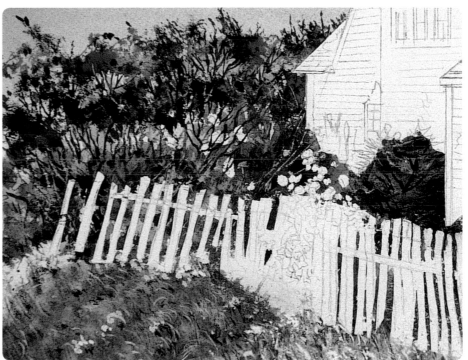

3 Paint the Foreground Grass and Weeds
With your no. 4 round and using Raw Sienna, Burnt Sienna and a little Naples Yellow, paint the yellow foreground grass on the right. When dry, scratch out a few blades of grass with the corner of your razor blade. Now, paint the shadow area to the left with Winsor Violet, Payne's Gray and Raw Sienna.

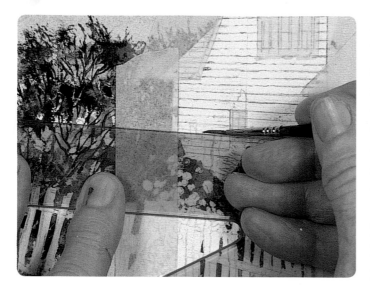

4 Paint the Shingles

Remove all masks, then re-mask the area around the house and the windows and frames with masking tape. Holding a no. 1 round loaded with diluted Burnt Sienna almost parallel to the paper, paint the house shingles one row at a time using your triangle for a guide. Don't try to make them perfect. Make them a little wavy and skip here and there. This is not as difficult as it looks. The trick is to keep the brush very dry and without much paint on it.

Keep the brush dry and pointed by constantly rolling it between your fingers while dragging it across some scrap paper. Remember that the lines aren't supposed to be perfect, so if you make a little blob or something it doesn't matter.

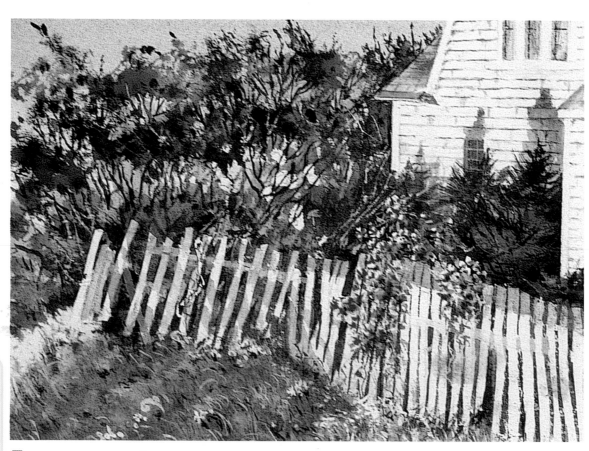

A Rose Is a Rose
Watercolor on paper,
14" × 21" (36cm × 53cm)
Collection of
Paul Gundlach

5 Paint the House, Trees, Fence and Roses

Remove all tape masks, then re-mask the roses with masking fluid. Paint the roofs with diluted Burnt Sienna, the windows with Cerulean Blue and the cast shadows with Winsor Violet using the same no. 2 round for all of them. Next, finish the small trees in front of the house with a no. 1 round using Raw Sienna, Payne's Gray and a dab of Burnt Sienna. Use Cerulean Blue and Payne's Gray and paint the cast shadows on the fence with your no. 6 round. Now, remove the masking fluid from the roses and finish the painting by painting the roses with (what else?) Permanent Rose using your no. 1 round.

Trees & Grass

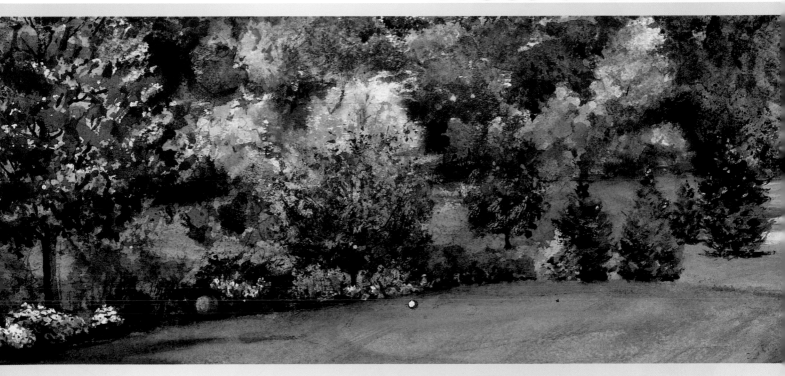

Blooming Trees

During springtime in Central Park, New York City, the cherry trees are in full bloom. The park is always lovely, but in the spring, it's spectacular. On this particular day, I was walking through the park near the Museum of Natural History when I saw a girl sitting on a huge rock reading a book. I suppose she was a student at Columbia University, considering its proximity to the park. What a way to enjoy the park and get your assignment done at the same time!

Painting Procedure

1 Sky

I laid in the sky with blue, going right down to the grass and rocks over the trees and buildings. (I knew I could get away with this because of my advance planning; I knew the buildings were going to be dark and the tree blossoms opaque, so this first layer of paint would not affect them).

2 Grass and Rocks

I washed in the grass, accentuated the white spots in the foreground and established the rocks. I then dry-brushed the grass in the rock crevices.

3 Trees and Buildings

I laid in the background trees on the left with a yellow and blue mixture. With the same brush, using appropriate colors, I then painted the buildings.

4 Additional Trees and Blossoms

I put in the tree trunks and branches using different brushes for each. I then mixed up a huge amount of crimson and white for the blossoms. I applied these switching among a brush, a sponge and the crumpled paper technique.

5 Figure

The figure was the last object to be painted. I painted the jeans with a pale blue mixture, the hair and face with Burnt Umber, and the sweater with red. Done!

Trees & Grass

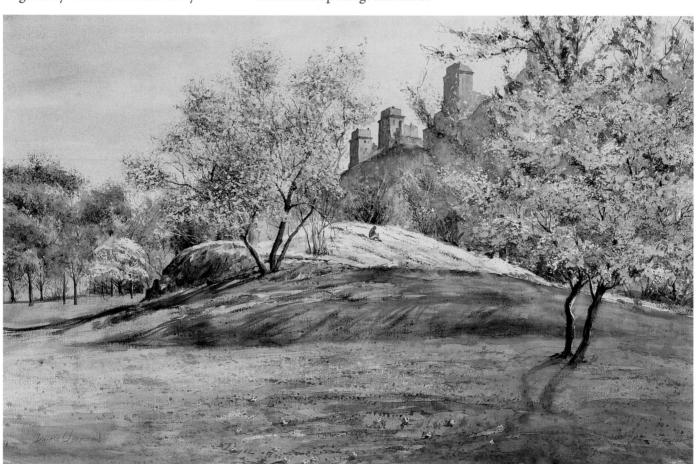

Day in the Park
Watercolor on paper, 24" × 39" (61cm × 99cm) Collection of the artist

Autumn Trees and Grass

The goal of this painting was to capture the stunning hues of autumn and depict the bright fall sunlight playing on the golden marsh grass. In order to accomplish this, I knew I had to establish a sharp contrast between the warm trees and the cool marsh. I wanted to keep the pine trees a cool dark mass and the grass a warm light mass. The water, of course, would be a cool blue with the added interest of the water lilies on the left. The sky is the palest of blues, almost colorless. I thought there was enough going on elsewhere in the painting that the color of the sky needn't be too prominent.

Painting Procedure

1 Sky

I used a very pale blue and then added one tiny cloud on the far right for balance.

2 Water and Marshes

I painted the water after masking out the lily pads with thinned masking fluid, leaving plenty of white paper. I used a pale yellow for the light golden marshes beneath the hill in the background, and made sure to leave some white paper.

3 Foreground Marshes

For the golden foreground marshes in the mid-left and front, I used a mixture of deep yellow and siennas.

4 Grass

I painted the clumps of grass in the mid- and foreground pond with sienna and umber.

5 Tree Branches

I first wet the area behind the sky with pure water and painted the dark tree branches into the wet sky. While it was still wet, I modeled some of the branches with a sponge. I kept the right side of the bushes lighter to honor the light source.

6 Lily Pads

I removed the masks and painted the lily pads and lilies.

7 Ripples and Highlights

I modeled the water ripples with a dark blue. To finish up, I took the broad side of a razor blade and scraped the water where the sun caught some ripples.

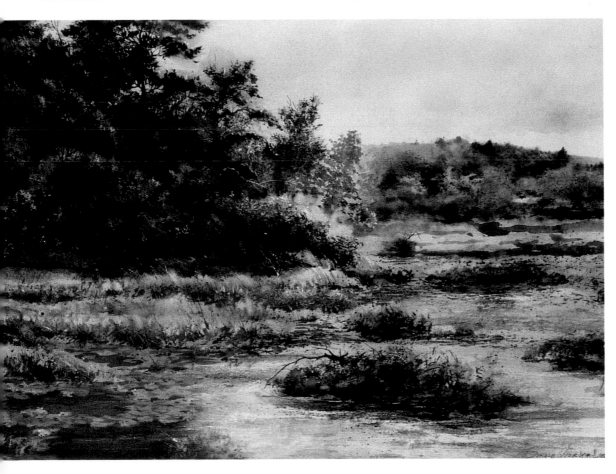

A Roadside Lake Somewhere in New England
Watercolor on paper,
21" × 28" (53cm × 71cm)
Private collection

Trees and Grass

Beacon Hill Country Club is about a mile from where I live on the central New Jersey shore. I was commissioned by the Board of Trustees to do a painting of one of the most scenic holes on the course. There was never any question as to which one should be painted. It had to be the fifth—with its magnificent vista, brilliant fall colors and the New York skyline in the background. What more could a painter ask for?

Because of the proximity of the course to my home, I was able to head there any time I needed a reference in person. One of the pitfalls of painting outside is the constantly changing light, so I established the time of day that was most conducive to my project before beginning.

I shot a roll of film from various angles to use as handy reference material for the painting. I carefully analyzed each resulting slide to determine which spot gave me the best vantage point from which to start the painting. In addition to setting up my easel in the best location to achieve my goal, it was necessary to take into consideration what would be least disturbing to the players.

Reference Photos

Materials

22" × 30" (56cm × 76cm) 140-lb. (300gsm)
cold-press Arches
Drawing board
No. 2 HB pencil
Natural sponge
Masking tape
Plastic eraser
T-square

PAINTS
Alizarin Crimson
Burnt Sienna
Burnt Umber
Cadmium Red
Cadmium Yellow Deep
Cerulean Blue
Naples Yellow
Payne's Gray
Pro-White
Raw Sienna
Ultramarine Blue

BRUSHES
1¼-inch (31mm) flat
1-inch (25mm) flat
No. 1 round
No. 6 round

1 Draw the Scene and Paint the Sky and Buildings
Draw in the horizon line using a T-square and HB pencil. Lightly sketch the approximate placing of the skyline and the trees whose tops extend over the horizon line. Next, sketch in the foreground trees, grass, flowers and golf course.

Use masking tape to shield the background buildings and tops of trees. Mix a batch of Cerulean Blue and Pro-White, making it light enough for a crisp blue sky but dark enough to show contrast with white clouds. Wet the sky, then use a 1¼-inch (31mm) longhair flat to cover the sky with the blue mixture with long, horizontal strokes. When dry, use the chisel edge of a damp 1-inch (25mm) flat to lift color out where you want clouds using the thirsty brush method. Paint the buildings with a no. 1 round with mostly Cerulean Blue and a little Alizarin Crimson.

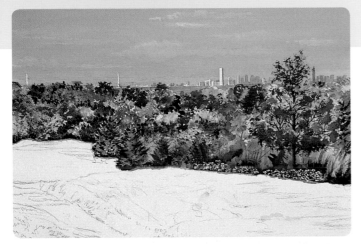

2 Color the Trees and Bushes

Mask out all the grass from the far left fairway across the putting green, the spruce trees and along the grass line to the far right. Also cover the areas where the flowers and reeds are going to be.

Now, premix several different batches of color. Make a green with Ultramarine Blue and Cadmium Yellow Deep, and another with Payne's Gray and Raw Sienna. Prepare two reds, one Cadmium Red with a touch of Alizarin Crimson and the other just the opposite. You'll also need a batch of plain Naples Yellow, plain Raw Sienna and an orange made from Cadmium Yellow Deep and a touch of Alizarin Crimson.

Cut a new sponge into several small pieces. Working left to right and alternating between the sponges and a no. 6 round, add the trees. When you paint the large red maple on the right, be careful to leave open areas to show some branches. Remove the masks and paint the rest of the foliage using the no. 6 pointed round and the appropriate color.

Detail of the Grass and Cart Path

3 Add the Grass and Detail the Golf Course

When the paper has dried, mask out the trees and sand bunkers with masking tape. Paint the fairway with a blue-green mixture of Cadmium Yellow Deep and Cerulean Blue using a 1¼-inch (31mm) flat. Use the same brush and colors for the tee and putting green; lighten the mixture for the putting green by adding more yellow, and darken it for the tee by adding more blue. Be sure to make some suggestion of mower marks in the grass on the tee. Paint the men's tee the same way, and add some shadows throughout with Payne's Gray.

Add the heavier grass at the edge of the tee and the mound on the left using stipple and spatter techniques to create the thicker texture. Paint the cart path last using Burnt Umber and a little Burnt Sienna.

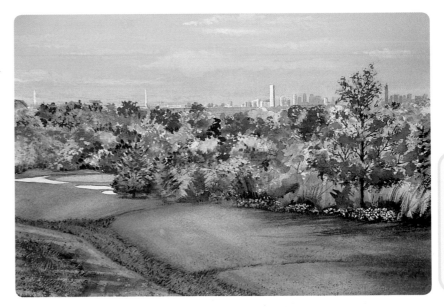

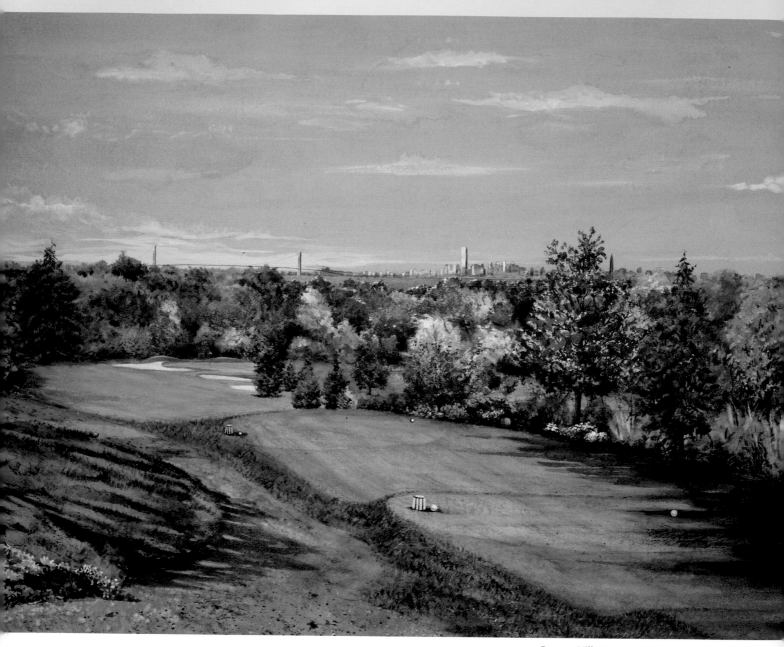

Beacon Hill Country Club
Watercolor on paper, 21" × 29" (53cm × 74cm)
Collection of the Beacon Hill Country Club

Artist Knows Best

This painting took me about two weeks to complete. My work routine went something like this: I'd go to the golf course around one in the afternoon and work until I started to lose the light, maybe four or five p.m. It was late October into early November, not exactly the prime golfing season. The following morning I'd work on it for a couple of hours, refining the previous day's work.

When the painting was almost completed, I wanted some feedback. I called my friend Chuck Snoddy, who was a member at Beacon Hill, and asked him to have a look. When he came over I put the painting on an easel and he stared at it for several minutes.

Finally, he said, "There's a tree missing." My artistic arrogance replied, "You look at it for ten minutes and all you can find wrong is a (expletive) missing tree."

He went on to explain that it was an important tree—the players used it to gauge their distance. This sounded reasonable to me, so the next day I gathered my gear and headed back to the course to add the tree.

Would you believe that the next time I went over the tree was cut down due to a course renovation program taking place over the winter?! The next time I saw my friend I told him I was psychic.

Dunes

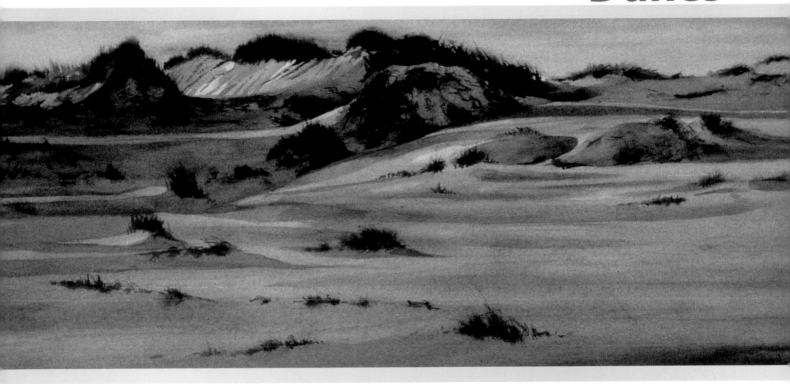

The Allure of the Dunes

In the early 1930s and 40s, a number of these dune shacks were constructed of driftwood and other scavenged materials. They were built and inhabited by so-called "squatters" who would live in them for a few weeks, months or even years. Eventually, the squatters rented them out to artists and writers who wanted to get away from civilization and pursue their creativity in the solitude provided by these hideaways.

These people were poets (E.E. Cummings, 1894–1962 and Harry Kemp, 1883–1960); writers (Jack Kerouac, 1922–1969 and Norman Mailer, 1923–); playwrights (Eugene O'Neill, 1888–1953); and painters (Jackson Pollack, 1912–1956).

Art Costa has been a Provincetown, Massachusetts, dune guide since 1946. He has been my guide many times and regaled me with his stories about people he has transported over the years. Some of them went out in the early spring or summer and weren't picked up for several months. Can you imagine waking up in the morning, going outside and all you can see for miles and miles are dunes and water?

This was a very spontaneously painted watercolor. Every part was done free and quickly with the exception of the shack, which was drawn and painted meticulously.

Painting Procedure

1 Sky

After masking for the building and flag, I wet the entire sky with water, going back two or three times to ensure it was soaking wet. I painted gray and blue onto the paper and let them mingle.

2 Dunes

I painted the lower, forefront dunes with a sienna, violet and crimson mixture. The grassy dunes came next. I used the same technique as the sky, washing in violet, crimson, blue, and gray among others and let them mix on the paper.

3 Grasses

When the dunes dried, I painted the very dark grasses using the fan method, supplementing it with single strokes of a small round brush.

4 Building

After adding the flowers, I finished up by painting the building very carefully with the same small brush, using a red and sienna mixture for the front and blue-gray mixture for the roof.

SECRET
Paper Tooth

Some watercolorists think you have to paint on the side of the paper that shows the watermark. This is true if you want a slightly rougher texture. Occasionally, as with this one, I chose to use the back. The "tooth" is a little less pronounced, giving you a slightly smoother surface. Many a good painting has been done on the back of a stinker.

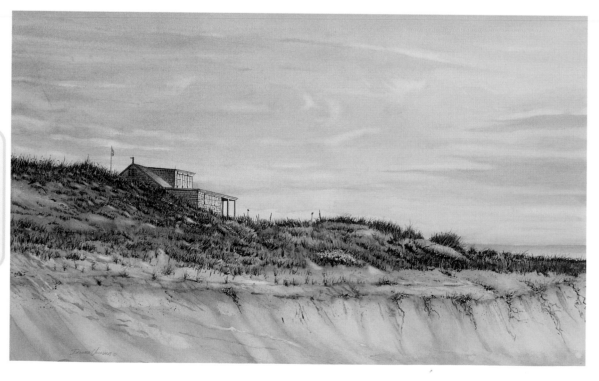

Secluded
Watercolor on paper
24" × 39" (61cm × 99cm)
Collection of the artist

Dunes

Creating All the Elements

The Fort Ord Dunes are about five miles north of Monterey, California. Fort Ord was an important military base from 1917 until 1994, when it was closed. It is now a state park.

Since I wanted to make this painting bigger than the normal imperial size, 22" × 30" (56cm × 76cm), I selected a double elephant sheet (25" × 40" [64cm × 102cm]) and trimmed it down a bit.

The first thing I did after making my drawing was to stipple the shells on the beach with masking fluid. I also masked the pilings and the seagull in front of the cypress tree with it. I didn't mask the tree because I knew it was going to be darker than the water.

Painting Procedure

1 Sky

I wet the sky down a couple of times with water, then with a big flat brush, washed in the sky colors, being careful to save the white cloud over the tree.

2 Beach

I gave the beach a wash of primarily Burnt Sienna and dried it with a hair dryer. I removed the shell masks and gave the beach a second coat of the same color, right over the shells, blending in with the sand and keeping them from becoming too apparent.

3 Water

I painted the background water, running the washes right over the tree, then painted the foreground water.

4 Grasses

After wetting the whole area on the right behind the dune grass with plain water, I painted the dark dune grass, allowing the washes to bleed into the background.

5 Foliage

Here, after wetting the area behind the tree with plain water, I painted the green tree foliage into it and let it bleed. I then added some very dark accents to the foliage while it was still wet. I dried it with my hair dryer, then painted the branches.

6 Details

I painted the wooden jetty, pilings and the wooden fence behind the tree with a small brush.

7 Gulls

I removed the masks from the gulls and painted them.

8 Highlights

Lastly, I used the corner of a razor blade to pick out small highlights on the tree, rocks, pilings, foreground water, fence and dune grass.

SECRET
When to Exercise Control

There are many instances where you can spatter and achieve the effect you're looking for, but it's important to recognize when more control is needed.

Control was necessary for painting these shells. They were washed up in a cove in a horseshoe-shaped pattern, which required much more precision to capture accurately. You must determine which method will do the job and proceed. In this case, stippling filled the bill. It was more work, but it came out just the way I wanted!

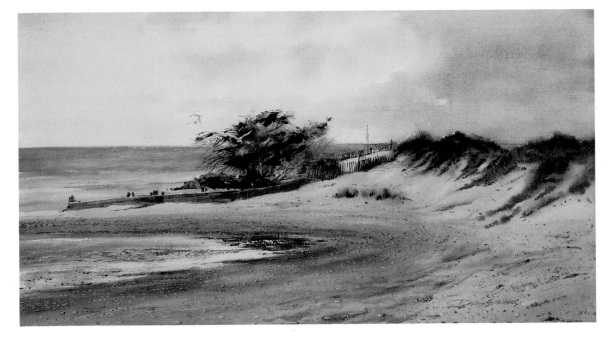

Sheltered Cove
Watercolor on paper,
18" × 33"
(46cm × 84cm)
Collection of
Dr. and Mrs. Saul Brody

Dunes

Cliffs of Many Colors

The Aquinnah Cliffs are on the most western corner of Martha's Vineyard island in Massachusetts. The 150-foot limestone cliffs were formed by glaciers over millions of years. Geologists tell us that sometime during this period the island was under water, and little sea creatures died and left their shells to form the light layers. At other times it was a rain forest and large plants, falling because of their weight, created the darker colors. The tremendous weight of the glaciers pushed the stone up at such an angle as to create the colorful cliffs.

Materials

10" × 12" (25cm × 36cm) 140-lb. (300gsm) cold-press Arches
Drawing board
No. 2 HB pencil
Tracing paper
Transfer paper
2-inch (5cm) and ¾-inch (2cm) masking tape
Plastic wrap
Plastic eraser
No. 10 craft knife
T-square
Triangle

PAINTS
Burnt Sienna
Burnt Umber
Cadmium Yellow Deep
Cerulean Blue
Pro-White
Raw Sienna
Ultramarine Blue
Winsor Violet

BRUSHES
1-inch (25mm) flat
No. 1 round
No. 2 round
No. 4 round
No. 8 round

1 Make Your Drawing and Paint the Sky
Make your drawing on tracing paper and transfer it to your watercolor paper. Use your T-square and triangle to square up the lighthouse and the horizon line. Lay 2-inch (5cm) masking

tape from the top of the lighthouse down, then mask everything except the sky, making sure the pencil lines can be seen.

Wet the sky area with water. Start at the top and working from left to right with your 1-inch (25mm) flat, brush in a heavy Ultramarine Blue. Halfway down, after a quick rinse, add a little Cerulean Blue. Across the bottom of the sky, add a light band of Winsor Violet. When dry, with the same tool using the thirsty brush method, lift out some streaky clouds.

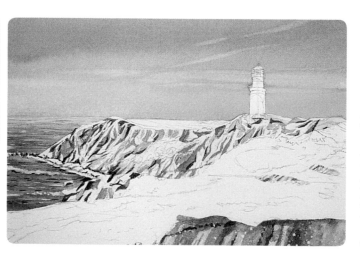

2 Paint the Water and Cliffs
Cut away only the water portion of the mask with a craft knife. Mask out the sky with 2-inch (5cm) tape. With your no. 8 round charged with Ultramarine Blue, paint the water in swift horizontal strokes. While it's still wet, pull out a few waves using a 1-inch (25mm) flat and the thirsty brush technique. When dry, paint a few small dark lines with Ultramarine Blue to suggest small waves using a no. 1 round.

With the sky mask still in place, mix up a little Cerulean Blue and Pro-White then brush a band of it across the horizon line to make the water recede in the distance.

Cut and remove the mask covering the cliffs with your craft knife, leaving only the grass areas covered. With a no. 2 round, paint the cliffs one area at a time with Winsor Violet, Raw Sienna, Burnt Sienna, Burnt Umber, Cerulean Blue and a little Ultramarine Blue. When you get to the foreground cliff use darker values of the same colors.

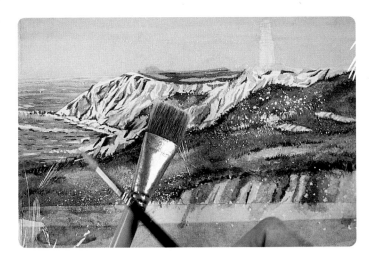

Of course you could always stipple flowers into your paintings, but a much better way is to use the controlled spatter: It lets you let the paint go where it wants, but within an area of your choosing. Ed Whitney illustrated it this way: "Take two coils of rope and cast one on the floor, then arrange the other. In a design contest the arranged one will always lose."

3 Paint the Grass and Flowers

Before you begin, cut two masks for the small patches of stone peeking through the grass and make a mixture of Cadmium Yellow Deep and Ultramarine Blue for your basic grass color. With your no. 2 round, use this mix to paint the small patch of grass in the background, first with a light shade. Let it dry, then make a darker value.

This painting needed more interest in the grass area, so I decided to add a cluster or two of flowers with a "controlled spatter" method. Spread a piece of plastic wrap across your painting. With your craft knife and using very light pressure, cut an oval shape out of the two places where you want flowers. You are now able to see where you are spattering. Use your no. 1 round and lightly spatter a mix of Pro-White with a smidgen of Cerulean Blue into the foreground area. Using only Pro-White, repeat in the other area. You may want to refine the shapes of the flowers a little and add some Raw Sienna centers after they have dried. Now you can remove the two masks on the stone patches and paint them with very pale Burnt Umber using a no. 4 round.

Aquinnah Cliffs
Watercolor on paper,
10" × 14"
(25cm × 36cm)
Collection of
Valerie Schauer

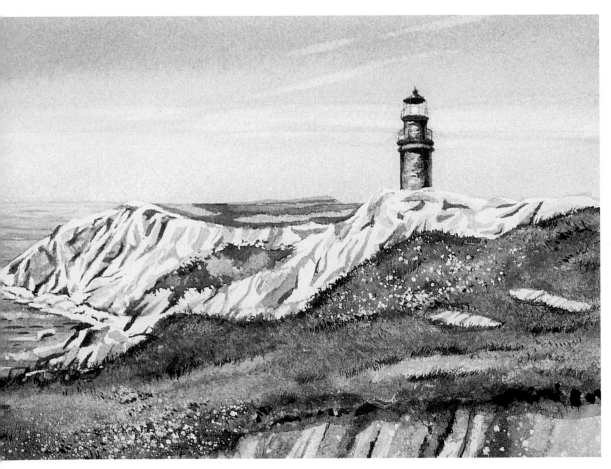

Light Patterns on Sand Dunes

I have been painting dunes for over twenty-five years, and I hope to share what I have learned with you. I'm so taken by their magnificent shapes and the fact that they are constantly changing. Years ago, when I first went to Cape Cod, Massachusetts, the dunes were rapidly eroding and there was no grass to thwart it. However, in subsequent years the National Park Service planted grass to preserve this national treasure. I used to get up at 4 A.M. to be out there by sunrise. No two dunes are ever alike, so they provided sufficient material and new inspiration every time.

Materials

10" × 12" (25cm × 30cm) 140-lb. (300gsm) cold-press Arches
No. 2 HB pencil
Tracing paper
Transfer paper
Hair dryer
Masking fluid
Plastic eraser
Soap
Rubber cement pickup
Kosher salt

PAINTS
Alizarin Crimson
Burnt Sienna
Burnt Umber
Cerulean Blue
Payne's Gray
Raw Sienna
Ultramarine Blue
Winsor Violet

BRUSHES
1¼-inch (31mm) flat
No. 2 round
No. 8 round
No. 12 round

1 Draw the Scene and Lay in the Underpainting

Capture the basic shapes on tracing paper, then transfer your drawing to your watercolor paper using the transfer paper. Create a light mix of Alizarin Crimson, Winsor Violet and Burnt Umber, then wash in the lower left area with a no. 12 round. Darken the mixture with more Burnt Umber and apply it to the upper left area. Add some Burnt Sienna to the lower right and also to the upper right of the area, then lay in a mixture of Winsor Violet and a touch of Alizarin Crimson over it.

Lay down a wash of clear water, then, one at a time, wash in Winsor Violet, Raw Sienna and Cerulean Blue wet-into-wet over the dunes using a no. 12 round. Re-wet as many times as necessary. Lay in an initial wash of Payne's Gray, Ultramarine Blue and Alizarin Crimson.

2 Refine the Shapes

Intensify the colors, leaving unpainted areas for the white sand. With a no. 8 round, define the shapes with Raw and Burnt Sienna.

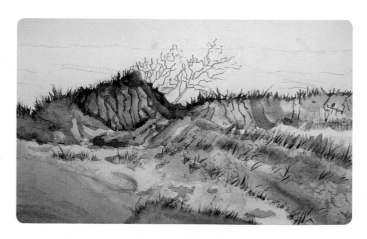

With a no. 12 round, lay in a wash of Winsor Violet and Ultramarine Blue over the largest dune, adding a little Burnt Sienna when dry. Dry with your hair dryer and then, with a no. 2 round, paint vines with a dark mixture of Alizarin Crimson and Payne's Gray. Add grasses using the fan method—alternate between the 1¼-inch (31mm) flat and a no. 2 round.

Add the grass blades with a no. 2 round. For texture in the lower right-hand corner, drop in a puddle of light Ultramarine Blue. Sprinkle in a little kosher salt and watch it explode.

3 Add the Trees and Accents

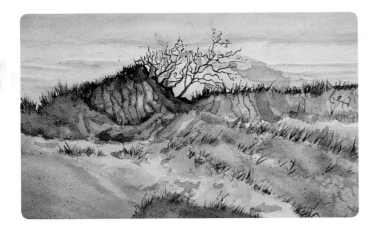

Mix up a puddle of very light Alizarin Crimson and Payne's Gray and lay in a wash in the upper sky with a no. 12 round. Load your no. 2 round with soap, dip it in your masking fluid and put a thin stroke of it across the tops of the small distant clouds in the lower sky. Wash the brush out immediately with soap and water. Once the paper is dry, lay in a wash of extremely light Raw Sienna in the same area with the no. 12 round. Dry and remove the masking fluid with your rubber cement pickup.

Very carefully paint the trees and branches with your no. 2 round loaded with a dark mixture of Payne's Gray and Alizarin Crimson. Now is the time to evaluate your painting and decide what it needs (or doesn't need).

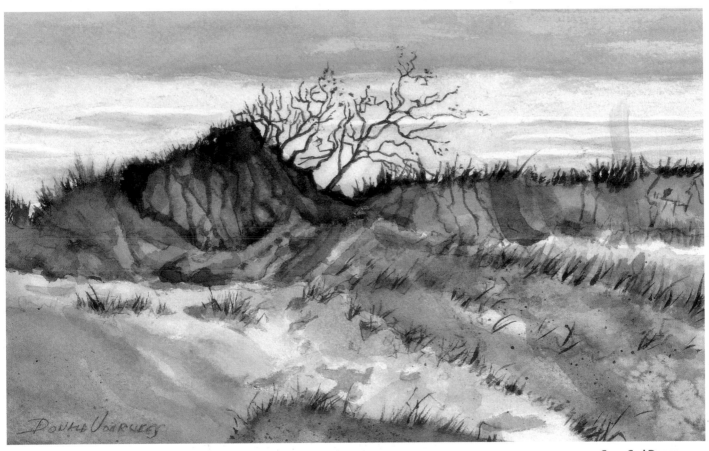

4 Fix the Contrast

Using a no. 12 round, darken the cloud and the large dune on the left with a mixture of Winsor Violet and Payne's Gray. Underneath that dune, use the same brush to add a mixture of Payne's Gray and Burnt Sienna. Wash Payne's Gray over the dune that runs diagonally from the center to the lower right corner with the no. 12 round, then mix the Payne's Gray with some Burnt Sienna and add it to the lower left corner.

Cape Cod Dunes
Watercolor on paper,
14" × 21"
(36cm × 53cm)
Private collection

Improving on a Photographic Reference

Dune paintings tend to be large, probably because, well, dunes are large. However, this painting is small: 10" × 14" (25cm × 36cm). It's a difficult challenge to capture a large subject on a small canvas realistically, getting all the big proportions correct in a small format. And sometimes, you have to adjust the color and other elements to give it just the right composition. This adjusting of your reference photos is a crucial skill to master for painting landscapes.

Materials

8½" × 12" (22cm × 31cm) 140-lb. (300gsm) cold-press Arches
Drawing board
No. 2 HB pencil
Natural Sponge
2-inch (5cm) masking tape
Plastic eraser

PAINTS
Alizarin Crimson
Burnt Sienna
Burnt Umber
Cadmium Yellow Deep
Cerulean Blue
Naples Yellow
Payne's Gray
Raw Sienna
Ultramarine Blue
Winsor Violet

BRUSHES
1¼-inch (31mm) flat
No. 1 round
No. 2 round
No. 6 round
No. 12 round

1 Make Your Drawing and Paint the Sky

Since this is such a simple composition, make your drawing directly on the watercolor paper. This doesn't mean you only need make a slash-dash sketch, but landscapes like this are more forgiving than those with buildings. When this is done, wet the entire sky with plain water using your no. 12 round. About midway down the sky area, wash in light washes of Naples Yellow, Cadmium Yellow Deep and Alizarin Crimson—in that order—and blend them on the paper.

When the wash dries, re-wet the sky and paint a few long, streaky clouds with Payne's Gray and Winsor Violet using your no. 1 round. Once it's dry, wet the sky again and, starting at the top with Winsor Violet, use a swinging horizontal motion with a no. 12 round to paint the dark part of the sky. Change the value and color as you go by adding Cerulean Blue and Payne's Gray and allowing them to blend on the paper. Once it's dried, pull out some light areas using the thirsty brush technique.

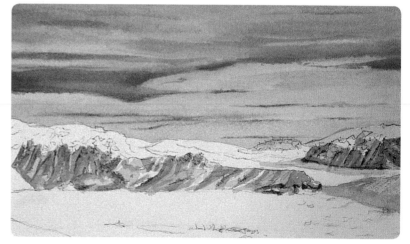

2 Model the Sides of the Dunes

Using a light mixture of Burnt Umber, Raw Sienna and Burnt Sienna, paint the sides of the dunes. Give them dimension and texture using your no. 2 round and short vertical and diagonal strokes. At this point, the painting needs these directional strokes to add more variety. Put in several small, dark strokes to suggest crevices in the sand, and leave plenty of white paper here and there.

There are two little pieces of sand at the far right that have to be painted before you leave this section. Use a little light Burnt Umber and your no. 6 round.

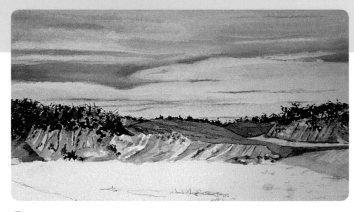

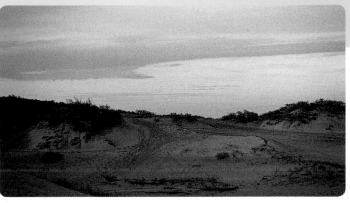

3 Paint the Dark Middle Dunes

Paint the dark hill in the middle area with Winsor Violet and Payne's Gray using your no. 6 round. Paint the trees on the left with Winsor Violet, Payne's Gray and Cerulean Blue using both the no. 1 round and the sponge technique. When using the sponge, protect your sky with a piece of scrap paper.

Before painting the small trees behind the middle and right-hand dunes, cut a mask to cover those dunes out of 2-inch (5cm) masking tape. Then you can safely use a small brush and a small piece of sponge to render the trees without worrying about getting paint on the dunes.

Compare the Painting to the Reference Photo

Sky. I probably followed the sky closer than anything else in the reference. I did make the upper part darker, intensified the blue-violet and gave it more variations. The lower part of the sky was kept somewhat the same as far as the color goes, but I did add some more small, streaky clouds to give it additional interest.

The Dunes. I not only expanded on this area, but I made them lighter and brighter. I made a lot more crevices and increased their prominence to add additional interest, as well as leaving spots of the white paper for variety.

Middle Ground Dunes. Instead of using the drab color shown in the slide, I introduced blue-violet to reflect the sky color and add contrast. I also made the trees more prominent.

Large Foreground Dune. I repeated the same color and added little strips of short dune grass to make it more interesting.

Well, there you have it. A picture is born.

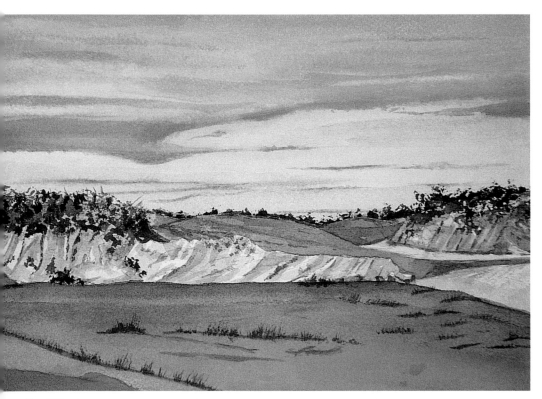

Small Dune
Watercolor on paper, 10" × 14" (25cm × 36cm)
Collection of Paul Gundlach

4 Paint the Large Foreground Dune and Grass

With your 1¼-inch (31mm) flat, lay down a wash of Ultramarine Blue and a little Payne's Gray with a couple of swift horizontal strokes. While it's still wet, work a little Raw Sienna into the wet wash and let it blend on the paper. When that has dried, add the grasses with long strokes of a no. 1 or no. 2 round, then use the fan method to create grass blades. You can alternate this technique by using individual strokes with your no. 1 round.

Dunes in the Summer

The thing that attracted me the most about these wonderful dunes was their beautiful, unique natural shape. Didn't have to do any composition revamping here! The subject matter was just picture-perfect. It was a beautiful summer day, with fluffy clouds in the sky and the dunes bathed in sunlight that defined the subtle undulations of their forms. Thirty-eight miles of unspoiled beach on South Padre Island, located at the very tropical tip of Texas on the Gulf of Mexico. (Gee, I missed my calling. I should be writing travel brochures.)

Painting Procedure

1 Sky and Clouds

I painted a light wash blue and then cloud shapes using a darker blue than the sky. While they were still wet, I scrubbed them with a bristle brush and began wiping with a small wad of paper towels, pulling out the light from the left side of the sunlit clouds.

2 Dunes

I allowed the sky to dry, then painted the sunny dune between the two darker dunes on the left side of the background.

3 Grasses

I re-wet the lower sky area, then used the fan technique with a gray-sienna mixture to paint the dark grasses, allowing them to bleed into the wet sky to appear soft.

4 Other Dunes

I painted these with the previous dune color mixture, then added the cooler shadows with a medium-valued blue mixture as I proceeded down the painting. This resulted in a bluish shadow color at the bottom. Finally, I added random patches of grass using the fan method.

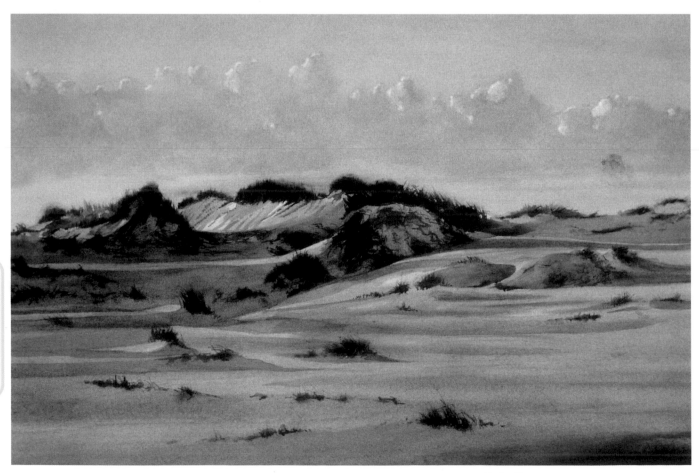

Padre Dunes
Watercolor on paper, 18" × 29" (46cm × 74cm)
Collection of Mr. and Mrs. Joseph J. Anina, Jr.

Dunes

Snow

Painting Snow That Sparkles

One winter day when we were looking for a little diversion, my wife and I decided to take a trip to eastern Long Island, New York. It turned out to be a poor decision: Upon arrival, we were greeted by an unexpected snowstorm. Returning home was not an option in such bad weather, so we decided to make the best of it.

It snowed all night and in the morning there was a good bit sticking on the ground. What a pretty sight! After breakfast, we set out to explore the area and see what kind of subject matter we could find. We found quite a few ocean-front mansions in the area, some of which were fenced in and gated, as this one was. The way the snow had drifted against the gatepost and the contrast of the dark, snowless trees in the background interested me. It was worth a few reference shots!

Upon our return home, I had the film processed, put it in my files and thought no more about it. A couple of years later, I was looking for a snow scene for another job. Going to my reference file labeled "Snow," I came across this one and almost went right by it. Then I went back for a second look and said to myself, "Wait a minute, this isn't bad." I liked its pristine simplicity, but it was apparent to me that it needed a center of interest. It suddenly occurred to me to add some red holly berries.

Painting Snow Drift

After making my drawing, I cut masks out of 2-inch (5cm) masking tape to protect the snow and gatepost. Then I put a few drops of masking fluid on the places where the berries extend past the

Snow Drift
Watercolor on paper, 11" × 17" (28cm × 43cm)
Private collection

gatepost on the left side. After that, I covered the sky area with plain water. When it was semi-dry, I painted in some of the soft trees in the background, alternating greens and grays. When they were dry, I painted the darker trees with Payne's Gray and Burnt Umber.

I then removed the snow and gatepost masks and put a little fluid on the places where the berries would be placed in front of the gatepost. Next, I painted the gatepost with light Burnt Umber on the front and Burnt Umber and Cerulean Blue on the shadow side. The shadows in the snow are Cerulean Blue. The holly branches, leaves and gate were done with Payne's Gray.

I scratched a few highlights out of the snow with my razor blade. The berry masks were removed and the berries painted with a small brush, using a little Cadmium Red. Clean, crisp and satisfying! (Sounds like a toothpaste slogan.)

Painting *The South Rim*

This is Bright Angel Canyon in January as seen from the South Rim of Grand Canyon National Park in Arizona. It was incredibly beautiful with the snow, but that isn't the best time of year to make the trip. We were lucky enough to get a gorgeous day when the roads were passable, but they can be dangerous in winter and are often closed.

I did this painting from photos I took when we were there. I didn't get very inventive in composing it: What you see is pretty much the way nature created it, but I did plan the painting very carefully. First, we know that strong light against the darkness of the rocks makes for good contrast. Next, since I wanted the painting to be large, bold and dramatic, I choose a large sheet of 22" × 30" (56cm × 76cm) cold-press Arches and used it vertically, with a couple of inches trimmed from the side.

After making my drawing, I painted the beige cliffs in the background with a 1¼-inch (31mm) flat. No mask is needed because the rocks in the foreground are so dark, you can paint them over the cliffs.

Once the cliffs were dry I painted the rocks, being careful to make different and interesting shapes. They are basically painted with Payne's Gray and Burnt Umber, with some blues in the lighter portions. After they were pretty well modeled with paint, I re-wet them slightly and scraped them lightly with the broad side of a razor blade to give them texture. Rocks need to look hard and rough.

I used my sponge for the small trees on the top and lower left. The bare trees were done with a small brush and very dark paint. The finishing touches were the white tree, which was scratched out with a blade, and the Cerulean Blue used to model the snow.

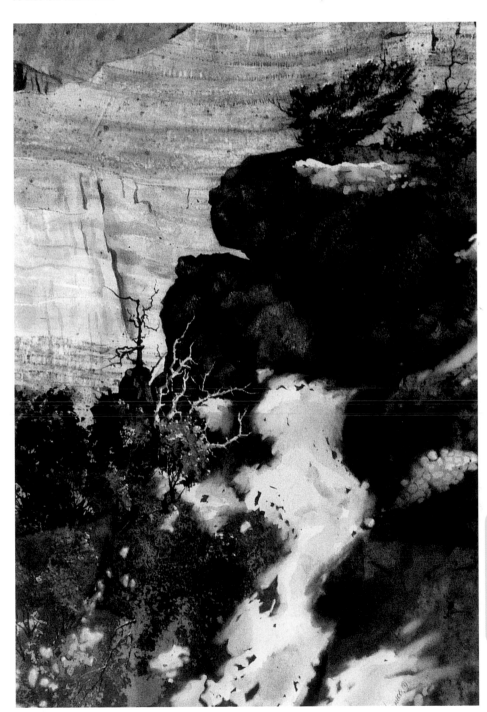

The South Rim
Watercolor on paper, 29" × 19" (48cm × 74cm)
Collection of Mr. and Mrs. Harry Keller

Snow

Capturing Snow

The Catskill Mountains are in southern New York. They are about a two-hour drive from our home and a beautiful place to visit in both winter and summer. We used to take a couple of trips a year up there during the skiing season.

This painting was done on location, and it was darn cold, I might add. One day when returning from the slopes to our hotel, we opted for a change of scenery and took a route we had not previously traveled. We came around a bend in the road and I saw this dilapidated red barn with snow blowing off the roof. I told my wife, "I've got to paint that!"

Upon our return to the hotel, I became obsessed with painting that barn. I couldn't get it out of my head. Despite the freezing weather, I decided to go back. Still in my ski clothes, I grabbed my painting gear and returned to the site. I believe I painted it in about two hours. Sometimes urgency is a good thing.

Materials

15" × 22" (38cm × 56cm) 140-lb. (300gsm) cold-press Arches
Drawing board
No. 2 HB pencil
Masking fluid
1-inch (2.5mm) masking tape
Plastic eraser
Soap
Rubber cement pickup
Razor blade

PAINTS
Alizarin Crimson
Burnt Sienna
Burnt Umber
Cadmium Red
Cerulean Blue
Payne's Gray
Raw Sienna
Ultramarine Blue

BRUSHES
1-inch (25mm) flat
No. 2 round
No. 4 round
No. 6 round
No. 12 round

1 Make the Drawing and Paint the Sky

After drawing the scene, take your bottle of masking fluid and give it a good shake. Load your no. 6 round with soap, dip it in the bottle and carefully apply the fluid to the roof, cupola, fallen tree and the top portion of snow. Immediately wash your brush with soap and water and make sure it's clean around the ferrule.

Using your 1-inch (25mm) shorthair flat, wash water over the sky. Mix up a puddle of Cerulean Blue and a touch of Ultramarine Blue and test it for color and value on a piece of scrap paper. When you are satisfied, wash it over the upper-mid sky. Remember to leave plenty of white, as shown. Also, make sure the darkest part of this wash is right behind the cupola roof so the snow will stand out when the mask is removed.

2 Paint the Mountains, Roof and Cupola

Re-wet the sky, then wash in a light mixture of Burnt Umber and Payne's Gray over the barn roof and let it blend into the sky. Keep it generally midtone in value, but dark enough to provide contrast with the snow later on. Don't forget the little bit of mountain peeking through the back of the barn.

3 Paint the Barn

Remove the masking fluid from the roof and cupola. Paint the cupola using a no. 6 round with Burnt Umber. Don't forget the weather vane! Now, use the same brush to paint the left side of the barn with Cadmium Red, Alizarin Crimson and a little Burnt Sienna with horizontal strokes. Move onto the front and side, making sure to keep the corner molding white.

Take an older brush, say a no. 6 round, make a chisel edge with it, and suggest the clapboard siding on the front. Loading it with paint, hold it on an angle almost parallel to the paper and pull it back and forth. Paint the dark interior with Payne's Gray and Alizarin Crimson using your no. 6 round.

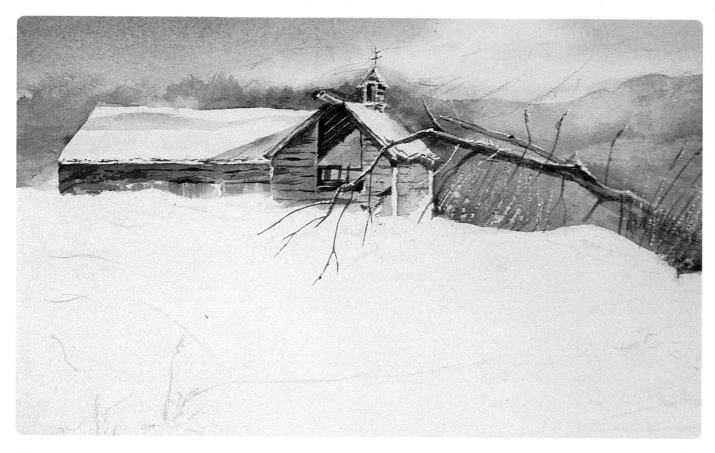

4 Paint the Tree, Branches and Weeds

Remove the masking fluid from the trees and snow. Using your no. 6 round with Payne's Gray, a little Burnt Umber and a touch of Ultramarine Blue, paint the tree. Now, paint the small branches with a no. 2 round and scratch in a few weeds with a razor blade.

Innovative Uses of Cold

On another skiing/painting trip, I decided to go out and paint. My wife had gone ice skating at the resort's indoor rink and I had the afternoon to myself. After doing as much as I could do in the freezing weather, I returned with what I thought was a pretty decent painting. When I got to the room, I discovered that I didn't have my room key. I leaned the painting against the wall and went to the desk to get another key. When I returned a couple of minutes later, there were puddles of water on the floor. What I hadn't realized was that the thin washes of watercolor had frozen while I was outside, and my painting had just defrosted! We spent the better part of the evening rescuing it. It actually turned out to be very interesting and a patron snapped it up at my next show.

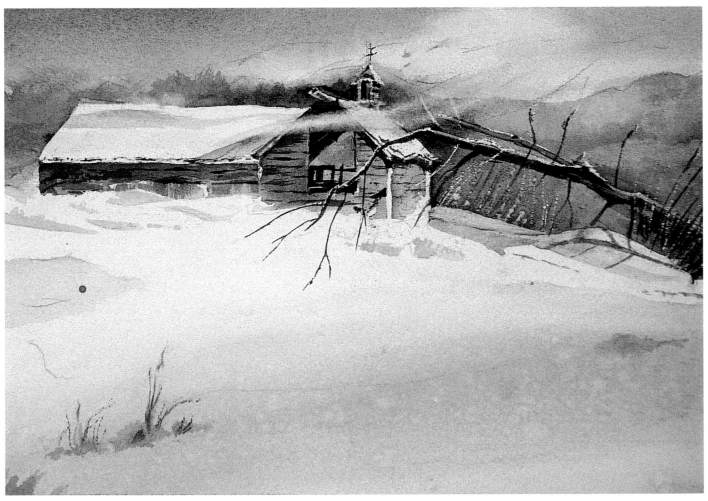

Snowbound
Watercolor on paper,
14" × 21" (36cm × 53cm)
Collection of Cheryl Healy

5 Paint the Snow and Drifting

Attack the small mound of snow beneath the tree first. Take a no. 6 round and wet the mound with a little water. Using Payne's Gray, Cerulean Blue, a little Raw Sienna and the same brush, paint the shadow area. Give special attention to forming the shadow on the mound. When that's dry, add the cast shadows using the same color mixture , but darkened with more Payne's Gray. While you have the brush in your hand, paint those few form shadows in front of the barn.

When it's dry, make a large, light mixture of Payne's Gray and Ultramarine Blue. Wet the whole foreground area and put in that large form shadow with your no. 12 round using just a few long, sweeping strokes. Add the weeds in the left foreground with your no. 4 round and a little light Payne's Gray.

Now, finish up the barn. With a 1-inch (25mm) flat, use the thirsty brush method in a sweeping motion from left to right and create the blowing snow. Keep the snow thin when you start and progressively wider. Repeat several times, if necessary.

Light & Shadow

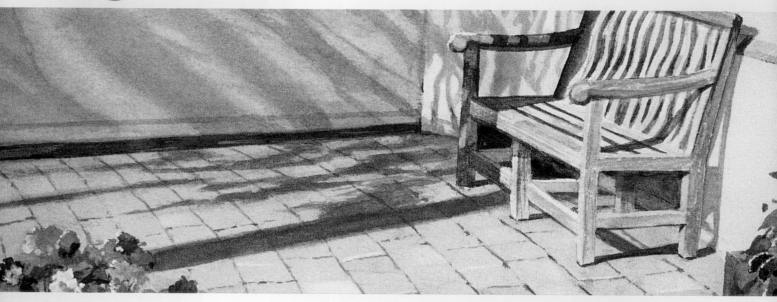

Strong Light and Shadow

The Spanish Paradores are restored historic buildings such as castles, forts, monasteries, etc. that have been converted into four-and five-star hotels owned by the government. This one was a fifteenth-century Franciscan convent and part of the famous Palace of Alhambra.

I took the shot that I used for reference for this painting from the second floor gallery. It gave me a marvelous view of the old colonnade-tiled patio, which I understand was part of the original convent. There were potted plants and vines everywhere. The bright morning sunlight, together with the "L" design of the scalloped cast shadow, gave me plenty to work with. In terms of great material, I knew I had a winner.

To emphasize the strength of the sunlight it was essential to make a strong contrast between the light and dark values.

Painting Procedure

1 Drawing

I made a careful drawing, giving special attention to the design of the tiled floor. I made sure to draw the dark chair in the corner in extra-dark pencil so I'd be able to see it later on through the dark wash.

2 Masking

I masked out the two chairs, the vines, the potted flowers and the white, diamond-shaped tiles with masking fluid. I ran tape across the floor where the tiles and stone meet and to protect the column on the left.

3 Floor

I painted the whole floor, including the masked tiles, with a mixture of Burnt Sienna and Alizarin Crimson, completely ignoring the shadowed area.

4 Back Wall

I laid a dark wash over the whole back wall with Burnt Umber and Burnt Sienna, leaving it a little lighter behind the chairs.

5 Shadows

I removed the masks from the column, the stone edge and the white tiles. Then I painted the whole shadow area with a mixture of Burnt Umber and Payne's Gray. For the shadow area of the floor and the walls I added Burnt Sienna and more Burnt Umber, making sure that the areas on the floor, column and wall were dark enough.

6 Spattering

For texture, I very lightly spattered the whole painting with Burnt Umber using a very small brush. After painting the dark chair in the corner I removed all the other masks.

7 Details

The vines, spider plant and potted plant were then painted with appropriate colors, leaving the chairs for last. They were painted with light Raw Sienna and Burnt Umber, with a little Burnt Sienna in the shadow area.

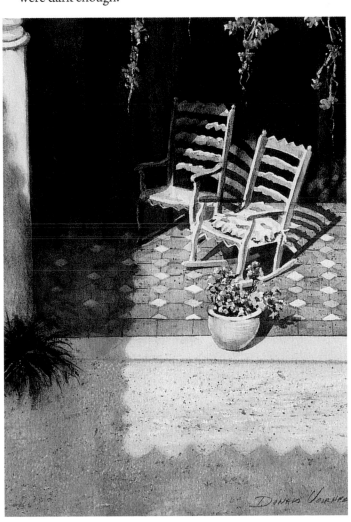

Twin Chairs
Watercolor on paper, 14" × 10" (36cm × 25cm)
Private collection

Creating the Light at Dusk

Highland Light, the oldest lighthouse on Cape Cod, Massachusetts, is officially named the Cape Cod Light on the maritime charts. However, it is indeed a "highland" light—it sits on a cliff 120 feet (37m) above the ocean. The elevation of the light beam is 183 feet (56m) above sea level.

Painting Procedure

After making my drawing, I masked out the lighthouse, keeper's house and land. In a cup I mixed a gray-pink made from Alizarin Crimson and Payne's Grey; in another I made a blue-violet with the same colors and a little Winsor Violet.

1 Sky

I wet the entire sky, dried it with a paper towel to just a sheen, then washed in the gray-pink mix. I let it dry, re-wetted it again, then added the clouds with the blue-violet mixture.

2 The Lighthouse

I removed the mask from the lighthouse and washed in the tower. After it dried, I added the walks, railing and roof. I finished by adding the beacon with a yellow and white mixture.

3 The House

I removed the mask from the house and immediately cut small masks for the windows, as well as applying masking fluid to protect the porch posts and corner trim. Next, I added the shingles with Burnt Umber, which I also used to complete the rest of the house. The roof, windows, porch posts, corner trim and chimneys were painted with different values of crimson and gray.

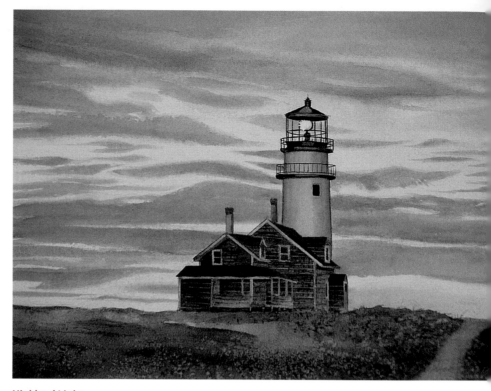

Highland Light
Watercolor on Paper, 14" × 22" (36cm × 56cm)
Private Collection

4 The Land

The land was painted quickly with a sweeping motion. I suggested some tiny flowers by sprinkling salt into the wet wash, and added the road with a mix of Raw Sienna, Payne's Gray and Pro-White. While that mix was still in the brush, I worked some of it into the front center of the painting. I liked it there so much I ended up spattering some over the whole area. To finish, I spattered in some crimson using the same brush.

SECRET
Premixing Colors

When I'm doing a painting such as this one, where the major part is the sky, I like to premix the colors I'm going to use before I start. This eliminates the risk of partial drying when you're laying in a large wash, as well as lessening the possibility that your colors are mixed in haste and don't come out exactly right. For premixing I use those little single-serving applesauce cups, but any small container will do.

Painting Strong Light

This scene could be found in almost any coastal town in the northeastern United States. What grabbed my interest were the big agate pots turned upside down on the porch. Washing and drying them was a ritual that prepared them for their role in the forthcoming feast.

Due to their size, a sunny day on the porch was ideal for drying the pots and it kept them out of the way until needed. It was so reminiscent of my childhood, when we would go up the street from our house to grandma's and she would cook lobster for Sunday dinner (hence the painting's title).

The bright day created these strong light and shadow patterns. That coupled with feelings of nostalgia and comfort made for a subject I couldn't dismiss.

Materials List

8½" × 9" (22cm × 23cm) 140-lb. (300gsm)
cold-press Arches
Drawing board
Artist's bridge (if you have one)
No. 2 HB pencil
Tracing paper
Transfer paper
Masking fluid
2-inch (5cm) and 1-inch (38mm) masking
tape
Plastic eraser
Rubber cement pickup
Razor blade
T-square
Triangle

PAINTS
Alizarin Crimson
Burnt Sienna
Burnt Umber
Cadmium Yellow Deep
Cerulean Blue
Payne's Gray
Pro-White
Ultramarine Blue

BRUSHES
No. 1 round
No. 2 round
No. 6 round
No. 12 round

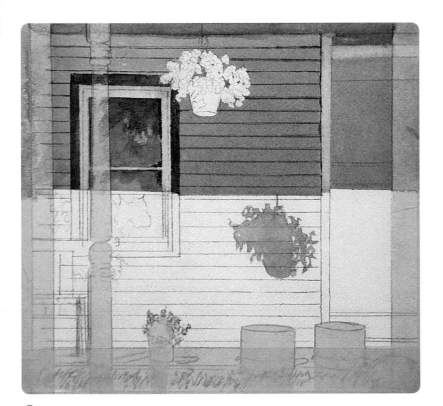

1 Make Your Drawing and Masks and Lay in the Initial Washes

As with most architecture, I recommend working your drawing on tracing paper first. Use your T-square and triangle to make sure everything is square. When you're satisfied, transfer the drawing to your watercolor paper. Make sure that the penciling of all the lines are dark enough to be seen through masking tape or a fairly dark wash.

After transferring your drawing, cut masks for the column, jug, planter, two pots and the lid in the lower right corner. Mask out the hanging flowers with masking fluid. When the flower mask is dry, create a fairly dark mixture of Cerulean Blue and Payne's Gray for the house shadow. When that's dry, decide if the shadow wash is dark enough. If you're not satisfied, strengthen it with another coat. Remember that transparent washes dry lighter, whereas opaque washes dry darker. This is particularly true of Payne's Gray.

Paint the shadow cast by the flowers with the same dark mixture. When that's dry, darken the mixture with more Payne's Gray and use a no. 2 round to paint the clapboard shadow lines. Use an artist's bridge or something else with an edge that will make the lines straight. Finally, remove the flower mask with rubber cement pickup.

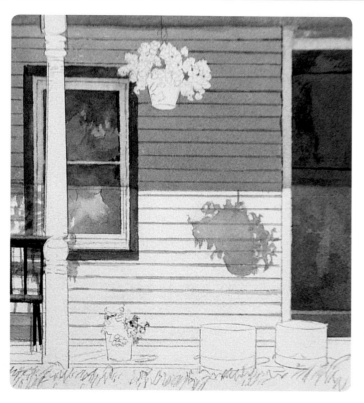

2 Add Additional Cast Shadows and the Bench, Window, Frame and Door

With a no. 2 round, paint the shadows cast by the bench seat and backrest on the left side of the porch. Use the same wash that you used for the previous shadows. Now, paint the bench using the same brush with Burnt Umber for the backrest and Payne's Gray for the seat and legs. Paint the window with various shades of the same gray and a no. 6 round. Try to get some interesting shapes in the reflections in the glass.

Use the no. 6 round and Cerulean Blue mixed with Cadmium Yellow Deep to paint the green window frame. Switch to a no. 12 round to paint the door with a darker shade of the same Cerulean Blue and Payne's Gray you used for the previous washes. Remove all remaining masks.

3 Paint the Column, Flowers, Porch and Remaining Shadows

Using a very light mixture of Cerulean Blue and Payne's Gray, model the column with your no. 6 round. Use a no. 2 round to paint the flowers and leaves, with light Alizarin Crimson for the pink flowers—but make sure you leave plenty of white flowers. The leaves can be painted with a green made with Cadmium Yellow Deep and Cerulean Blue.

Run a piece of 1-inch (2.5cm) masking tape across the line where the house meets the deck. Use your no. 6 round to paint the deck with a light coat of Burnt Sienna. Put a couple of dabs of masking fluid on the jug to protect the flowers, then paint it with Burnt Sienna. When dry, remove the mask and paint the flowers and leaves using your no. 2 round. Use a darker shade of the shadow color and the same brush to paint all the remaining cast shadows.

When dry, run a strip of 1-inch (2.5cm) masking tape across the front edge of the deck. Now, with your no. 1 round and masking fluid thinned a little with water, use numerous short strokes to mask the grass blades. When the fluid is dry, paint the side edge of the deck with the same brush and color.

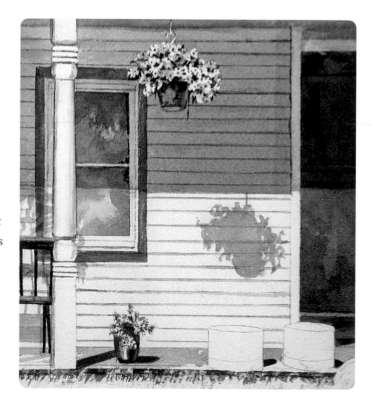

Using a Mask
Before painting the pots in the next step, carefully apply masking tape around them to protect the already painted portions.

4 Paint the Pots and Grass
After masking, paint the first pot and lid with dark Ultramarine Blue and a touch of Payne's Gray. When dry, spatter them with diluted Pro-White and repeat with the other pot and lid. Lastly, add the highlights using your no. 1 round and Pro-White.

Remove the grass mask with your rubber cement pickup and paint the grass with your no. 1 round and alternating between mixed yellows, light and dark greens, Burnt Sienna and Pro-White.

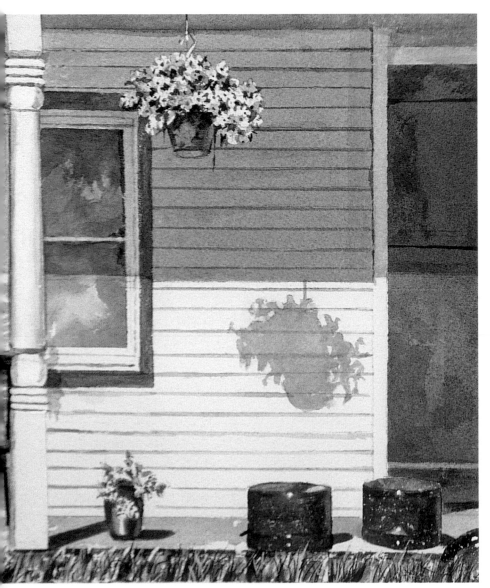

Lobster Tonight
Watercolor on paper, 29" × 21" (74cm × 53cm)
Collection of Mr. and Mrs. John Sabato

Painting Strong Shadows

Here's another one of the old houses in Atlantic Highlands, New Jersey. This is a Queen Anne style Victorian built in the 1890s. It was originally occupied by a Captain Mount and became known as the Mount House. This is one of those cases where I had probably passed by this house a hundred times and didn't notice it. However, on that particular day, in the right light and at the right time of the year (making the marvelous shadows), it presented itself as great subject matter. I set up my easel and went to work.

Materials

8½" × 9" (22cm ×23cm) 140-lb. (300gsm) cold-press Arches
Drawing board
No. 2 HB pencil
Natural sponge
Tracing paper
Transfer paper
Masking fluid
Plastic eraser
Rubber cement pickup

PAINTS
Alizarin Crimson
Burnt Sienna
Cadmium Yellow Deep
Cerulean Blue
Payne's Gray
Pro-White
Raw Sienna
Ultramarine Blue
Winsor Violet

BRUSHES
No. 1 round
No. 2 round
No. 6 round
No. 8 round
No. 12 round

1 Lay in the Initial Washes

After making your drawing, use a no. 2 round with diluted masking fluid to mask out the porch posts, window, railing, chair and flowers. Next, lay in a light wash of Ultramarine Blue for the sky with your no. 12 round. With a no. 6 round, lay in an initial wash of light Cerulean Blue on the side of the shed.

The initial porch washes are all done using the same no. 8 round. Start with the back windowed wall using a mixture of Winsor Violet, Burnt Sienna and Ultramarine Blue. Do the sidewall with the same colors. Paint the porch in dark values—the porch is key to the strong light in this painting.

2 Add Intensity and Detail

With your no. 12 round, wet the sky and then flow in a slightly deeper wash of Ultramarine Blue than the previous one, particularly in the upper left-hand corner, to give it more gradation and punch. Rule in the clapboard shadows in the shed and dormer areas with your no. 1 round and Cerulean Blue.

Mix a puddle of Payne's Gray, and use your sponge to stamp bushes in that area. With your no. 6 round, introduce Raw Sienna here and there to add variety. Using your no. 2 round and Payne's Gray, start painting a few branches and leaves in the area near the shed and around the masked-out flowers.

3 Paint the Porch Details

With your no. 6 round and a mixture of Cerulean Blue, Payne's Gray and Raw Sienna, paint the porch posts, rail and balusters. Using the same brush and colors, paint the area under the eaves.

With the same brush but only using Payne's Gray, paint the clapboard and window on the side of the house. Paint the shadow from the eaves with Winsor Violet using the same brush. Switch to a no. 1 round and use Ultramarine Blue and Payne's Gray to paint the clapboards in the porch area right over the chair that's still masked.

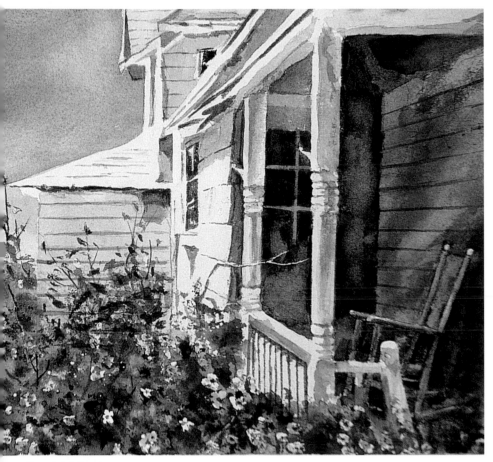

Grandma's Porch
Watercolor on paper, 10" × 14" (25cm × 36cm)
Collection of Paul Gunlach

4 Finish the Painting

Paint the front railings using a no. 6 round with Payne's Gray and Cerulean Blue. Remove the chair's mask and paint it using a no. 2 round with a dark, grayish yellow made from Raw Sienna and Payne's Gray.

Remove the flower masks with your rubber cement pickup. Refine the outline of some of the white flowers with a little Pro-White using your no. 1 round. Use Cadmium Yellow Deep and Alizarin Crimson for the colored flowers. Add a little Cerulean Blue for the shadows in the white flowers, then put dark yellow centers in some of them and you're done.

SECRET
Diluting Masking Fluid

Thinning masking fluid out with water gives you more control, makes it easier to work with and enables you to mask more defined details. What I do is just pour a little of the fluid in the cap and thin it with water. This does not affect the masking aspect in any way; it sticks just as well as if you took it right out of the bottle.

Making Strong Cast Shadows

Several years ago, when my wife and I were in Argentina, we took a bus tour to visit a Gaucho Ranch about fifty miles west of Buenos Aires. This scene is a waiting room in the historic ranch museum. What caught my attention were the interesting floor tiles which were laid in a circular fashion, giving a touch of elegance to the simple wooden bench that must have offered a moment's rest to many travelers over the years.

Add to this the incredible play of light creating strong cast shadows on the bench, floor and walls, and you have a touching scene worthy of a painting. The drama of the light and the poignancy of the bench just waiting for more travelers is what I was trying to capture.

I was very particular when making my drawing. Notice how each width in each row of tiles recedes—they are drawn in correct perspective. My palette for this painting was Raw Sienna, Burnt Sienna, Burnt Umber, Winsor Violet and Cerulean Blue. An extremely light wash of Cadmium Yellow Deep was used for the wall to emphasize the warm sunlight. The most important thing you can learn here is that you must make sunny cast shadows strong.

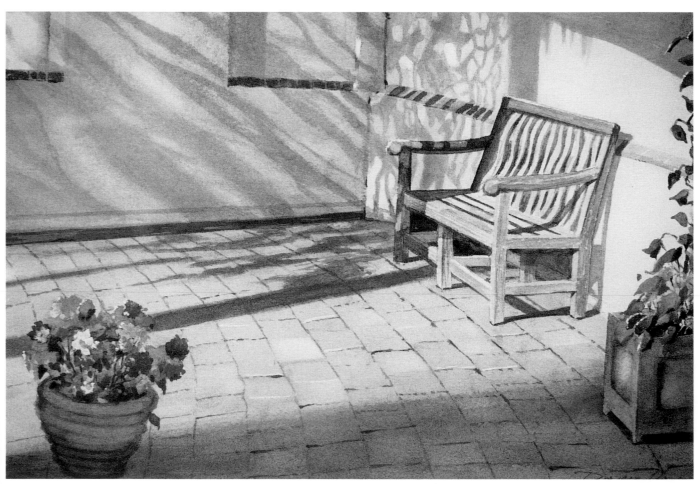

Waiting
Watercolor on paper, 10" × 14" (25cm × 36cm)
Private collection

Using Contrast and Detail for Impact

My wife and I discovered this beautiful floral arrangement hanging on a porch in Adelaide, a lovely city in southern Australia. I was not only impressed by the casual arrangement of the plants but also the unusual beauty of the decorative porch posts. Obviously I didn't sit down and paint this on the spot—I did it from a slide when I got home in the comfort of my studio.

I decided to keep this painting pure and simple. Therefore, I had to have the utmost contrast in order to achieve the impact I desired. When making my drawing, I paid very close attention to the detail in the post. I also put a lot of detail in the flower drawing and used light pencil lines.

Painting Procedure

1 Masking

After completing the drawing, I masked out the post using a combination of tape for the post itself and masking fluid for the intricate decorations on it. I did the same with the flowers, using tape for the bowl and masking fluid for the flowers.

2 Background

I wet the whole background area a couple of times. I washed in, starting from the left, Burnt Sienna, Payne's Gray, Ultramarine Blue and some Raw Sienna, mixing them on the sheet as I went. I took a handful of salt and sprinkled it into the mix. If something happened that was not to my liking, I'd take my wad of paper towels, blot and repaint it.

3 Mask Removal

I used a hair dryer to dry the mask completely and removed all tape masks (the hair dryer makes the tape release easier). I then used rubber cement pickup to erase the fluid.

4 Details

Next, I carefully painted the post leaving a lot of the paper white. I re-masked the flowers in front of the bowl with fluid, then painted the copper-colored hanging vase with Raw Sienna and Burnt Sienna. The flowers were painted using the appropriate colors, leaving plenty of white paper to create the right impact.

G'Day
Watercolor on paper,
21" × 29"
(53cm × 74cm)
Collection of Mr. and
Mrs. Harry Keller

Light & Shadow

People & Crowds

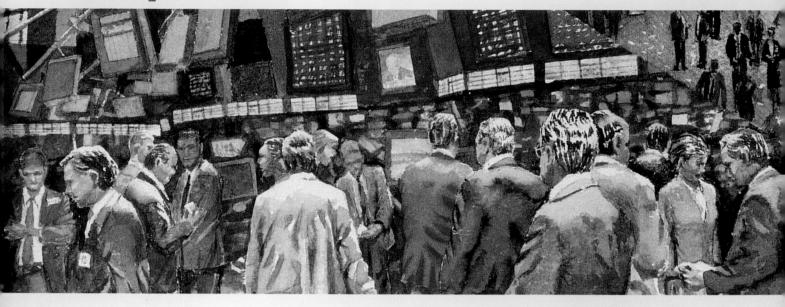

Capturing What Inspires You

The city of Portimao is the heart of the sardine fishing industry in the Algarve region of Portugal. This scene, of fishermen just in from the water, intrigued me—it had all the ingredients of a successful painting. The dark trees on the cliff in the background playing against the light, the shades and different textures of the stone building, the clothes on the line and of course the figures themselves made for a perfect setup. If a movie director staged this it couldn't have been better. With my ever-present camera around my neck, I quickly took a couple of shots before anybody moved.

You have to take advantage of an opportunity like this one when it happens or risk the loss of the moment that inspired you. The moment was still fresh in my mind when I viewed the slides in my studio and I set to work re-creating the simple, charming tableau. A painting is all about feeling—without it, it's just a picture.

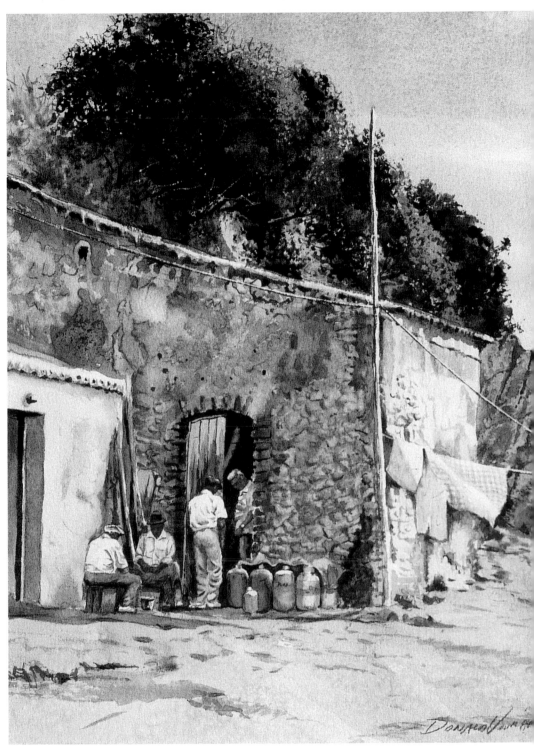

After the Catch
Watercolor on paper, 14" × 10" (36cm × 25cm)
Collection of Herb Honnold

Placing People in a Landscape

There are times when painting a seascape, cityscape or other type of landscape requires a figure or even several figures, for that matter. Figure drawing is an extremely difficult thing to do unless you've had some formal training. If you have an opportunity to do so, I strongly recommend taking a life drawing class. You can usually find a college, junior college, art guild or art school offering life classes. However, you must understand that the figures you use in a painting are not the same as those drawn in a life class.

When I first started painting golf courses, I looked at other golf artists' work to see how they handled the subject. Some neglected to include any figures, which makes no sense—golf is a game that can only be played by people. Without their inclusion, it's just another landscape. Many of those that did include figures were of very poor quality.

To me, figures are what make a golf painting come alive. The emphasis should be on the scene, not the game. I like the figures to be doing things that people do when engaging in whatever activity they are involved in at the time. For goodness sake, just don't have them standing there like cigar store Indians.

I picked Pinehurst for this lesson because I thought it was a good example of this philosophy. The two figures on the left are caddies and they're doing what caddies do: The first guy is holding the pin and the second is carrying a bag. The player in the pink shirt is watching the other golfer putt. Makes sense to me.

Materials

10" × 12" (25cm × 30cm) 140-lb. (300gsm)
cold-press Arches
Drawing board
No. 2 HB pencil
Tracing paper
Transfer paper
Magnifying glass (optional)
Masking fluid
2-inch (5cm) Masking tape
Plastic eraser
Rubber cement pickup
Razor blade
No. 10 craft knife
Straight edge

PAINTS
Burnt Sienna
Burnt Umber
Cadmium Yellow Deep
Cerulean Blue
Payne's Gray
Pro White
Raw Sienna
Winsor Violet

BRUSHES
No .1 round
No. 2 round
No. 4 round
No. 12 round

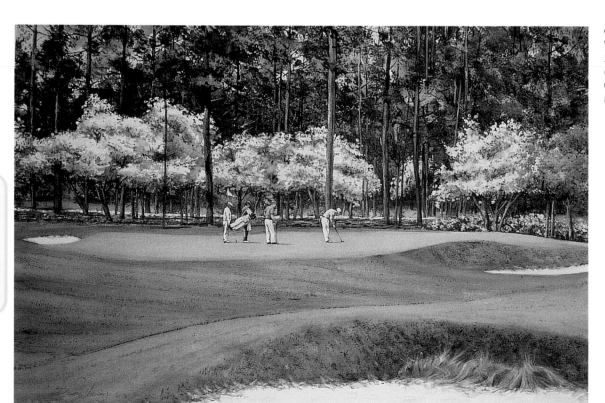

Golf's Capital
Watercolor on paper,
21" × 29"
(53cm × 74cm)
Collection of Mr. and
Mrs. Clarence V. Lee III

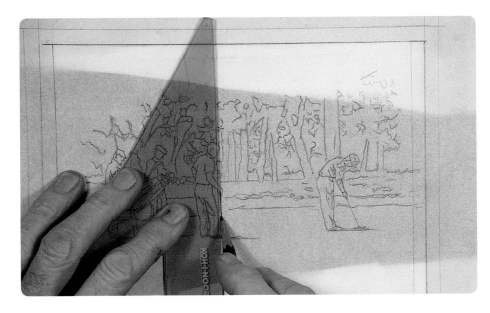

1 Create Your Drawing and Apply Masks

Make a careful drawing on tracing paper and transfer it to your watercolor paper. Be particularly careful with the figures and make sure the drawing is dark enough to be seen through the tape. Use a straightedge to draw the club shaft.

Lay down a couple of overlapping pieces of 2-inch (5cm) masking tape to cover the figures and cut your mask with the razor blade. It's important that you use masking tape instead of fluid because you get a sharper edge with tape. Mask the bigger trees and blossom masses with masking fluid.

2 Paint the Trees, Blossoms and Putting Green

Mix a light green puddle of Raw Sienna and Cerulean Blue for the putting green, and apply it with a no. 12 round. Make a lighter mixture of the same colors using mostly blue, and apply it to the blossoms that you masked in the previous step with the same brush. Wet the whole paper with clear water, rinse your brush and use it to apply a wash of the light green mixture directly over the foreground and masked figures, creating an abstract edge. Paint some blossoms with the light blue-green mixture using the same brush. As that area is drying, continue to paint the

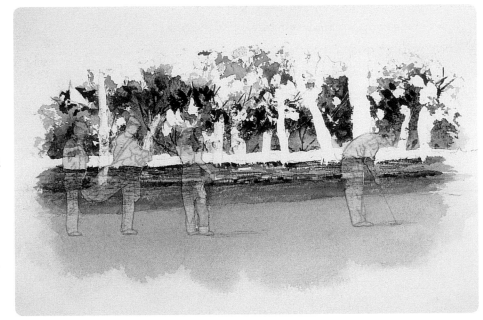

background with greens made with different mixes of Raw Sienna with Cerulean Blue and grays made from Payne's Gray and Raw Sienna.

Paint the pine chips on the ground with a mixture of Winsor Violet and Burnt Umber using your no. 4 round. Remove all the masking fluid from the background with rubber cement pickup and paint it with varying values of mixed Payne's Gray, Raw Sienna, Burnt Umber, Winsor Violet and a touch of Burnt Sienna. Paint the ribbon of dark green grass behind the men using Cerulean Blue and a little Cadmium Yellow Deep.

3 Remove the Masks Over the Figures

Figure Drawing

If you're really serious about learning how to draw a figure, you should obtain one of the greatest books on figure drawing ever. *Figure Drawing For All It's Worth* by Andrew Loomis (1892–1959) covers everything you need to know: male and female figures, scale, perspective, anatomy, hands, faces and the draping of clothing. My copy is a 1946 edition from my art school days and I treasure it like gold.

The bad news is, after 25 editions, the publishers stopped publishing it in 1975 and it's still very highly sought after. However, used copies in decent shape are available on the Internet. They're relatively expensive—around $60—on sites like eBay and Amazon.com. Shop around and pick up a copy; it's worth it!

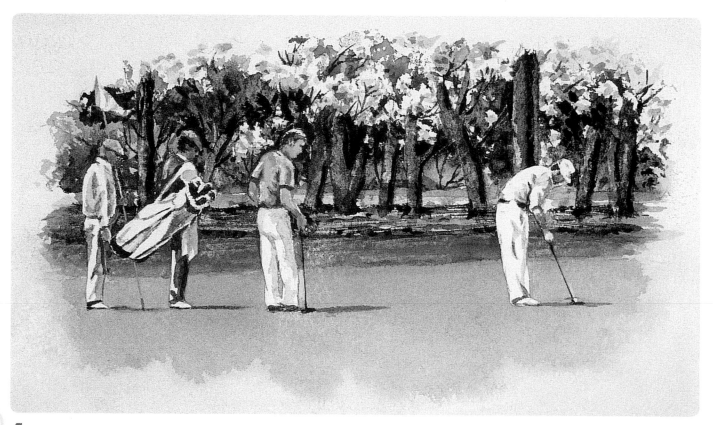

4 Paint the Figures

You need only your no. 1 and no. 2 rounds to paint the figures. We're only doing the caddy on the left; model all the other figures after him. Mix a small amount of Burnt Sienna and Pro-White and carefully paint his face with a no. 1 round, leaving a little white on the back of his head for blond hair. Put a dark accent of Burnt Umber under his cap and in his eye socket. Use a magnifying glass if you have one. Paint his hands with the same color, leaving a white space for a highlight and a dark accent under his cuff.

Paint his hair and cap Cadmium Yellow Deep. Add his pants with a light mixture of Raw Sienna and Payne's Gray. Put a shadow of Payne's Gray on his shoe, under his pant cuff. Paint the flag shadows with light Payne's Gray. Put down two strips of masking tape side by side with perhaps ¹/₆₄ of an inch between them, and paint the pin he's holding with a very dry wash of Pro-White and Cadmium Yellow Deep. Also do this when painting the players' club shafts.

Capturing a Bustling Scene

Like millions of other people, I have been in the visitors gallery of the New York Stock Exchange. Several artists have depicted the floor of the Exchange as seen from the visitors' gallery, but I've never seen one that was actually done from the floor. I started thinking about this, discussed it with my wife, Terry, and said to myself, "Why not?" It would be tough to do, but if I could get the proper clearance, I thought it could be a great painting.

After many months, and many investigations of my credentials, we finally received permission. With camera in hand, I took as many shots of the activities as time permitted. My goal was to catch the excitement generated by the floor brokers, specialists, traders, clerks and other workers of the Exchange.

I knew the planning for the painting had to be done carefully, and eventually decided that so much activity had to be divided. I wanted to show the trading booths, an overview of the entire floor and the various specialists at work. There was a lot to look at, so I ended up dividing it into six parts. That would make it easier for the viewer to get a feel for all the activities that were taking place.

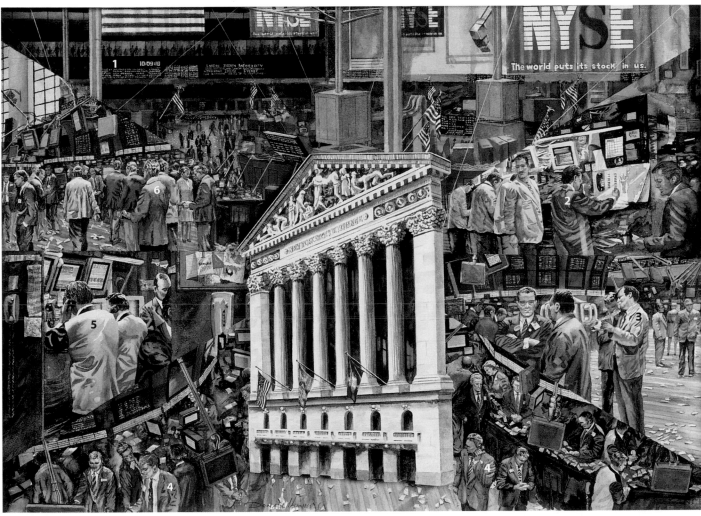

After the Bell II
Watercolor and collage on paper,
21" × 29" (53cm × 74cm)
Collection of the artist
NYSE "The World Puts Its Stock In Us" NYSE Trading Floor and NYSE building facade are registered service marks of the New York Stock Exchange, Inc. and are used with permission of the New York Stock Exchange.

1 The floor of the Stock Exchange, with the visitors' gallery, local time and information on other major exchanges in the world.
2 The specialists' booth. This is where the specialists, the people who make the trades, work (the color-coded jackets identify them).
3 Specialist taking an order on the phone.
4 General view of the floor, with several brokers.
5 Close-up of the trading booth, with specialists on the phone.
6 Brokers on the floor.

Adding People to a Scene

The painting in this demonstration emphasizes the importance of knowing how to paint good figures when it's necessary to do so. Fortunately, I went to an art school that had good figure drawing classes, mostly under the guidance of the renowned portrait painter Stanley Turnbull. He had studied anatomy at the Art Students League under the great George Bridgman. He taught us the Bridgman theory of anatomy, which treats muscles as wedges of interlocking shapes.

I later took classes at the Art Students League in New York and even ran a figure drawing class at the local art guild. I suggest you join a local class if you can. Attention to anatomy is important when painting the clothed figure. How the clothing drapes on the figure is equally as important as the figure itself. I believe we must be very conscientious about portraying folds and drapery as accurately as possible.

Materials

10" × 12" (25cm × 30cm) 140-lb. (300gsm) cold-press Arches
Drawing board
No. 2 HB pencil
Plastic eraser

PAINTS
Burnt Sienna
Cadmium Yellow Deep
Payne's Gray
Raw Sienna

BRUSHES
No. 6 round
No. 12 round

1 Draw the Jacket and Apply the Initial Wash
Make a light pencil drawing of the jacket, paying special attention to the creases. Use a no. 12 round to cover the back of the jacket with a light mixture of Cadmium Yellow Deep and a tiny bit of Raw Sienna. Be careful to leave white areas where indicated.

2 Define the Folds
Using a no. 6 round, brush in the larger folds with a darker mixture of Cadmium Yellow Deep and Raw Sienna. While doing this, keep in mind that there's a body under that garment—don't disregard the anatomy. Using the same brush, paint the hands, neck and side of the face with Burnt Sienna. Use light Payne's Gray for the hair, jacket sleeve, collar and telephone.

3 Finish the Figure

Using a no. 6 round, further intensify the darker shadow areas in the jacket, adding a little more Raw Sienna to your mixture. Be aware that some of the folds have hard edges. Darken the side of the face and further develop the hand with the same brush and Burnt Sienna. With the no. 6 round, add dark Payne's Gray to the sleeve, collar and hair and voila—you're finished!

After the Bell II (Detail)

Porches

Capturing the Correct Perspective

I guess, using the correct terminology, this would be considered the back steps rather than a porch. However, artistically I prefer the word porch. What the heck: It's off the ground, I can use artistic license.

At any rate, I thought it was very charming subject matter. I was particularly intrigued by the weathered color and texture of the cedar shake shingles. After painting this picture and giving it a hard look, I decided that it needed some added interest. Again, using artistic license, I added the reflection of a local lighthouse in the storm door window.

Painting Procedure

1 Masking
After finishing my drawing, I masked out the storm door, window and corner molding on the right. Again

I masked out the steps and pot with tape, then switched to fluid for the orange flowers.

2 Shingles
I painted the shingles primarily with Burnt Umber but worked a lot of different colors into them, such as Cerulean Blue, Winsor Violet and, of course, Burnt Sienna for the stains beneath the window.

3 Shadows
With a small brush I painted the shadows under the shingles.

4 Foliage
I painted the foliage on either side of the steps using Cerulean Blue and Raw and Burnt Sienna using both a sponge and a brush.

5 Leaves
The autumn leaves (top right) were also done with Raw and Burnt Sienna.

6 Final Details
I removed the rest of the masks and painted the door, window, and finally, the flower pot and brick steps. As I mentioned earlier, after some thought I decided to add the lighthouse.

SECRET
Shingle Perspective

When making my drawing, I paid particular attention to the perspective in the shingles. My horizon line is at the bottom shadow line of the fourth row of shingles. You will notice that all the rows above that line slant slightly down toward the right vanishing point. The opposite is true of the rows below the horizon line—they all slant slightly up toward the right vanishing point.

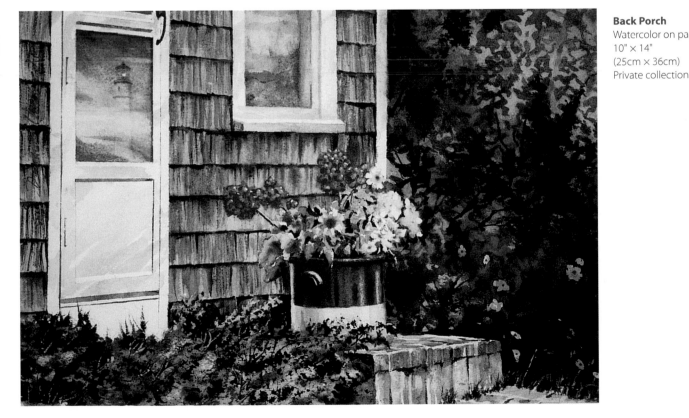

Back Porch
Watercolor on paper,
10" × 14"
(25cm × 36cm)
Private collection

Porches

Searching for Subjects Everywhere

I was driving down a side street not far from where I live and this scene caught my attention. As I'm always looking for subject matter, I pulled over to the side and grabbed my little viewer to check it out. The bright summer sun filtered through the leaves, creating hundreds of silver dollars on the pale sidewalk. It just looked like a place where you would like to be—the kind of porch where you could sit down on one of the chairs and rock yourself to sleep in the shade of the lovely old trees.

The lesson here is to always be on the lookout for good subjects. You may find them in the most unassuming places.

Reference Photo
This is a close-up of the porch. As you can see, the flowers, silver dollar shadows, porch columns and balusters were all good. The problem was the porch and porch furniture—it's completely in shadow. Not much to work with there. I had to do a lot of improvising, but all in all, I think it worked out quite well and am pleased with the result.

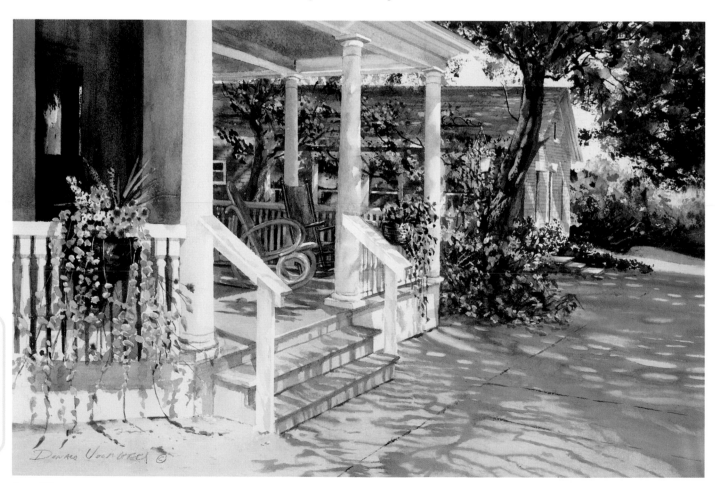

Lazy Afternoon
Watercolor on paper, 14" × 21" (36cm × 53cm)
Collection of Karen and Bill Robinson

Depicting Victorian Detail

This lovely Victorian beach house, with its "gingerbread" trim, rose bushes and lighthouse in the background, makes for great subject matter.

Painting Procedure

1 Masking

After my drawing, I first cut a mask for the house, porch posts and brackets out of tape. I then masked out the roses with fluid.

2 Sky

I laid a light wash of Cerulean Blue and Payne's Gray over the sky that got progressively lighter as it moved toward the water line.

3 Buildings

I painted the lighthouse and keeper's house with a mixture of Payne's Gray and Raw Sienna for the siding. I defined the details of the house with Naples Yellow, adding a little Payne's Gray for the shadows under the arched overhang. The roofs, top of the lighthouse and walk are all Alizarin Crimson painted with the same brush. I tried to preserve most of the white paper in the roof and only painted the shingle shadows.

4 Details

I painted the peak of the eave with Payne's Gray, then used the same brush and a lighter value of the gray to paint the eave's background, the porch overhang and the first-floor window's trim. I switched to a smaller brush and painted the posts with the same gray. Again, it's important to leave paper showing to create highlights. The window trim on both upper windows were left untouched

5 Water

I added the water using a light wash of Cerulean Blue and Payne's Gray.

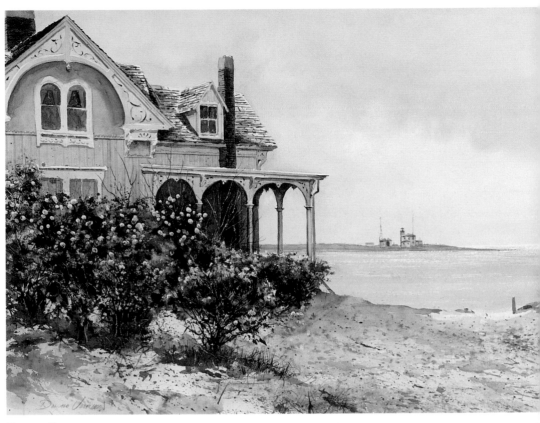

Summertime
Watercolor on paper, 21" × 29" (53cm × 74cm)
Collection of Mr. and Mrs. Pat Belmonte

After it dried I scraped in highlights with the side of a razor blade.

6 Beach

The beach was painted wet-into-wet with a gray and sienna mixture. Next, except for the beach, I covered the painting with newspaper and did some bold splattering with various dark colors, polishing the details with a small brush.

7 Bushes and Roses

I stippled in the bushes over the rose's mask using a sponge. I removed the mask and used a mixture of Alizarin Crimson and Permanent Rose to paint the blossoms, leaving white for accents. With the tip of a razor blade, I scratched highlights into the branches in front of the porch.

> ### SECRET
> **Almost Famous**
>
> In the mid-1980s, I had a dealer in Los Angeles who did a lot of business with set designers who worked in the film and television industry. Every now and again, one of my prints would pop up in a TV show or movie. My lithograph of *Summertime* was used in the television series *Hotel*. Other sets my prints appeared were *The Love Boat*, *Dynasty* and the *Caddyshack* movies.

Painting a Porch

I brought this painting back home after a day of painting outside, and showed it to my wife for her opinion. "I like it," she said, "It looks like a place where you'd like to sit and have a tall, cold lemonade." That's how the title came about.

Because I painted the original *Lemonade Porch* freehand, it resulted in a slightly looser painting style than is my norm. However, I think if you're a student, you are probably better off using the tracing paper method. It depends on how accomplished you are as an artist. That is your decision. And also, remember that you're painting a smaller version than the original.

Materials

8½" × 9" (22cm × 23cm) 140-lb. (300gsm) cold-press Arches
Drawing board
No. 2 HB pencil
Artist's bridge (optional)
Masking fluid
2-inch (5cm) masking tape
Plastic eraser
Rubber cement pickup
Razor blade
No. 10 craft knife
T-Square
Triangle

PAINTS

Alizarin Crimson
Burnt Sienna
Burnt Umber
Cadmium Yellow Deep
Cerulean Blue
Payne's Gray
Raw Sienna
Ultramarine Blue
Winsor Violet

BRUSHES

1¼-inch (31mm) longhair flat
No. 2 round
No. 6 round
No. 8 round

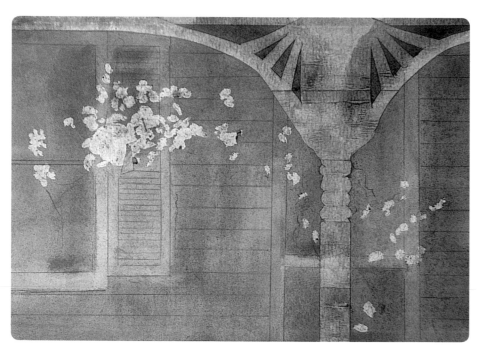

1 Make Your Masks and Lay in the Underpainting

Cut a mask for the post and brackets out of 2-inch (5cm) masking tape, then mask the flowers and vine with masking fluid. Using your 1¼-inch (31mm) longhair flat, wet the whole paper with clear water. With the same brush, lay down separate medium-to-dark washes of Burnt Umber, Payne's Gray, Raw Sienna, Burnt Sienna, Cerulean Blue, Ultramarine Blue and Winsor Violet, and let the colors blend together.

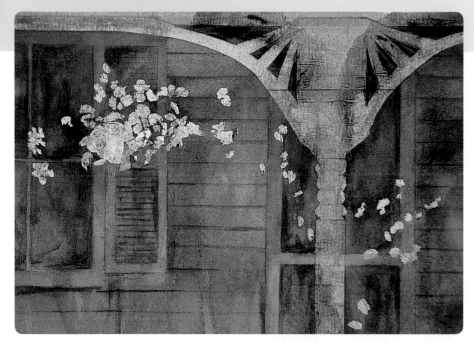

2 Intensify and Detail

Dry the paper with a hair dryer, re-wet it and layer in the same washes again, making them darker. Dry the paper again, then use a no. 6 round, with a mixture of Payne's Gray and a little Ultramarine Blue to develop porch details such as the windows, shutters, clapboard, door, etc. If necessary, use mechanical aids such as the artist's bridge. Let the painting dry and remove all masks.

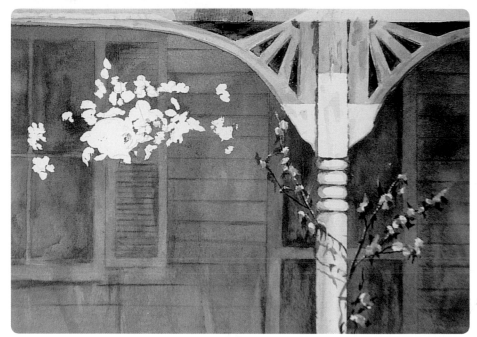

3 Paint the Post, Brackets and Vine

With your no. 8 round, paint the cast shadows on the upper square part of the post and brackets using a mixture of Raw Sienna, Burnt Sienna and Cerulean Blue. Next, switch to a no. 6 round and paint the round part of the post using Cerulean Blue for the shadow and Raw Sienna for the reflected light. As long as you have the brush in your hand, go ahead and model the four decorative rings on the porch post with the same colors.

Paint the cast shadows from the vine with Cerulean Blue. Paint the vine itself using Payne's Gray and a no. 2 round. With the same brush, use Payne's Gray and a little Cadmium Yellow Deep to make a nice green and paint the leaves on the vine.

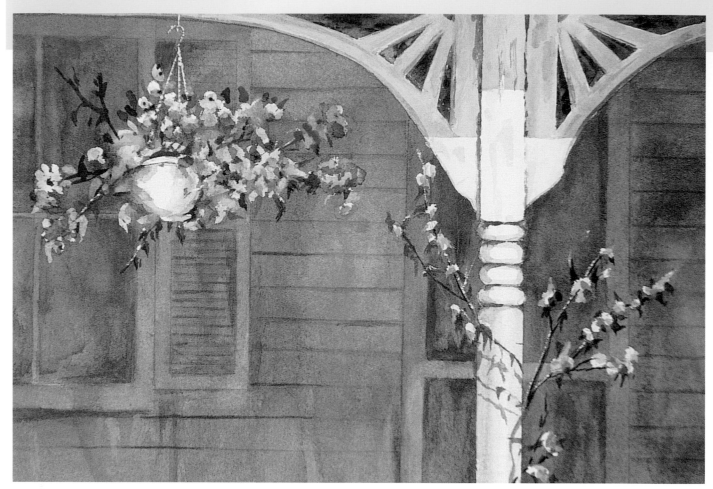

4 Paint the Hanging Flowers

Once more, with the no. 2 round and the same colors you used for the vine in the previous step, paint the green leaves around the hanging planter. With a no. 2 round and light Alizarin Crimson, paint the light part of the roses. Be sure to leave plenty of white on the paper. Wet each flower with water first, then touch them gently with a fully loaded brush point and let the paint bleed.

While each flower is still wet, go back and gently touch it with just the point of the brush loaded with a little stronger Alizarin Crimson, and once again let it bleed. When they're dry, add their dark centers with Payne's Gray. Next, paint the planter with a little Cerulean Blue and Payne's Gray using the same brush. Now you can scratch out the hanging chain and hook with your razor blade. That's it! We're finished.

Lemonade Porch
Watercolor on paper, 21" × 29" (53cm × 74cm)
Collection of Diane and Larry Adler

Intensifying Values

Since transparent watercolors tend to dry lighter than they appear when wet, sometimes you may need to lay down a second or even third wash over the first in order to get the value intensity you desire in a solid background such as this.

Architecture

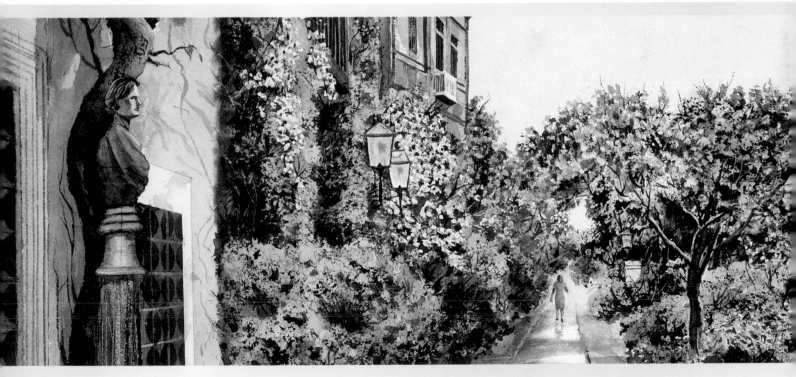

Finding Perspective in Everyday Life

Sorrento is a very pretty resort city in southern Italy, sitting on cliffs overlooking the sapphire waters of the Gulf of Naples. Capri, Pompeii, Herculaneum, Naples, Positano and the Amalfi coast are all a short distance away. Just walking around the town is a visual feast for a painter! There are flowers and fruit trees everywhere. As you walk along the sidewalk you can reach up and touch an orange or lemon on a low-hanging branch.

Seeing the Opportunity

We were walking through one of the piazzas shortly after a spring shower and this extraordinary scene caught my attention. One-point perspective is the dominating feature here, just like looking down a railroad track. Surefire composition! Your eye just has to go to the girl walking on the wet pavement.

The colorful buildings on the left were especially notable for their unique windows, grillwork and the bust of what may have be a hero to the locals. The flower boxes in the foreground speak for themselves, serving as pointers to the girl. Even the lilac trees emphasize the importance of the girl as the focal point. Notice how the size and shapes in the pavement recede and lead the viewer to the figure. A good lesson in perspective!

The puddles on the pavement gave it the final touch. Always be careful when doing puddles—don't make them too important or they'll steal the show.

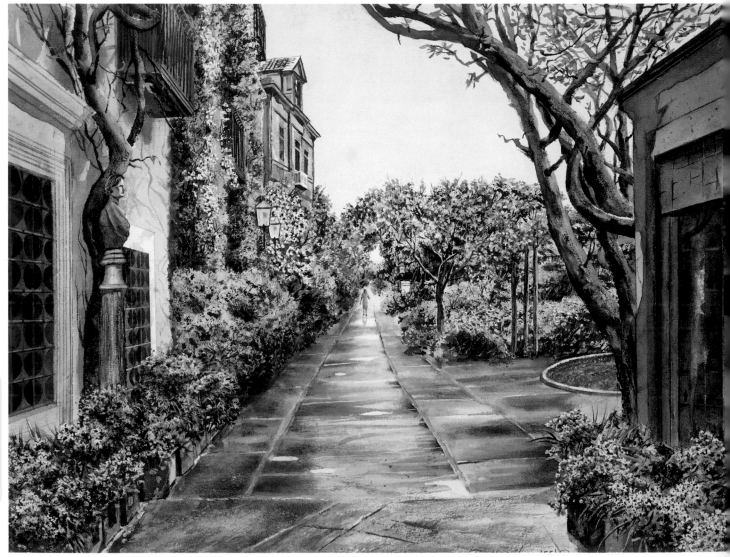

Return to Sorrento
Watercolor on paper, 21" × 29" (53cm × 74cm)
Collection of the artist

Architecture

Keeping Objects in the Distance

Lighthouses absolutely fascinate me as symbols of life and hope. Twin Lights lighthouse has guided thousands of seamen safely in and out of New York Harbor since 1862. It received international notoriety in 1899 when the twenty-five-year-old Italian genius, Guglielmo Marconi, selected it as the site from which to send his first wireless message. That was the beginning of worldwide radio transmission.

This was painted from what they call Plum Island on Sandy Hook, New Jersey. It was early evening, the sun had just disappeared in the west behind the hills and there was a little amber reflection in the shallow water.

Twin Lights
Watercolor on paper, 10" × 14" (25cm × 36cm)
Collection of Mr. and Mrs. H. Grillon

Painting Procedure

1 Masking

After carefully drawing the scene, I masked out the towers, the buildings on the hill and the sail using masking fluid.

2 Sky and Water

I wet the sky (stopping short of the towers), then let flow Ultramarine Blue with a large flat brush. I let it dry then washed a mix of Cadmium Yellow and Alizarin Crimson across the bottom of the sky. I then added the water with a light wash of Cerulean Blue.

3 Middle Ground

I painted the sand with light Burnt Sienna. For the weeds and darker accents, I used the fan method with a mixture of Burnt Sienna and Burnt Umber. The tide pools are a diluted Cerulean Blue.

4 Sand and Grass

I defined the foreground sand with little touches of Payne's Gray and Winsor Violet. I then added the grasses with Burnt Umber using the fan method.

5 Hill and Houses

For these I removed all the masks, and re-wet the hill. I separately dabbed in blue, gray, and Burnt Sienna. When that was dry, I detailed the trees and other dark accents with the same colors. I then painted the small strip of background beach.

6 Lighthouses

At last, I painted the lighthouse with Burnt Sienna and scraped the water with a razor blade for a little texture.

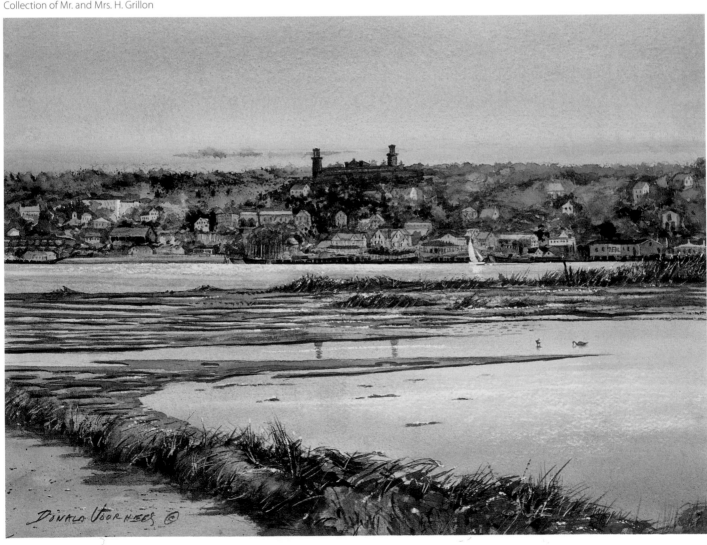

Painting Detailed Architecture

This building is the Loggia dei Lanzi, an open-air sculpture museum in Florence, Italy. Completed in 1381, it faces the Piazza della Signoria, the political heart of the city, and houses several important statues. The most famous ones are the extremely beautiful *Rape of the Sabines* and *Hercules Fighting the Centaur Nessus* by the Flemish master Giovanni da Bologna (1524–1608). There is a reproduction of Michelangelo's masterpiece *David*, but the original is held in the Accademia Gallery, also in Florence.

In 1559, a huge U-shaped building was built incorporating the Loggia dei Lanzi, facing the piazza and on the bank of the Arno River. The extremely rich and powerful Grand Duke Cosimo de Medici (1519–1574) used the edifice to house his administrative offices. The Medici family installed their tremendous art collection on the second floor and created what was Europe's first modern museum when it was opened to the public in 1591.

At first it was only open to the public by request, but eventually it became open on a regular basis. Today it contains the finest collection of paintings in Italy. All the great masters are here: Leonardo da Vinci (1452–1519), Raphael (1483–1520) Michelangelo (1475–1564), Rembrandt, (1606–1669), Titian (1488–1576) and many others.

Sometimes, Keep It Small

I photographed this driver, the horse, the carriage and Giovanni da Bologna's gorgeous white marble statue. With this made-to-order subject, what more did I need? This is a small painting, only 8" × 13" (20cm × 33cm). I purposely made it small so I could have more brush control over the driver, the sculpture and the horse.

First I masked out the driver, carriage and horse with fluid, and then cut the mask for the statue out of tape. Masking the statue enabled me to paint the dark, juicy wash in the background. I then painted the columns, adjacent buildings and pavement. I removed the fluid mask from the driver, horse and carriage and painted them in that order. Remember: When you're painting a figure this small, don't worry about facial features. This isn't a portrait!

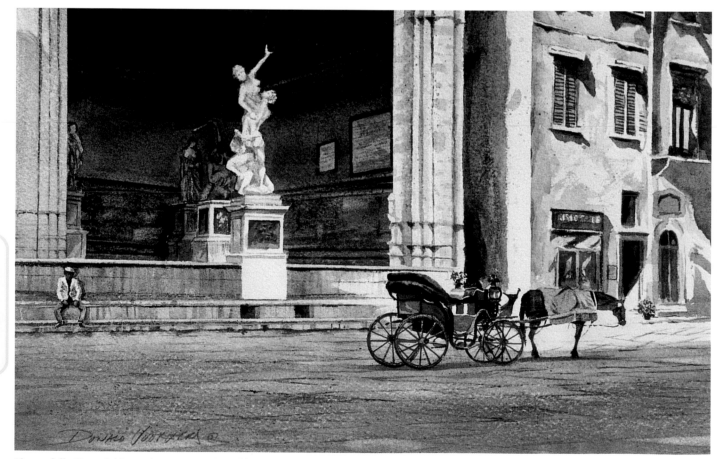

Piazza della Signoria Watercolor on paper, 8" × 13" (20cm × 33cm) Collection of the artist

Greek Architecture

Aegina is the Greek island where Nikos Kazantzakis wrote *Zorba the Greek*. This town is located on the western side of the island. As you wander into the town, its charming little white and pink houses and a large pink cathedral are truly impressive. To the left is this tiny white chapel dedicated to St. Nicholas, the patron saint of sailors. I knew this scene had all the ingredients for a good painting, such as: The striking light on the chapel, the colorful flags waving in the breeze, the mountain in the background and interesting architectural details, including lampposts and other unusual objects.

Materials List

10" × 12" (25cm × 30cm) 140-lb.
cold-press Arches
Drawing board
No. 2 HB pencil
Transfer paper
French curve
2-inch (5cm) and ¾-inch (2cm) masking tape
Plastic eraser
Razor blade
Sandboard or fine sandpaper
No. 10 craft knife
Straight edge

PAINTS
Alizarin Crimson
Burnt Sienna
Burnt Umber
Cadmium Yellow Deep
Cerulean Blue
Payne's Gray
Raw Sienna
Ultramarine Blue
Winsor Violet

BRUSHES
No. 1 round
No. 2 round
No. 4 round
No. 6 round
No. 12 round

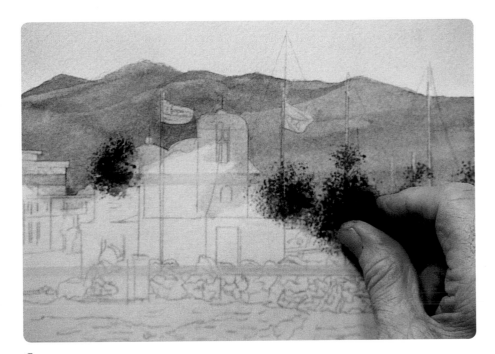

1 Prepare the Paper and Begin Painting

After making your drawing, transfer it to your watercolor paper in the normal manner. Cut your mask out of 2-inch (5cm) masking tape. Make sure you don't miss the flags, flagpoles and boat masts.

Paint the mountain using Payne's Gray and Winsor Violet with your no. 12 round. With your sponge, stipple in the pine trees behind the building and boat yard with Cadmium Yellow Deep and Payne's Gray.

2 Paint the Church and Adjacent Buildings

Remove all masks except for the street lamp and both blue-striped flagpoles in front of the church. Paint the church using your no. 6 round and various shades of Payne's Gray. Work a little bit of Raw Sienna onto the left side of the building for reflected light. Paint all the windows using nos. 1 and 2 rounds with medium to dark values of Payne's Gray.

Lay down a strip of ¾-inch (2cm) masking tape on both sides of the two flagpoles and burnish them well. Now, diagonally stripe the poles with your no. 1 round charged with dry Ultramarine Blue so it won't bleed under the tape. Using the same brush, paint the Greek flag with Ultramarine Blue and the yellow flag with Cadmium Yellow Deep mixed with a little of the blue.

Remove the tape from the lamp and paint it with Payne's Gray using your no. 1 round. Paint the bell using your no. 1 round with dark Payne's Gray. Because of the small size of this painting, use a French curve and a sharp no. 4 pencil to add the bell cord. Paint the pink building on the left using your no. 2 round with Alizarin Crimson and Winsor Violet. Paint the windows with Payne's Gray. Using the same brush, paint the surrounding buildings with a mixture of Burnt Umber, Burnt Sienna and Alizarin Crimson.

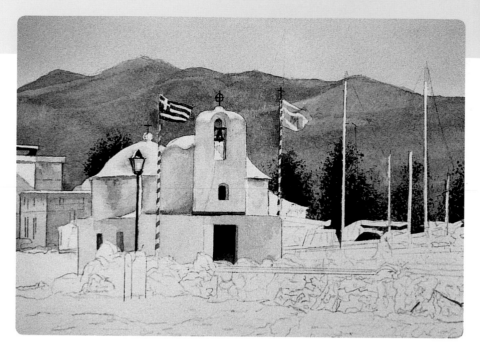

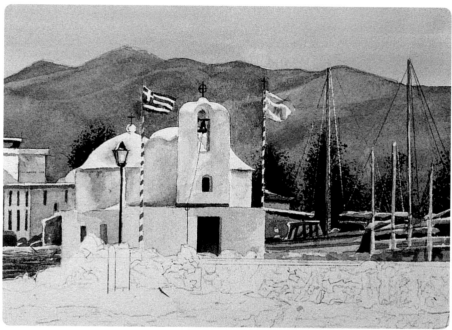

3 Add the Boat and Masts

Paint the boat cabin and trim using your no. 1 round with Burnt Umber. Rinse the brush and use it to paint the masts and sails with a mixture of Payne's Gray and Raw Sienna. Draw in the rigging lines with a hard, sharp pencil and a straight edge. Scrape a couple of rigging lines out with the corner of a sharp blade to suggest light hitting them.

Use a no. 1 round to paint the small building near the flagpole with both light and dark Burnt Sienna. With a no. 2 round, paint the water with Cerulean and Ultramarine Blues. Paint the rocks behind the wall with Burnt Sienna and the grass with a mixture Raw Sienna and Cerulean Blue using a no. 2 round.

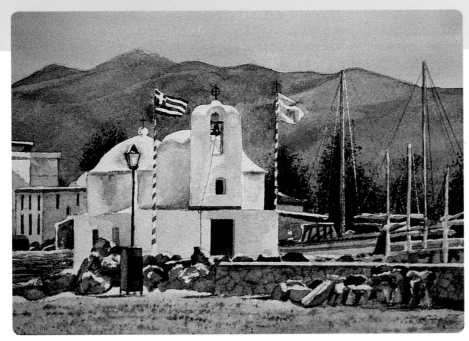

4 Paint the Rocks and Foreground

Cut a mask for the mailbox out of ¾-inch masking tape, then cut a mask for the small wall. With your no. 2 pointed round paint the foreground rocks. For color, alternate between Burnt Sienna, Raw Sienna, Burnt Umber and Winsor Violet.

Remove masks and paint the mailbox using the same brush and a touch of Raw Sienna and Cerulean Blue. Again with the same brush, paint the wall with Payne's Gray and Raw Sienna.

Mix up a batch of Raw Sienna, Payne's Gray and Burnt Sienna and paint the foreground with your no. 4 pointed round. Accentuate it while wet with a little salt. When dry, spatter Burnt Sienna very lightly with your no. 2 pointed round.

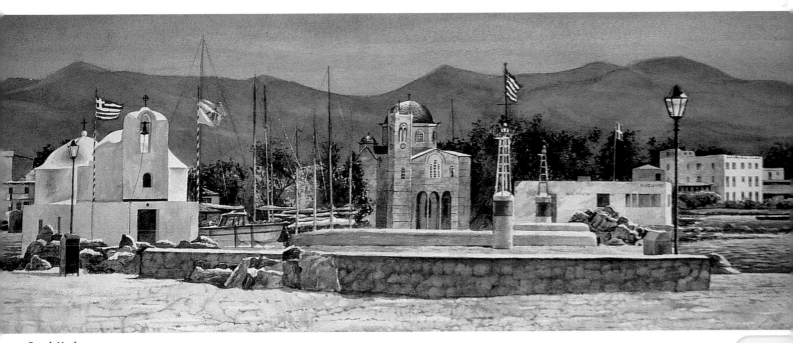

Greek Harbor
Watercolor on paper, 11" × 29" (28cm × 74cm)
Collection of the artist

Painting Architecture from Start to Finish

The most amazing thing about the Pantheon in Rome, Italy, is not its size, as immense as it is (until 1960, the dome was the largest ever built). The truly startling thing about it is the height of the rotunda to the top of the dome is precisely the same as its diameter, so the interior space is a perfect sphere.

The 29-inch (74cm) oculus at the apex of the dome signifies the "all-seeing eye of heaven." Everything in the interior is made of marble, gold or bronze, all materials that reflect lots of light and reflect it in different ways. The most important thing was to choose the right colors and plan to make the painting shiny by leaving plenty of white paper showing. In general, I used Burnt Sienna for the darks and Raw Sienna for the lights sparingly and carefully.

The Concept

What really attracted me to this subject was the pattern of light from the oculus as it played on the walls, the Corinthian columns and the marble floor. When I first walked in on a bright sunny day, I thought, wow, what a painting this would make! I thought about it for a couple of years until I determined exactly how I was going to do it.

Painting Procedure

1 Drawing

As in most of my architectural paintings, I made a very careful drawing of the interior using my T-square and triangle on 24-inch (61cm) vellum. The reason I used the vellum is it's very strong, so it's easy to erase and re-draw. When I was satisfied with the drawing, I transferred it to the watercolor paper with graphite transfer paper.

2 Masking

The first thing I did was mask all the columns. I also masked the entire floor using the newspaper method. One of the things that helped me capture this scene was breaking it into four different areas to be treated as different paintings.

3 Painting

I started by cutting masks for all the pictures and frames, the roof and the gold columns of the shrine. Starting with the background, I began painting. I then cut the picture masks away and re-created the paintings from the Pantheon, then removed the frame masks and painted them. This same procedure was followed for each of the four areas.

4 Finishing Touches

Advancing from areas A to D, I painted the bluish gray and gold circular mouldings at the top. When I returned to each area, I removed all masks, except the floor. Then I painted the columns with light blue-gray shadows and just a suggestion of fluting in the light areas. I painted the shrine on the right using mostly Cerulean Blue and Raw Sienna.

I removed the floor mask, but made sure I masked all areas abutting the floor (including the bottom of each column). I started the bottom half by painting the marbled floor using a muted Burnt Sienna and Payne's Gray. It was difficult to keep the sunlit area lighter than the rest of the floor.

Lastly, all masks were removed. I very carefully went over the whole painting with my plastic eraser to make sure that all pencil marks were removed. With a sigh of relief, it was finished.

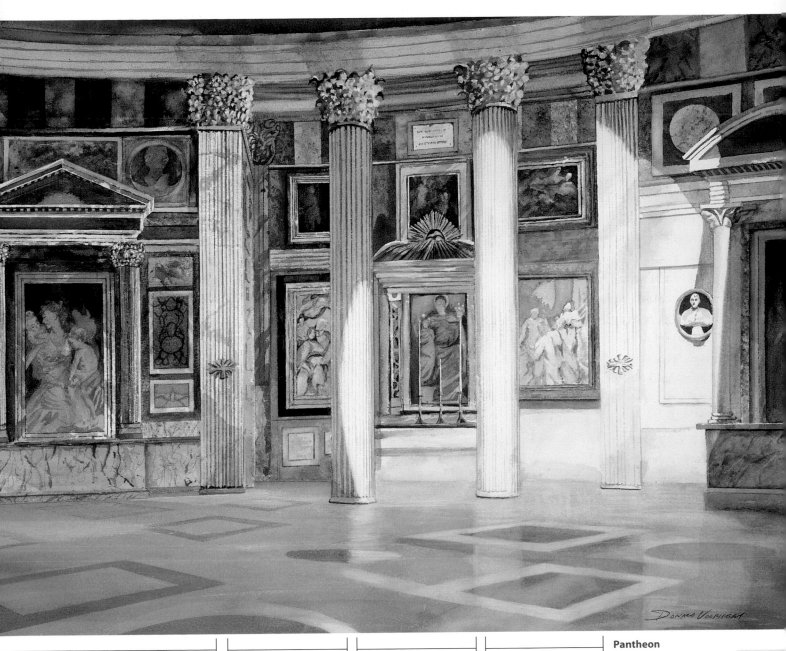

| Area A | Area B | Area C | Area D |

Pantheon
Watercolor on paper,
21" × 29"
(53cm × 74cm)
Collection of the artist

Conclusion, or How I Made It in the Art World

Where do you go from here? Well, that depends on what you want to do with the rest of your life as an artist. Just paint for your personal satisfaction, if that's what you want. You can give a few paintings to your friends and even enter a few local shows. That's fine. Everyone has his or her own goals.

But if you want to make a living as a professional artist, take it from me, it's a hard buck. Very few artists—except the really big names—can make a living today solely on the sale of their paintings. They must supplement it with teaching, commercial freelance work or a separate job entirely unrelated to art.

The Story of My Career

This is how my art career started. I was discharged from the Navy in 1946 and shortly after I entered the Academy of Arts in Newark, New Jersey, on the GI Bill of Rights. It was a good, small school based very much along the lines of the Art Students League, and it was an easy commute on the train from my parents' home in Neptune, New Jersey. I was immediately put in the beginner's class. There I put in endless hours of drawing plaster casts of heads, hands, feet and various other parts of the human anatomy.

The instructor was Nick Parris, to whom I give credit for teaching me drawing and perspective. Sometimes we spent a whole day drawing a simple square box, cylinder or ball. He had very inventive ways of instructing us. Some days he would come into the classroom carrying two arms full of cardboard boxes, throw them in the corner of the room and say, "Draw them." (If you don't think that's hard, try it sometime.)

After several months of this I was promoted to more advanced classes where Stanley Turnbull, a George Bridgman student at the Art Students League, taught life drawing and anatomy. Avery Johnson and Edmond Fitzgerald taught the watercolor classes. I would sit in class, dumbfounded, and watch Avery demonstrate how he painted his magnificent transparent watercolor landscapes. His class initiated my lifelong love affair with this exciting medium. I graduated from school in 1949.

After Art School

In the 1960s I learned that one of my favorite watercolorists, John Pike, was opening a school in Woodstock, New York. I was thrilled and quickly signed up for classes. John was a man of many talents, one of which was carpentry. He built a building behind his house in the woods of Woodstock especially for the purpose of painting demonstrations. He demonstrated in the mornings, then in the afternoon we went out into the woods surrounding his property and painted. John had a great impact on my learning process and for years I tried to emulate his style. This is a common occurrence, but it eventually passes and you develop your own style.

At this time I was selling a few paintings, primarily to friends and neighbors for something like fifty dollars apiece. One of these people was so impressed with my work that she suggested I teach some private classes. I decided to take a chance and put up notices on the bulletin boards in the local supermarkets. Within a short period of time I was getting calls. My first class consisted of five or six students. If the weather was good,

I'd take them outside to paint, and if not, I would set up a couple of still lifes in the recreation room. Eventually I began teaching watercolor at the Guild of Creative Art in Red Bank, New Jersey.

In the mid-1960s, on two consecutive summer vacations I went to Kennebunkport, Maine, to join Ed Whitney's famed workshops. I learned a lot from Ed. He was a great teacher and it was a truly invigorating experience, to say the least. In the late 1960s, I joined Mario Cooper's watercolor class at the Art Students League. I really learned how to paint flowers in this class. Mario obtained bunches of flowers from a wholesaler in the flower district before class and arranged them into several bouquets.

The Beginnings of Success

In 1970 I was elected to the New Jersey Water Color Society, and in the subsequent years I have served as treasurer, secretary, vice president and eventually president. At the same time I was accepted into the Salmagundi Art Club in New York City, got listed in several *Who's Who* publications and started getting into some major shows around the East. My work was selling well in several galleries. In 1972 and 1973 I took my summer workshops with Don Stone on Mohegan Island off the coast of Maine.

(I'm not telling you all this for the sake of bragging, I'm just showing you how my career evolved so you can see what's involved on that bumpy road to success. It's important to see some of the steps that shape the career of an artist. As I said earlier, it's not easy. You have to work at it and love what you do.)

I met my wife Terry in the fall of 1974. It was she who suggested I become

more aggressive about marketing my work. At that time, the larger shopping malls had periodic art shows. I decided to sign up for one and was pleasantly surprised by the response.

In March of 1976, Terry and I were married—best move I ever made career-wise and otherwise. We started doing more mall shows, which I hated, and eventually started doing some summer outdoor shows

The Print Business

During our outdoor shows we noted that three paintings were very well-liked, but not enough for people to lay out the money to buy them. Had they been prints, we would have sold several. That gave us the incentive to take the paintings to a printer in Long Island to reproduce. That's how we got into the print business. Then we heard of a printer in the area who printed original lithographs. I took samples of our three prints and some originals and went to see him. He liked them, so I starting making lithographs.

We started attending trade shows as bona fide print publishers. Sales wise the shows weren't terrific, but once, in Chicago, we landed a ten thousand dollar commission. One thing you learn is that you have to be out there or nothing happens.

Our First Gallery

That same fall we opened a gallery here in Atlantic Highlands. The rent was affordable and it gave us a start in the gallery business. Realizing that a better location would be more conducive to selling art, we leased a place on a major highway. The first thing we did after opening was to install a picture-framing facility. Not only did it increase sales, it also reduced framing costs for my paintings and prints.

In the meantime I was accumulating several new print editions, knowing it was important to have a presence in the print market. With variety, I could gain a foothold in a very competitive market. I was doing more and more trade shows all over the country.

The year was 1979 when my friends Del Filardi and Harriet Rubin opened a summer gallery on Cape Cod, Massachusetts. They asked me if I would like to exhibit there and I jumped at the chance. This turned out to be a great decision: They gave me a show every Fourth of July until they sold the gallery in 1999.

We're Having a Party

In 1981 we made a bold decision. We wanted to expand our New York market, so we took matters into our own hands and rented one of the ballrooms at the Waldorf-Astoria in New York City for a pre-Christmas show. We bought a mailing list from A.S.I.D. (American Society of Interior Designers), combined it with our own mailing list and sent out the invitations. The show entailed a lot of work, but again, our friends helped out. The weather was not on our side—it poured. However, much to our delight, we had great attendance and the event was an enormous success. In fact, even to this day, it was the best show we ever had.

I continued doing trade shows—in the 1980s I did as many as ten or twelve a year. In fact, once we hired additional personnel for the gallery, Terry started doing some shows. This became necessary when two good shows were scheduled at the same time.

In the 1990s we continued to expand our line, and in particular, painting golf scenes took us to many new and exciting places. Finally we started doing some personal traveling for pleasure, but as you know, there is always something that just has to be turned into a painting.

Still Painting After All These Years

We sold our gallery in 2002 and no longer participate in shows. I continue to serve my old customers and new ones who found me through my Web site: www.donaldvoorhees.com

Index

Learn to paint gorgeous watercolors with these other fine North Light Books!

Get close to nature without ever leaving the studio! In *Artist's Digital Photo Reference: Landscapes*, you will find an abundance of photo references covering a wide range of subjects including mountains, oceans and trees, along with suggestions on how to paint from photos and an introduction to the art of photography. Discover the wonders of nature with this must-have tool!

ISBN-13: 978-1-58180-901-5
ISBN-10: 1-58180-901-8
Hardcover, 128 pages, #Z0313

No other current book focuses entirely on representing weather in landscape painting. From the haze of summer to the snow of a blizzard, *Painting the Elements* provides all the step-by-step instructions you need to portray a wide variety of climates and conditions. Bring the most dramatic landscapes to life in oil, acrylic, and watercolor with over 25 projects that showcase the work of North Light Books' bestselling authors!

ISBN-13: 978-1-58180-887-2
ISBN-10: 1-58180-887-9
Paperback, 192 pages, #Z0275

Watercolor artist Laurel Hart is a master at putting people into realistic scenes. No other book provides such clear instruction for painting people as important elements within such settings as landscapes, cityscapes, interiors and more. *Putting People in Your Paintings* covers all the basics including shape, value, composition, color and watercolor technique to help your watercolor paintings be filled with life. There is more to people than portraits!

ISBN-13: 978-1-58180-779-0
ISBN-10: 1-58180-779-1
Hardcover, 128 pages, #33449

Splash 9: Watercolor Secrets provides an inside look at the style of successful artists. You are given tips on techniques including light, color, composition and brush application, as well as insights into the methods and ideas behind great watercolor painting. With more than 100 paintings on subjects including street scenes, landscapes, animals and people, this is one book that will make a splash in your studio!

ISBN-13: 978-1-58180-694-6
ISBN-10: 1-58180-694-9
Hardcover, 144 pages, #33353

These books and other fine North Light titles are available at your local fine art retailer or bookstore or from online suppliers.